To My dearest
Hinckl
With tender love
Susan
1978

P9-DBM-808

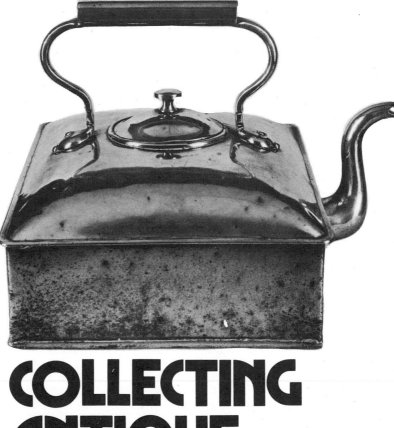

COLLECTING ANTIQUE METALWARE

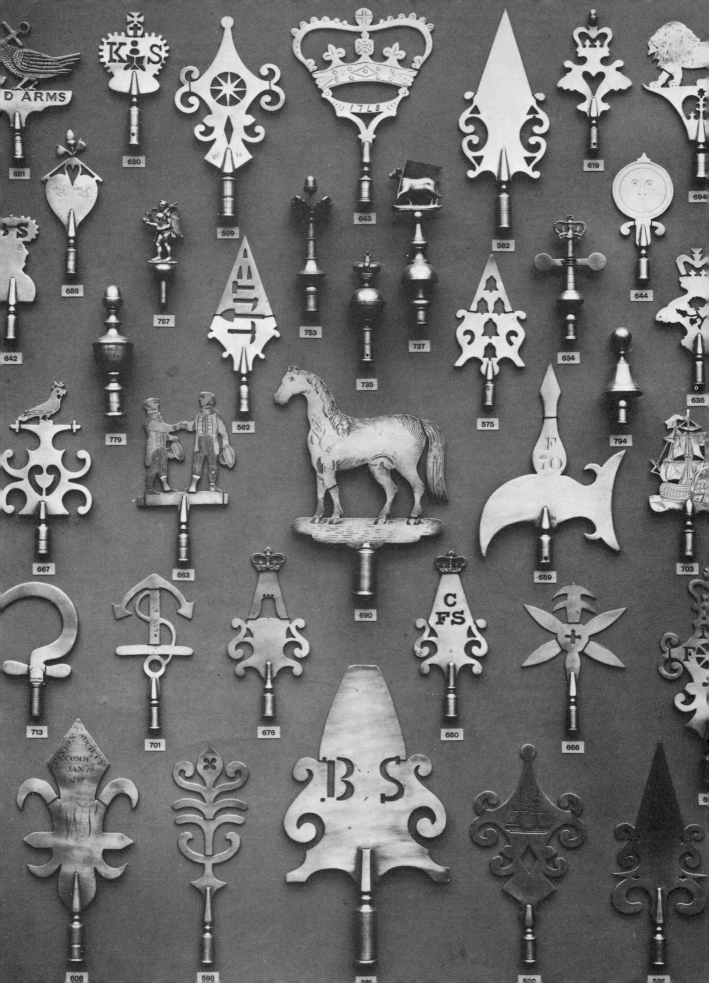

COLLECTING
ANTIQUE
METALWARE

EVAN PERRY

Doubleday & Company, Inc.
Garden City, New York

1 *half-title page* Square copper kettle. Mid 19th-century.
Royal Pavilion, Brighton.

2 *frontispiece* West country brass pole-heads.
Victoria and Albert Museum, London.

3 *title page* An unusual combination of tools: the
Victorians were delighted by gadgets of this sort.
Hampshire County Museum Service.

4 *below* Corkscrew, chestnut roaster, waffle iron
and a skillet. Brighton Museum.

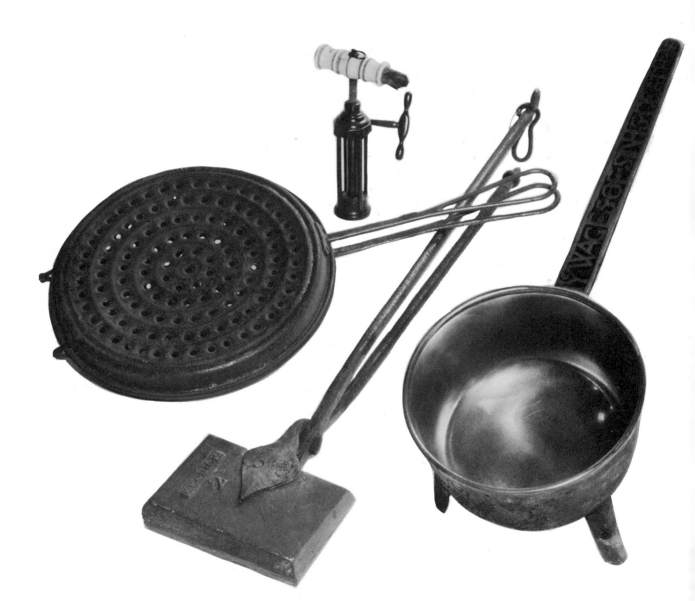

Published by
The Hamlyn Publishing Group Limited
London · New York · Sydney · Toronto
Astronaut House, Feltham, Middlesex, England
© Copyright The Hamlyn Publishing Group Limited 1974

ISBN 0-385-05197-2
Library of Congress Catalog Number 73-19293

Text set in 'Monophoto' Plantin by
London Filmsetters Limited, London
Printed in England by Butler & Tanner Limited, Frome and London

CONTENTS

A SHORT HISTORY OF METALLURGY 7

THE FIREPLACE 23

KITCHEN EQUIPMENT 39

THE DININGROOM 63

LIGHTING DEVICES 75

THE PERSONAL ITEM 107

DOOR, STREET AND GARDEN 125

SOME TOOLS AND IMPLEMENTS 143

SOUVENIRS AND SAMPLES 155

FAKES, FORGERIES AND REPRODUCTIONS 167

CARE AND CONSERVATION 179

ACKNOWLEDGMENTS 188

BIBLIOGRAPHY 187

INDEX 189

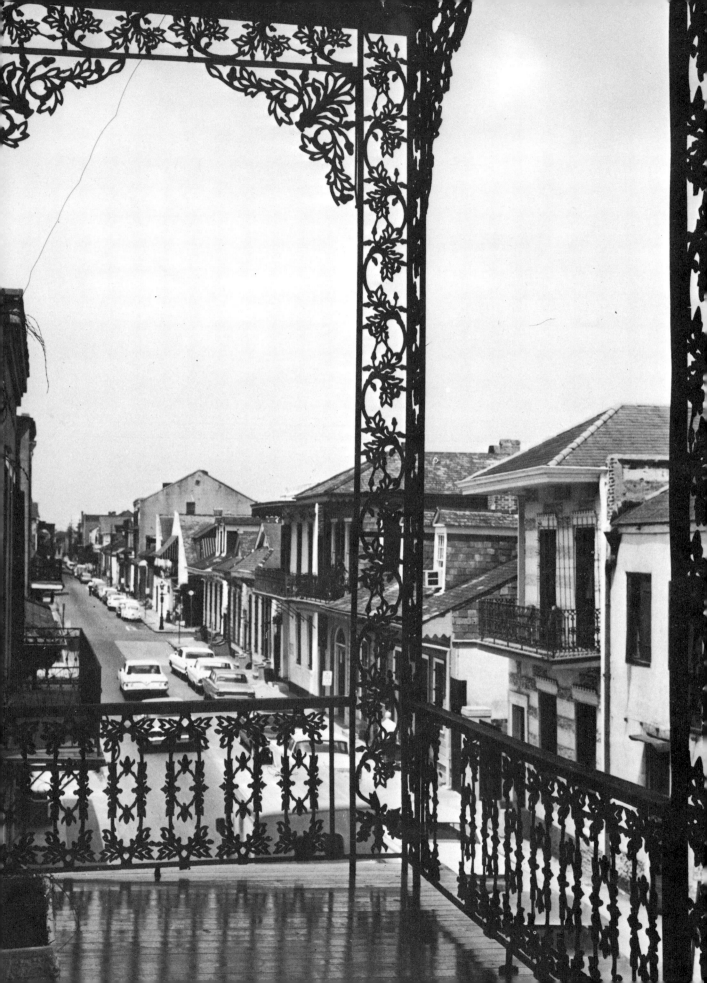

A SHORT HISTORY OF METALLURGY

Numbers in the margin refer to illustrations

There is sheer romance in metal for it has been with us, making our tools, our weapons, our ornaments, for over five thousand years, and without it we could have achieved nothing like the advances that we have made.

Metals can be divided into two main groups: natural and man-made. The natural, pure metals are those found in the ground, and it is by mixing them that man discovered 'alloys', the second group. Of the natural metals, the ones that the collector is likely to be most interested in are copper, lead, zinc, tin and iron; and of the alloys, chiefly bronze, brass and pewter, with many variations in each group.

Apart perhaps from gold, the first metal that man had was almost certainly copper, stumbled on accidentally when in some remote ravine, possibly in Anatolia, some 7000 years ago a nomadic tribe, searching perhaps for pretty coloured rocks to crush up for pigments to decorate themselves and their walls, discovered actual small lumps of copper, a red rock which, they found, would not crush up but could be beaten into small objects such as rings or disks. At the same time it was probably discovered that blocks of rock used to build a site for an overnight fire disintegrated in the heat of that fire, causing the copper content to run out, so that in the morning they found this strange, tough, pliable material. Ancient man soon found that he could hammer this metal and by reheating, or annealing, keep it soft and workable. He could then beat it both into flat sheets and also into shapes such as cooking pots, tools, swords and spears.

Soon after came the discovery of tin, lead and zinc. The early craftsman soon learned the basic laws of metal: that hammering hardens and that heating softens. He learned that in their natural state metals are either too pure to have strength or so impure that they have to be refined. In these processes he discovered that by mixing ores he could produce different varieties of greater strength, hardness or cheapness. By one mixture, which had a preponderance of copper to tin, he arrived at bronze (by 3000 BC); by a different mixture, with a preponderance of tin to copper, pewter; by a mixture of copper and zinc, brass. These man-made metals, or alloys, were sympathetic to casting: by the aid of small fires, furnaces were built to smelt the metal. A mould could be made out of sand, clay or carved rock, the metal run in and you would have a cast knife for a warrior, a cast brooch or ornament for a girl; a cast handle for a cooking pot. In Europe the Celt, marching out of the mists of Scythia, took the technique of bronzeworking all over his continent.

The metalworker became pre-eminently important, being both desired and feared. He would establish himself near his material and create ornaments, knives, axes, etc. Traders coming to deal with him would perhaps stay, and a small community might be formed. As long as possible a craftsman or group of craftsmen would keep their secret—a comparison with 'trade secrets' of today can be made. Some skilled workers continued their nomadic habits; they were itinerant smiths, wandering over the continent, who would appear in a district, make 9,19 cooking pots, brooches, pins and weapons, and then move on. They would take, in part payment for their work, old, worn-out and broken articles in the same metal, ensuring a steady supply of raw materials. Each individual craftsman was in fact a one-man business: purchaser of scrap metal, maker and retailer of new goods. By the very conditions of the times he would be a secretive and lonely man and would often cache his hoard of raw material some miles outside a village before venturing in. Sometimes he would never return and his hoard of bronze would be lost until uncovered in our own century by the archaeologist or the ploughman. These early workers were essentially loners and the 'mystery' of the craft was born as early as this.

From 2000 BC iron became known, probably starting in an area of Turkey and progressively, through experiment, becoming more and more important. While great civilisations of the Middle East, people such as the Hittites, used the power of iron to conquer, in our world inevitably—as with brass, bronze and pewter—it was the Romans who made 10 most use of it. Many examples of Roman metalwork

5 Fine ironwork preserved in New Orleans.

6 Testing the fit of the tyre on a new waggon wheel before finally fixing it.

can still be obtained and at reasonable prices. I have recently seen an early kitchen strainer, small bronze plates, several lamps and, surprisingly, a Roman pewter flagon.

The discovery of iron brought additional problems to the craftsman. By its nature iron needs much more heat than either copper or bronze, so that he had to improve his fires or forges, and in this experimentation he would discover that he could evolve two types: cast iron and forged (or wrought) iron. In early times it was the forged iron which was really important: it was tough and durable, and, by hammering, a sort of temper (the correct combination of hardness and flexibility) could be induced which enabled the craftsman to give it an edge, thus making it an ideal metal for tools and weapons. It also had the great advantage that it was possible to join the metal by placing two pieces side by side, heating them and then hammering them until they forged into one. This heat-welding is almost a lost art today **6** but certainly wheelwrights putting an iron tyre on a wagon knew this skill. Out of this technique of heat-welding came all the beautiful wrought ironwork which can be seen throughout Europe in old castles, **7,19** medieval cathedrals and parish churches. The skill continued in the building of wrought iron grills and balconies in the 17th and 18th centuries. Many examples of 18th-century ironwork can be seen

in towns such as Brighton, Cheltenham, Edinburgh, etc., and in the older towns of the U.S.A. (New Orleans is a good example). **5,11**

By a combination of both cast and forged iron in the ever-improving forges, steel was ultimately evolved.

Iron in all its forms advanced civilisation considerably. In war and peace this exceedingly strong metal would from the beginning provide an increasing range of bolts, bars, hinges, locks and gates for the home, cauldrons for the kitchen, implements for the farm and tools for every trade. Some of the early locks, keys and hinges are superb works of art, well worth collecting. Strangely, in the 18th century, steel was used as jewellery. Carefully cut and polished it would sparkle like diamonds, and it was used for belt and shoe buckles, sword hilts, etc. During the troubled period of the early 19th century in Europe it became fashionable for patriots, in order to raise funds for the army, to surrender their bronze, brass or silver fire-irons, candlesticks, furniture mounts and the like and have them replaced by fine quality ironwork. Gold jewellery went the same way, together with book mounts and decorative pots. Over the years this group of iron articles has been given the name 'Berlin Iron'; sometimes, cynically, 'Berlin Bronze', due to its dark colour. It is rare today. It was brittle and so was easily broken; when broken it tended to be thrown away, being worth little in hard cash. Some of the examples that remain are, however, very beautiful and well worth looking for.

In the 5th century AD European progress had its first real setback. Imperial Rome, controller of the greater part of Europe, broke up under the invasions of barbarian tribes. Many of the skills of civilisation became dormant, but the skills of metalworking lived on through the 'lost' centuries. Then, with the rise once again of cities, metalworkers tended gradually to concentrate in certain parts of the city and so to form themselves into guilds. This occurred probably as early as 1250 and, by the 16th century, they have coats of arms and mottoes.

Many variations of bronze and brass gradually creep in: latten, bellmetal, gunmetal, Dutch metal. These names sometimes cause confusion today. I am of the opinion that they are difficult to pin down because, over the centuries, they have been applied rather haphazardly to all metals in the bronze group.

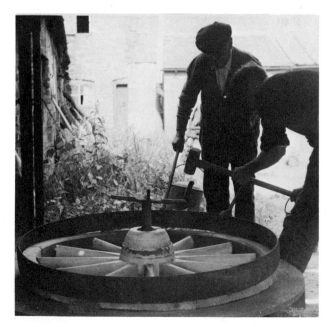

7 The magnificent west door of Southwell minster,
Nottinghamshire.

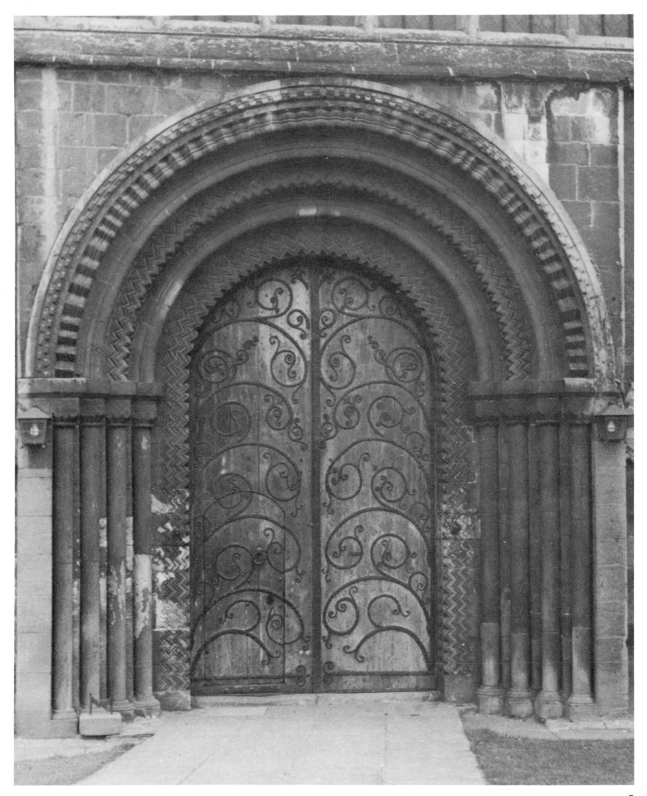

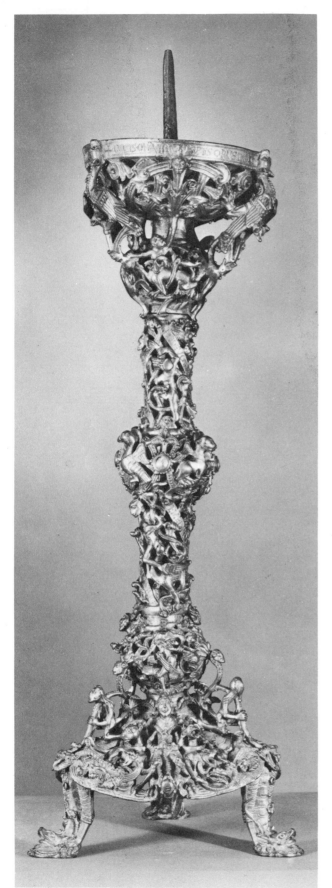

8 The Gloucester candlestick. 12th century. Victoria and Albert Museum, London.

Pieces in these metals can be found as early as the beginning of the Middle Ages. By the 17th century, as an alternative technique to casting, metal presses were being used; an object such as a candlestick would be stamped out by the press in two halves and these halves would then be brazed together. By the mid 18th century, patents were being taken out to produce scutcheon plates for furniture, doors, etc. by this method. To economise on metal in the Victorian period one amusing method was to place a thin brass sheet in a secured mould with a pinch of gunpowder; when this was exploded the sheet was blown into the required pattern shape. This technique produced very thin but decorative doorknobs, curtainpole terminals etc.

In the case of the pewterworkers, they had formed their own separate guild of 'hammermen' by 1348. Each member had his own 'touch' or stamp to identify his work, and there is evidence that these touches had been registered as early as the middle of the 15th century. Pewter, although too soft to stand direct heat, is a long-wearing, tough metal, basically tin with minor additions of metals such as copper and lead. From the medieval period it gradually superseded wood or leather for plates, flagons, etc. By the 17th century all classes were using it and for a wide range of purposes. By the 18th century there were many different qualities from 'tavern' pewter to fine quality pewter for the parson or squire. It remained popular for taverns and eating-houses all through the 19th century and, surprisingly, there was a renewed interest in it in the Art Nouveau period. Its ductile body and smooth finish lent themselves to the flowing wave-like lines which were the inspiration of this art form. English pewter is still being made and exported today.

By the mid 18th century a new, toughened form of pewter called 'Hard metal' was in use, which by the 1800s was called 'Britannia metal', a name that is still in use today. The best is extremely good, and some early writers on pewter do consider it a form of pewter. There are, however, many grades of Britannia metal and, at its worst, it should best be described as 'Black metal', a debased form producing articles of inferior quality. It was very popular and for a time almost superseded pewter. In the past much Britannia metal was scrapped so that good specimens have become scarce. It is now arousing

9 Three prehistoric safety pins. The design of the mechanism has hardly changed in 3000 years. British Museum, London.

10 Roman pewter found in Britain. British Museum, London.

interest and many collectors find it attractive.

Of a harder texture altogether is the group of white metals—such as German silver and tutenag or paktong—which are based on nickel. Nickel was known as a problem metal early on in the 15th and 16th centuries when it appeared in bronze castings, causing faults. This, of course, annoyed and worried the workers who, not understanding the reason, attributed it to evil spirits or the Devil himself, 'Old Nick' as he was known—hence the name 'nickel'. Tutenag is an alloy of copper and zinc.

Antimony should be mentioned here as small objects made in the 19th century in this material are often found. It is a hard, durable, white metal, heavy to the touch, and gives a crisp casting. It is frequently found plated.

In 1743 a revolutionary discovery was made by Thomas Boulsover, a Sheffield cutler. He found that, by placing a slab of copper and a thinner one of silver together, they could be fused by heat and rolled under pressure into a thin sheet of metal which was silver on one side and copper on the other. From this 'copper rolled plate', as he called it, he made

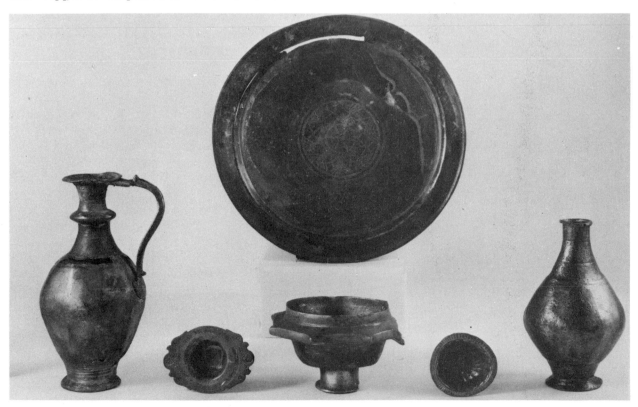

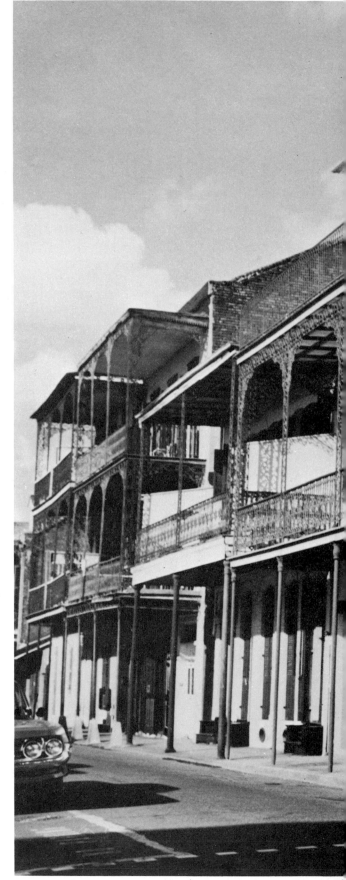

buttons and small boxes. Later, three layers—silver, copper, silver—were sandwiched together, making it even harder to distinguish it from solid silver. It
13 became known as Sheffield plate and was heartily disliked by silversmiths for a long, long while. To collectors of plate the slight sign of wear showing pink through the silver is much esteemed. (Note: not all articles that show copper through silver are Sheffield plate: some early electroplate also may do so.) One of Boulsover's apprentices, Joseph Hancock, succeeded him and improved the technique. The range of articles made in Sheffield plate was greatly widened to include tea and coffee pots, hot water
12 jugs, candlesticks, etc. Trade catalogues were issued showing the ever-increasing demand for it. It was probably to this workshop of Joseph Hancock that a young boy named Matthew Boulton went to be trained. The son of a Birmingham metalworker, he founded in the 1760s the Matthew Boulton & Plate Co. at Soho, a suburb outside Birmingham. He built up a great business and was in partnership with James Watt, the inventor of the steam engine. This great metalworker produced an immense range of goods: candelabra, coins, sword hilts, dishes.

Sheffield plate continued to be made until the discovery of electroplating of silver upon base metals, such as copper or nickel, by the firm of Elkington in 1840. Usually called E.P.N.S. (Electro Plated Nickel Silver), this destroyed the older craft of Sheffield plate and is itself now worth collecting: good specimens are superb. It was at this period that electrotype castings from an original became possible.

Plating gave a silver finish to metals. Gold finishes are also to be found, as in 'ormolu' and 'pinchbeck'. With ormolu the technique was to cast the object in good bronze, finely finish it by hand and then gild it with powdered gold mixed into a paste with mercury. The mercury was then vapourised by heat, leaving the gold in position. This technique, which is known as 'fire gilt', was a dangerous trade because of the poisonous vapour given off by the mercury. Good early ormolu is really beautiful, but later the castings were not so well made and in addition, as a finish, were lacquered with golden varnish, a cheap alternative to gold.

'Pinchbeck' was named after the assumed inventor, an 18th-century London watchmaker named

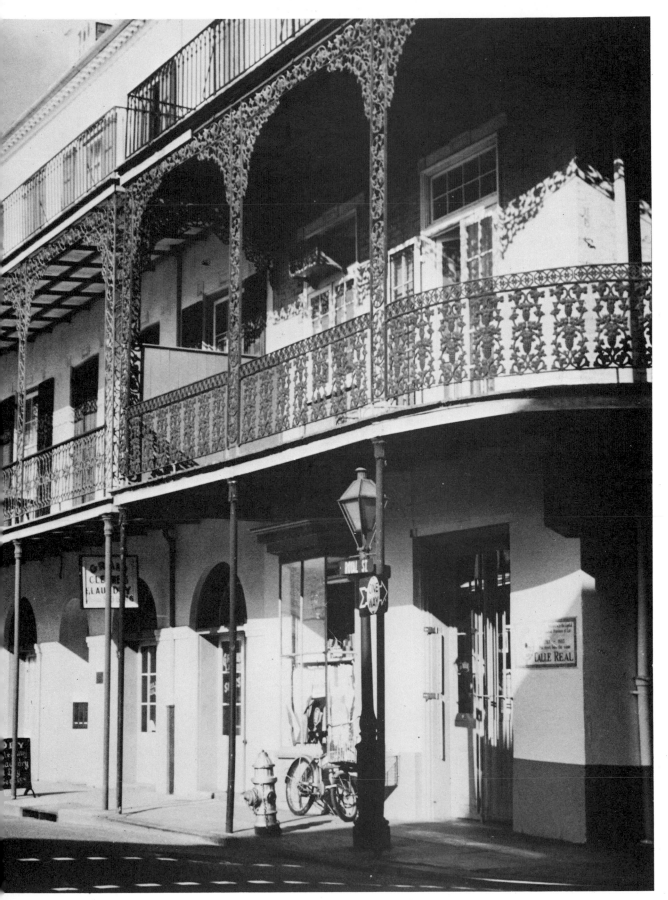

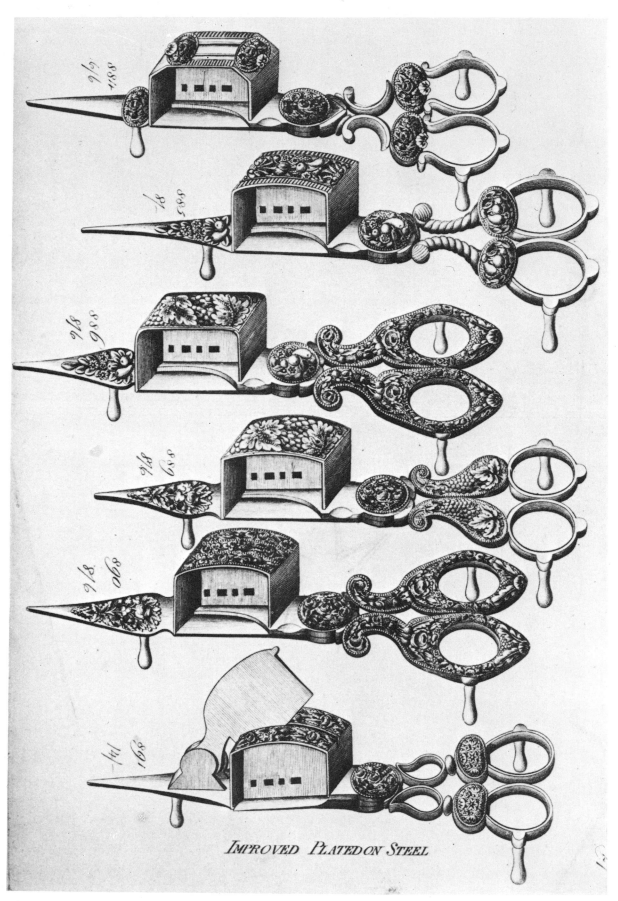

IMPROVED PLATED ON STEEL

14

12 Candle snuffers in Sheffield plate, from a Victorian manufacturer's catalogue. The prices ranged from 6s. 6d. to 14s. Sheffield City Libraries.

13 Pen and wash drawing in a manuscript account of Sheffield plating. This drawing, the only known contemporary illustration of the process, has never before been published. Sheffield City Libraries.

Christopher Pinchbeck. He gilded an alloy of copper and zinc, i.e. brass, and found that this seemed to retain its gilt finish for a long while. Many dealers today offer gilded objects as pinchbeck but I have never seen an example that I could guarantee. It is difficult, however, to be dogmatic about this finish.

A combination of both gold and silver decoration is to be found in the technique known as 'damascening', attributed, probably wrongly, to the city of Damascus which was famed in medieval times for good metalwork. The process, which was brought to Europe by the Saracens when they held Spain, consists in making slightly rough the surface of the metal to be decorated and hammering on to it sheets of fine gold and silver foil. The loose foil not hammered was then removed, leaving a design in precious metal.

Another, but comparatively rare, form of finish upon metals is enamelling (enamel being normally a form of coloured powdered glass which settles and fuses upon metal when heated). The technique is extremely old but, for our purpose, starts in the

Middle Ages with decorative metalwork on horse-harness. The metal was worked until there was a series of depressions forming a design into which the enamel was placed and then fired. The earliest backing was normally copper but later brass was used. These early enamels are beautiful and rare, and even a damaged piece is worth including in a collection. Do not assume that you will never have the luck to find a piece of this enamel: there is a story that, some years ago, an American collector bought a piece of the enamel trappings of a medieval horse-harness in a Damascus street market, which bore the arms of a noble family known to have fought in the Crusades. In the 17th century another method of enamelling was evolved: the object to be enamelled was cast with the pattern upon it, and the enamels were poured into the depressions of this pattern—obviously a much quicker and cheaper method but not capable of such fine results. This form of brass and enamel was known as 'champlevé' because of the 'raised field' of brass between the enamels. This work is popularly known in England as 'Surrey

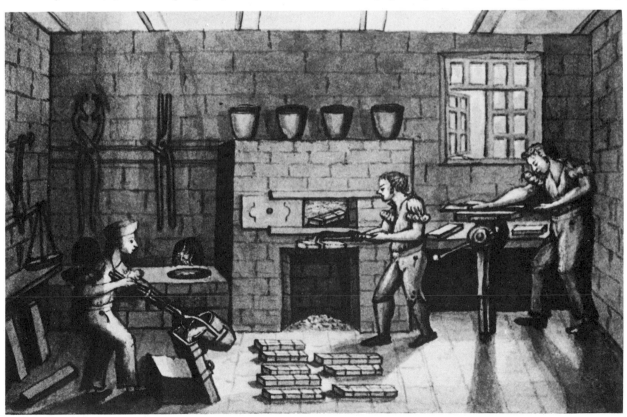

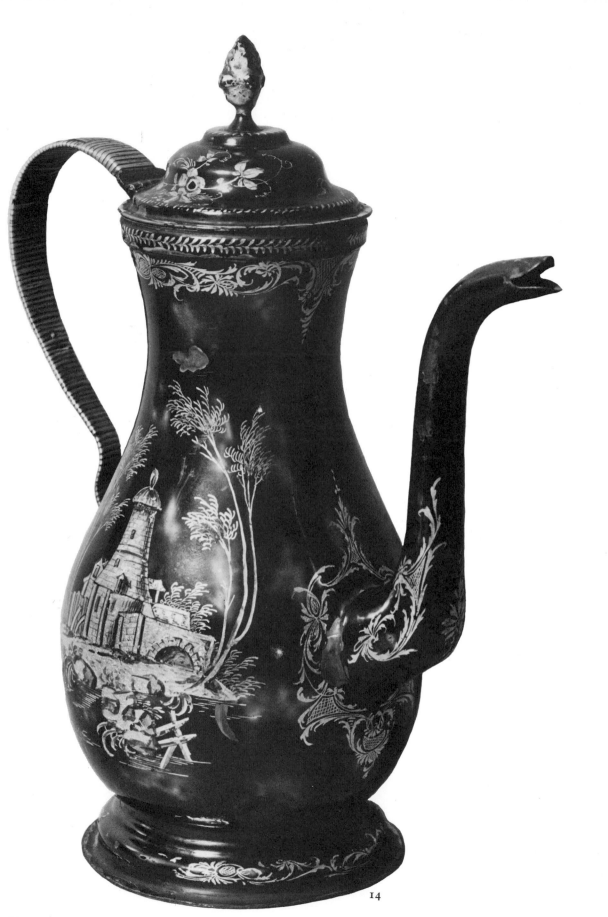

Enamels' and on the continent as 'Meuse Enamels', but they were certainly made in many other places. Champlevé enamels rose and fell in popularity with the fashions of the times and were especially appreciated in 19th-century France where one may find numerous examples in candlesticks, oil-lamps, small decorated trays and the like. (Champlevé enamels should not be confused with cloisonné, a technique described on page 163.)

Another form of enamelled metal is that in which the enamels are actually painted on the metal. On the continent, Limoges was the most famous centre for this work. Here, from the 16th century onwards, they were enamelling beautiful scenes upon small copper plaques for caskets, plates, dishes, etc. In the 18th century, both at Battersea in London and at Bilston in Staffordshire, there was a large industry turning out chiefly snuffboxes, wine-labels, candlesticks and small dishes. Some are hand-painted, some transferred.

Finally there are painted finishes to metal surfaces, often called japanned ware. This is also known to the English collector as Pontypool ware, after the most important district where this work was carried out, and to the American collector as tole ware (tole is derived from the French 'tôle peinte', meaning painted metal sheet). The name 'japanning' obviously points to the East. Early in the 17th century European craftsmen had started to copy the lacquers of the East and by the reign of Charles II were lacquering or, as it became known 'japanning', both wood and metal surfaces. There was a fashion in oriental art at this period (as there would be again in the English Regency) and, as there was not sufficient of the original to be found, the style was simulated. Japanned metalware normally consists of tin-plate (i.e. thin iron sheets dipped in liquid tin) carefully covered with layers of paint and baked at a low temperature. This is smoothed down and the process repeated again and again over a period of weeks, the final result being a surface so tough and durable that it can be put on a charcoal fire. Upon this surface, which was so similar to a dark lacquer, they painted distinctly oriental patterns and scenes.

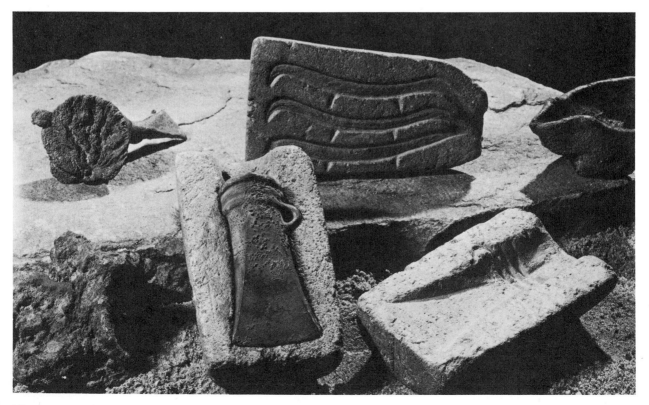

18 Prehistoric bronze horse trappings from Stanwick, Yorkshire. British Museum, London.
19 Chest in Icklingham church, Suffolk.

20 *pages 20–1* A splendid display of metalware on sale at a dealer's shop. Rod Antiques, Portobello Road, London.

When this first phase ended, japanned ware continued to be made but now had traditional English decoration: castles, country houses, bouquets of flowers, pastoral and sporting scenes. Clever effects were obtained by decorating in silver which was then lacquered with a yellow lacquer, giving the impression of gold tracery. The technique started in Bilston, Staffordshire, in the late 17th century and soon spread to Wolverhampton, London and Birmingham. One of the most famous early masters in this field was Edward Allgood who worked first at Pontypool, Monmouthshire, and later at Usk. The National Museum of Wales has wonderful examples of this highly decorative ware. In Birmingham this work was closely allied to papier mâché work which, visually, it closely resembles. Due to its remarkably tough surface, japanned ware is ideal for a vast range of articles which need heat, as braziers used on the table for lighting pipes, keeping food hot, etc., trays, tea and coffee urns, plate-warming cabinets, candlesticks and many other articles.

Also of interest is another English variation called 'barge ware'. When the canals of England were used 22 for transporting goods, the bargemen and their families lived aboard the barges. They loved colour and decorated almost everything, including metalware, with brightly coloured designs, often incorporating castles and flowers. This is one aspect of real folk art in England, and the technique and style are very similar to American tole ware.

The trade in japanned goods continued until the middle of the 19th century by which time it is possible that the cheaper method of transfer printing on tin had begun. I suppose one could say that an amusing final flowering of decorated tin – not japanned or tole ware but transfer printed – is to be found in the decorated biscuit boxes and tea caddies which started in the 1860s, are still being made and are now being collected.

One final note: inevitably the work of the early masters of japanning was copied by workers with lower standards. Some of these called their productions Pontipool ware, spelt with an 'i' instead of the 'y' of the original work.

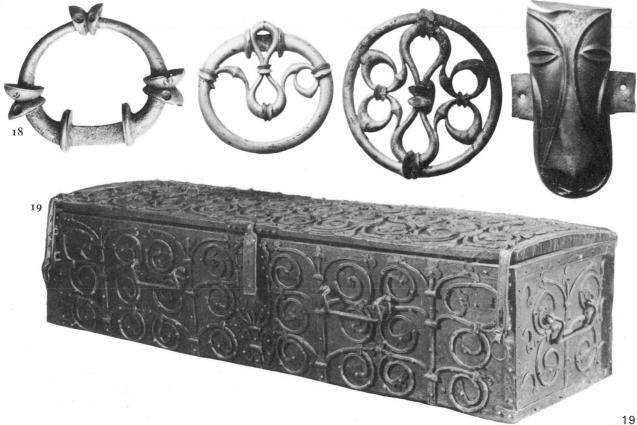

18

19

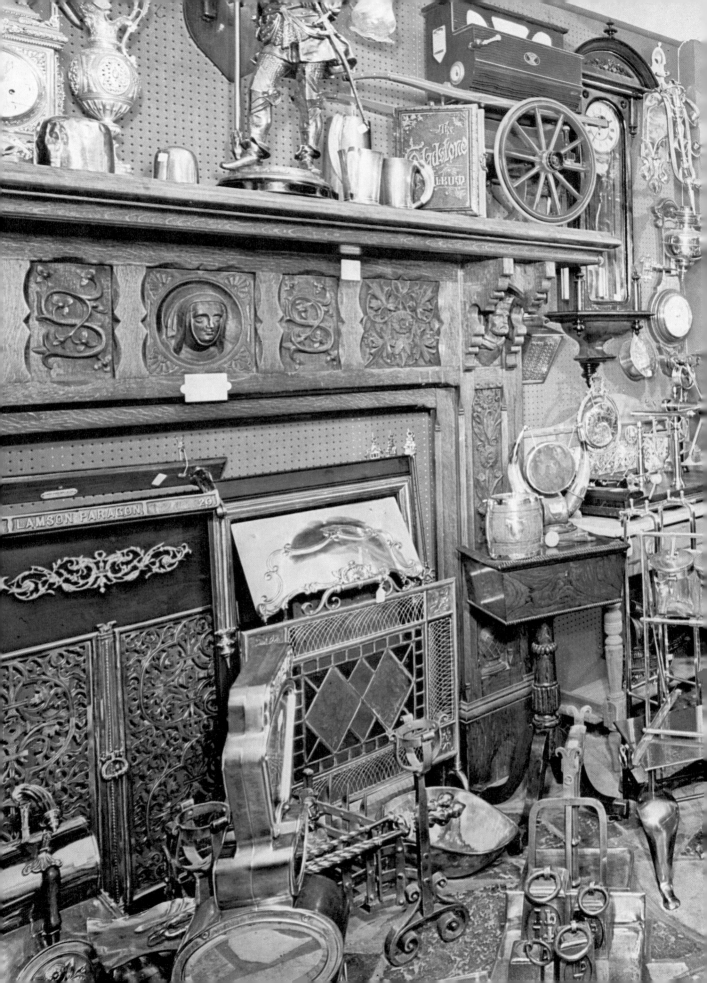

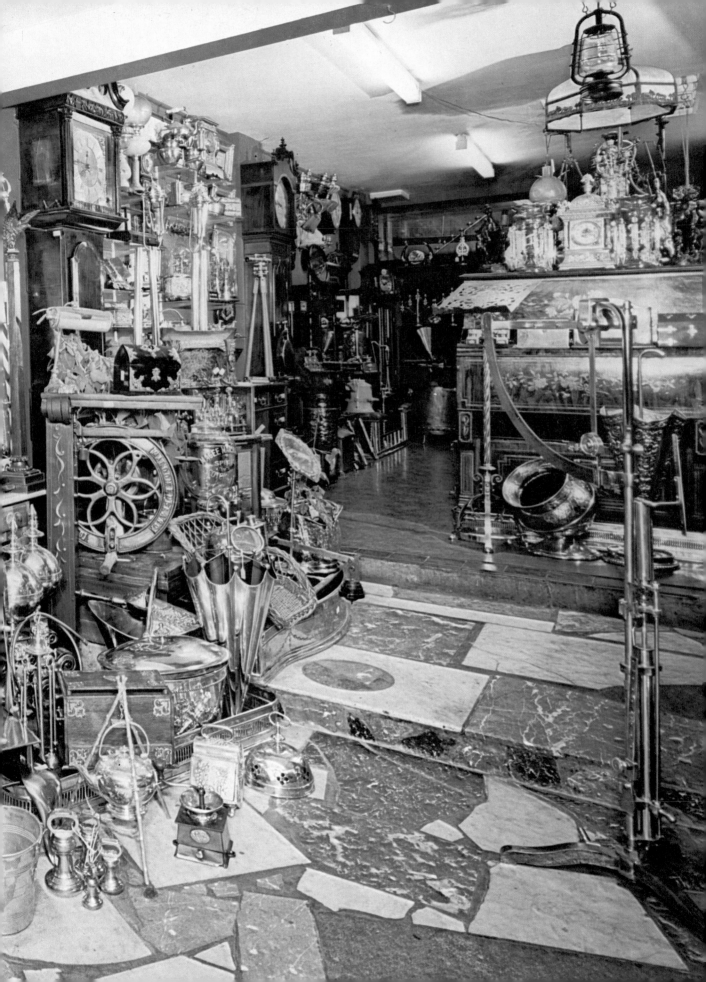

THE FIREPLACE

Incredibly, the Romans did not have fireplaces; they were so advanced that they had central heating and, for smaller homes, some form of charcoal brazier which could be moved from room to room as needed. (Charcoal braziers were still in use in Italy during World War 2 as many soldiers of the Allied Forces who were in the march northwards may remember.) All the advanced technology of the Romans was forgotten at the time of the break-up of their Empire. New tribes settled where the legions had been. They were tough, sturdy and primitive in outlook; they built their houses of wood instead of stone and the home now consisted of one large room – the hall – which made up the living quarters of the warlord and all those who had settled with him. There was a central hearth upon stone blocks, and this great fire gave heat for comfort and for cooking and was a centre where the family and servants would gather at night before sleeping. The fire was built right down on the ground and was called a 'down hearth'. Logs for the fire were controlled by iron brackets called 'firedogs' or, sometimes, 'andirons' when they were grand and ornamental.

Gradually the central hearth disappeared with the return of building in stone or brick, when it was found possible to build chimneyed fireplaces up against the wall. As lighting a fire was difficult, it was the custom to keep it going overnight. This was a dangerous practice because of flying sparks, so the wood ashes were gathered into a pile and covered overnight with a copper or brass hood called a 'curfew' (from the Norman *couvre feu*, 'cover fire', which by the way gives the expression 'curfew time', a time when lights must be extinguished and, as an extension of this, when people may be ordered off the streets). In the morning the ashes would be blown with a blowing tube or some sort of bellows to rekindle them. The hearth was still controlled by firedogs, but these were now viewed from one side only, with the result that fine ornamental work soon appears on the front. By the 17th century these firedogs were frequently decorated with brass overlay

or, in the case of some of the very great families, were of solid silver. Also, but extremely rarely, one finds enamel work on the firedogs, an example of the 'Surrey enamel' already referred to on page 15.

To avoid burning the wall behind the fire, great iron firebacks were placed against it. These were made by the ironmasters of the Sussex weald, an area that was once thick forest and streams; the forest provided the fuel, charcoal, for their furnaces and the streams provided their water-power. In the 16th century they were content with a flat sand mould into which the hot iron was poured, but by the 17th century elaborate carved wood moulds were made; pressed into the sand, they enabled a number of backs to be cast. Fine examples of these may be seen in the Every Collection in Anne of Cleves House Museum, Lewes. The patterns on the backs often consist of the arms of a great family. Sometimes they show the trade of a yeoman; a very good example of this is to be found in the famous Lennard fireback, dated 1636, where Richard Lennard, a Sussex ironmaster, is shown by his forge with all the tools of his trade about him.

It was in this century that Englishmen started out for the New World, the Americas, and amongst them were ironmasters or men skilled in this craft. Rather remarkably, as early as this, one finds the firebacks made there assuming a distinctly American feeling. Near Boston there was a deposit of bog-iron and the settlers used this source of material at the Saugus Iron Foundry, probably the first in the New World. In the American Museum at Claverton Manor, near Bath, there is one especially interesting fireback; it was made in Oxford, New Jersey, bears the royal coat of arms and is inscribed 'Oxford 1746'.

The iron industry of the weald gradually declined in the 18th century. There were two main reasons for this: the discovery of steam-power made it no longer necessary to work by water-power and, secondly, the timber for fuel had almost run out. In addition, the new fuel, coal, was available towards the north of England, and it was there that the industry shifted.

You now have firebacks to protect your walls and firedogs to control your fire. In time an iron box

21 A fireplace at Longleat, Wiltshire.
Note the wind direction dial.

22 A gaily painted barge can. Private collection.

23 Tinware tray painted with a 'Chinese' scene. Royal Pavilion, Brighton.

24 The Penshurst firedog. 16th century.

25 Prehistoric firedogs and grate from Welwyn.
Note how the basic design of the firedogs resembles
that of the Penshurst firedog. British Museum,
London.

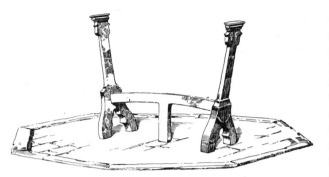

25 called a grate would be placed between the dogs.
Quite early in the Middle Ages the grate had begun
to be used in the grander houses. It may have been
inspired by the iron baskets in which camp fires were
controlled by armies on the march. Another possi-
bility is that iron braziers, built for warmth, may
have been transferred to the kitchen and so given
the idea of a grate in the house. With the coming
35 of coal, grates became essential because a coal fire
requires much more draught than a wood fire does.
At the start, grates were plain iron-barred boxes,
standing on four legs to give them the necessary

current of air. Later they became more decorative
and reached their artistic peak in the elaborate dog
grates of the 18th century where one finds incor-
porated into one unit the grate, the fireback and the
firedogs. This style was so popular and practical
that it continued right through the main coal-burning
era of the 19th century. (Note: due to the appeal of
this classic Georgian style, there have been many,
many copies, but it is usually possible to distinguish
them .as they are generally lighter in weight and
smaller.)

As soon as the grate became raised it was necessary
to have something to stop embers from rolling into
the room, and the fender was evolved. From the late 40
17th century right through to the 1900s, metal
fenders were considered essential. As happened with
so many other objects in the home, they reflected
the prevailing taste in art of their period: in the 18th
century, for instance, they were classical in feeling,
in the Victorian age overdecorated and florid. It is
interesting to note that the plain classical styles con-
tinued to be made by metalworkers in Birmingham
certainly up to 50 years ago. Of pierced brass, copper,
ormolu or finely cut steel and, in the Victorian period,
of cast iron, many of them are so beautiful that they
have always been popular. The plainer ones, or those
less valuable, have now come into their own when
cleaned and either lacquered or painted, as window
boxes and book tidies.

Another safety device was the fireguard, nearly
always made of a matching material to the fender. It
stood up against the fire and usually consisted of a
metal mesh within a shaped framework, standing
upon two sets of feet. It was probably intended
chiefly to prevent the voluminous skirts of the ladies
from blowing into the fire. These guards came into
use in Georgian times and are found in cut-steel,
ormolu and brass to match the rest of the hearth
furniture. They are often of an attractive shape but,
being purely functional, cannot really be converted
to any other use.

Fire-irons started with the wood fork, an iron bar
with a fork on the end and sometimes a spike on the
side. They were used for controlling and turning the
billets of wood on a hearth and were sometimes made
in the shape of a large pair of hinged claws. This
primitive log claw developed gradually into the fire
tongs that we now know. In addition to the tongs, a

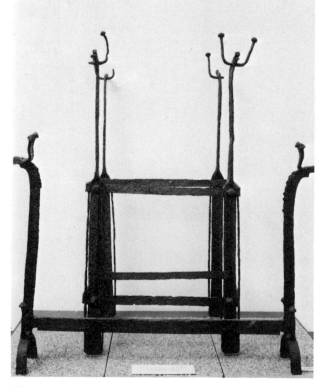

The Penshurst firedog in the centre of the Great Hall at Penshurst Place, Kent.

27 *page 28* A selection of bellows. Private collection.

28 *page 29 top* Mantel ornaments, including two copper spillholders and a third one, in brass, shaped like a boot. Private collection.

29 *page 29 bottom* Mechanical bellows of the 'Irish' type. Private collection.

26

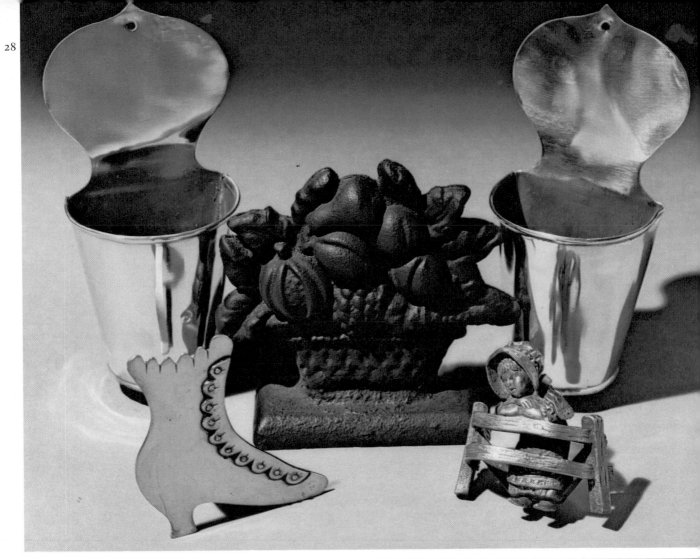

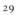

30 Curfew in beaten brass. Brighton Museum.

31 One of a pair of late 18th-century American brass andirons by Paul Revere and his son. Metropolitan Museum of Art, New York (Sylmaris Collection, gift of G. C. Granes 1930).

30

poker and in time a shovel would come to be part of the furnishings of the hearth. The shovel, like the tongs, was at first very utilitarian but later became much more sophisticated, often delicately patterned and pierced to enable the cinders to be sifted from the ash. These three items form the so-called 'set' of fire-irons which, by the 18th century, was often of finely decorated steel sometimes with ormolu handles. Indeed, by this period fire-irons had become so sophisticated that they were even decorated en suite with the iron furniture of the fireplace, and a great architect such as Robert Adam, who was an interior decorator as well, would design the hearth furnishings to match the decor of the room. Special racks were made to dispose of these sets of fire-irons in an elegant manner so that they either rested horizontally on an ornamental bar inside the fender or hung from a standard at either end of the fireplace. Some were brought together in 'fireside companion' stands which consisted of a centre standard containing a complete set of irons plus a brush for sweeping the hearth. There are, amusingly, complete sets of fire-irons made out of Second Empire French bayonets. They are quite efficient and suit the gun-room or den admirably. 34

In most cases where an open fire was used, bellows 27

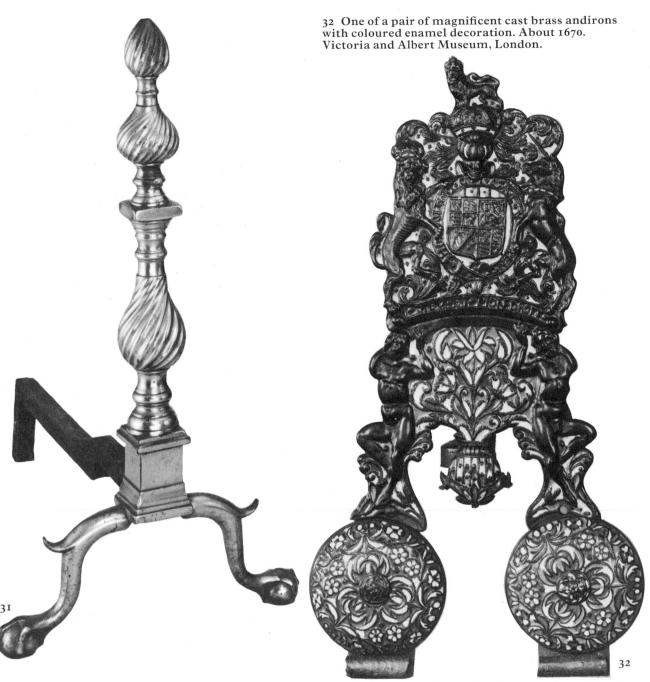

31

32

were needed to introduce a draught. They are known from the Tudor period in England although very few have survived from earlier than the 18th century. Not entirely of metal, the bellows themselves being leather tacked to wood, they are however always equipped with brass or iron nozzles and frequently have beautiful beaten copper or brass repoussé work on the front; often, too, they are elaborately decorated with brass studs.

29 A rarer type of bellows, known as Irish bellows, was operated by turning a wheel which engaged a series of wheels connected with fan blades inside a brass or wooden housing. When the wheel was turned

the blades revolved, sucking in air and expelling it in a concentrated form through the nozzle. These bellows, first made in the 18th century, were being made up to 50 years ago.

Bellows were hung near the fireplace; so, often, were warming pans in which, last thing at night, hot cinders were put to take the chill off the sheets. Later, in the mid 19th century, hot water containers, shaped like bottles or small pans, served the same purpose. These were also used as footwarmers on long journeys.

Gradually, according to the taste and social status of the family, other objects accumulated round the

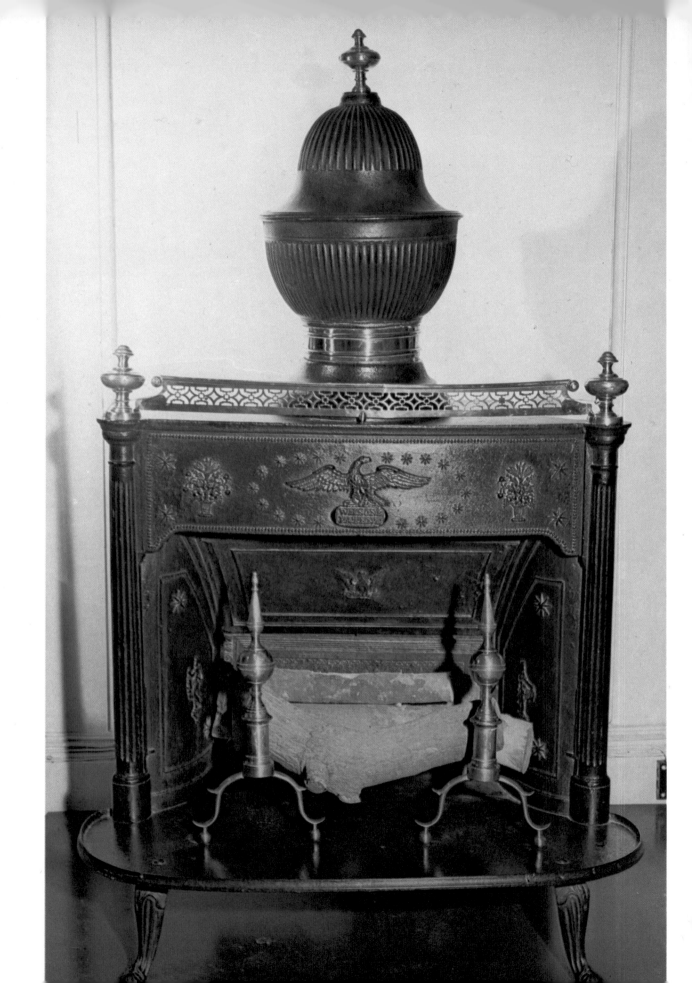

33 The Franklin stove in the entrance hall at the American Museum in Britain, Claverton Manor, Bath.

34 Bayonet fire-irons. Private collection.

35 Cast iron grate in the shape of a house front. Private collection.

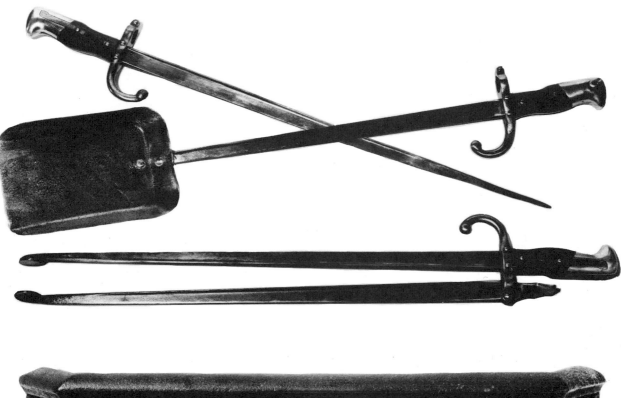

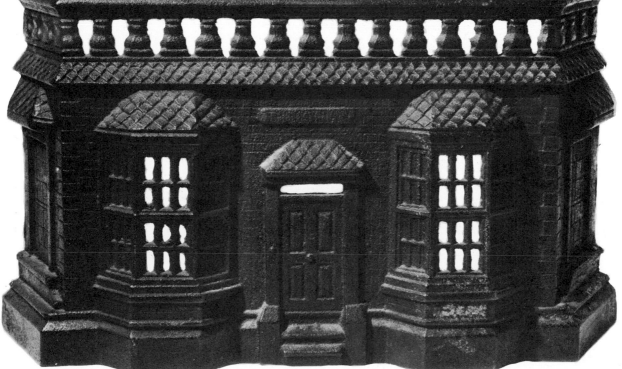

36 The wooden model of a fireback from which the mould was made. Brighton Museum.

37 The Lennard fireback. 1636. Brighton Museum.

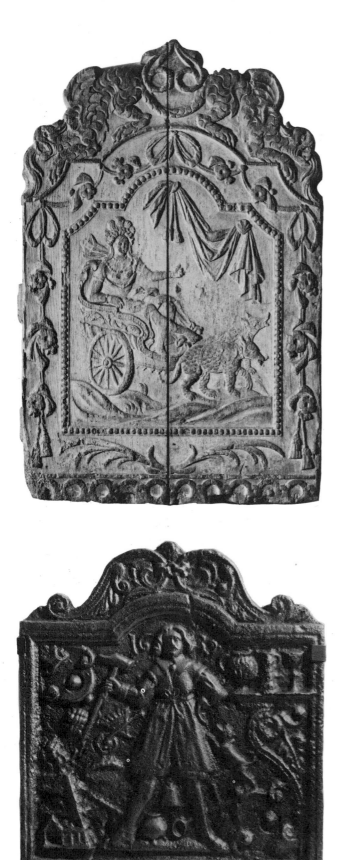

fireplace, as for example toasting forks, chestnut roasters, match and spill holders and, last but certainly not least, alewarmers. Some of these items, of course, might well be duplicated in the kitchen.

There are many varieties of toasting fork all developed, almost certainly, from the two- or three-pronged fork, used in early times for cooking a piece 48 of meat. The most usual toasting fork was the three-pronged one upon which a slice of bread was placed to be toasted. Others had peculiar brackets to hold a 56 slice of cheese as well. The Georgians especially appear to have had a positive passion for toasted cheese, and references to it constantly turn up in books and diaries of the period. This passion may have been provoked by the extreme difficulty of toasting cheese without a horizontal grill upon which to place it. Accordingly they invented an extraordinary contrivance for pinning the toast and cheese together. I cannot think that they were particularly effective. Most of these toasting forks are for holding in the hand and, for the comfort of the person using them, some had extending handles. They are found usually in wrought iron or brass, often very decorative; some have turned wood handles. Other forks were incorporated in trivets or set in weighted bases, adjusting rather like an angled desklamp. These latter —and again they were made up to 50 years ago—are sometimes called 'lazyman toasters'. In the case of the all-brass ones, it is difficult to date them as many English firms still produce debased versions of them. Where, however, the patterning and decoration are crisp and well tooled it is reasonable to assume that they are getting on for 100 years old. I knew one American lady who had acquired over 110 different patterns, all in brass. Some were undoubtedly 18th-century, but most were late 19th-century; however, as a collection they certainly looked delightful.

Similarly with chestnut roasters: the best consist of a brass or copper box at the end of a long shaft 4 so that when the chestnuts began to cook they did not fly all over the room. Others were in iron and were usually dish-shaped.

As for alewarmers, from time immemorial the English have liked their ale warm, and in the 18th and 19th centuries particularly they liked it really hot and well spiced. One method of heating the ale was to

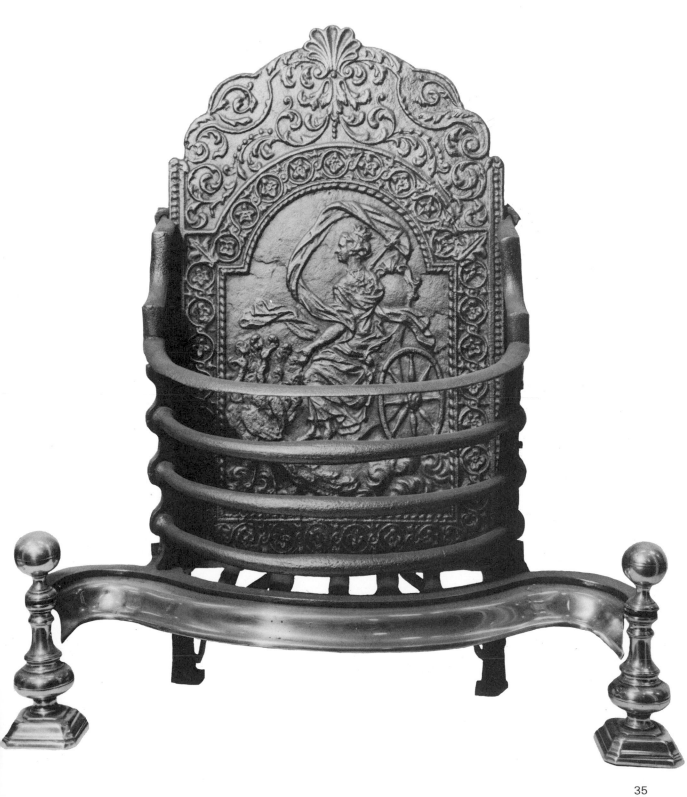

39 Chinoiserie fireplace suite of the mid 18th century, consisting of grate, bellows, tongs, hearth brush, shovel, poker and stool (or possibly trivet). From *A New Book of Chinese Designs* (1754) by Edwards and Darley. Victoria and Albert Museum, London.

40 Two 18th-century fenders in cut-steel. Victoria and Albert Museum.

plunge a red-hot poker into the pot, and many a soft-metal pewter pot was ruined in this way. A better method was to use a copper pot specially designed for the purpose. These alewarmers were 42 either cone-shaped for sticking into the embers of 41 the fire or boot-shaped for standing up against the bars of the grate. These latter ones were called 'slipper' alewarmers.

From the 18th century onwards, containers for keeping a small supply of coal near the fire are found in cut-steel, brass, copper and japanned metalware. These containers are known as coalscuttles, coal-buckets, coalhods and – a word typical of the late 19th century with its fussy refinement and classical overtones – purdoniums. They show an infinite variety of shape and form according to the taste of the period.

An interesting by-product of the Industrial Revolution was the production in small workshops of little cast brass and iron decorative plaques and ornaments to stand in the hearth or upon the mantelpiece. 28 They were essentially for the middle and lower classes and not many appear to have survived. The subject-matter was that likely to appeal to the simple

41 A boot or slipper alewarmer made of copper.
42 An 'ass's ear' alewarmer.

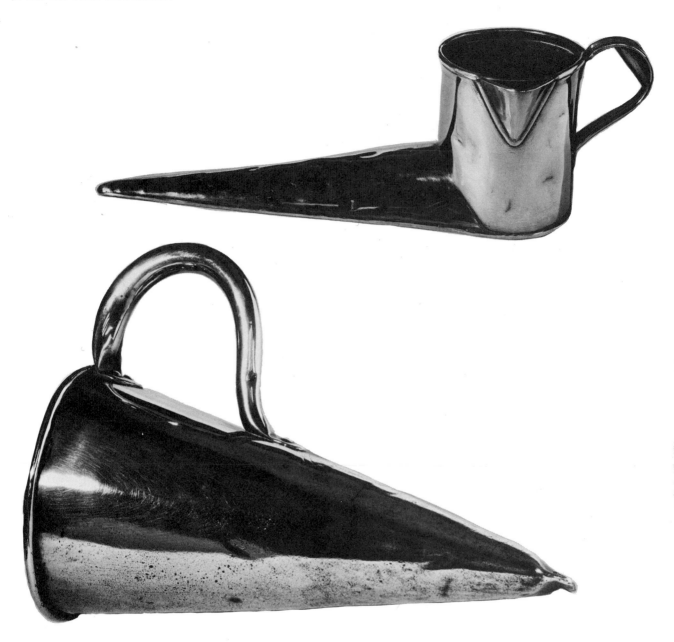

taste of the period: country girls leaning over gates, pairs of pheasants, horses. One extremely interesting one is of a farmer killing the Sunday goose with the family looking on, and there is another very rare one of two farmers quarrelling over a cow: one pulls the horns, one pulls the tail and in between is a lawyer milking the cow. Some of these ornaments which were in pairs have survived by being converted into bookends.

These little mantelpiece ornaments, intended for the smaller home, would in many cases have been found in the kitchen because, in the 18th and 19th centuries and especially in remote country districts, the kitchen was the focal point of the house. Here would come the tradesman or farmhand to talk business; and the pedlar bringing news of the next village would be entertained here, the drawingroom or front parlour being reserved for the parson or lawyer.

I have deliberately separated these two aspects of the hearth, and in the next chapter will go on to deal with the actual kitchen and with the numerous collectable articles formerly connected with the preparation, cooking and serving of food.

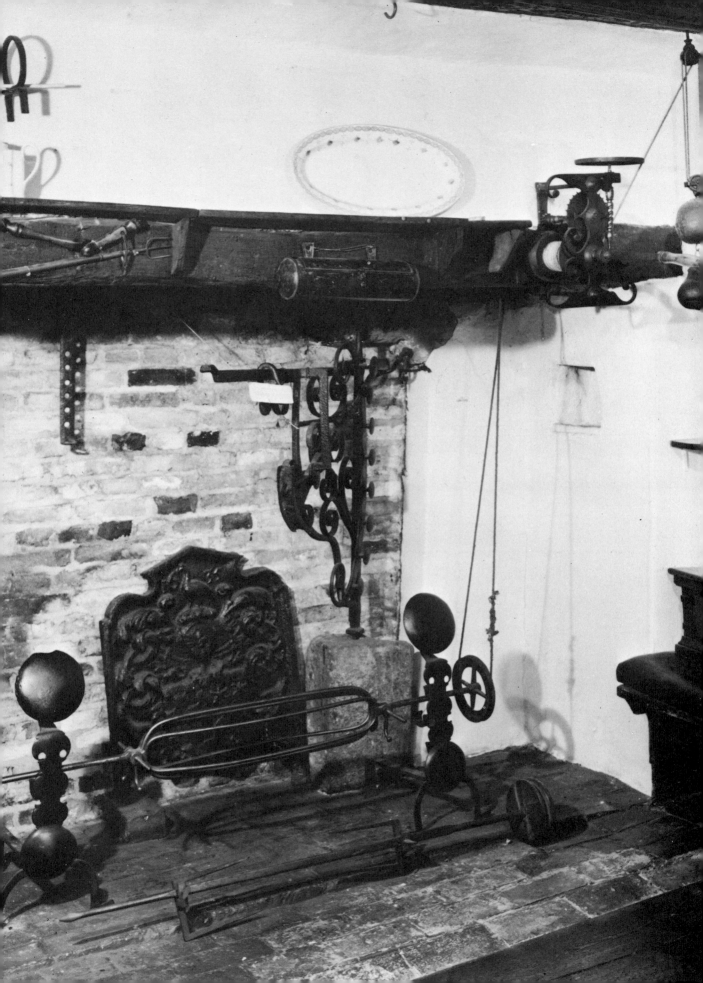

KITCHEN EQUIPMENT

The coming of metal was of great benefit to the housewife and made her life much easier, whether she was living in a cave in the Pyrenees, in a wood hut in the Rhineland or in a felt tent on the steppes of Asia. Leaving behind her the old technique of heating water by dropping hot stones into a large earthenware pot, she could now place her cooking pot straight on to the fire. Instead of an oyster shell or a piece of carved wood, she could now have a copper ladle or spoon for liquids, a skewer for meat, and hooks for food in general. She could now have a range of cauldrons and pots. These new utensils were tough, durable and, if kept clean, pretty safe.

The Roman kitchen was incredibly modern, even by today's high standards. The Roman wife had bronze buckets and ewers. She had cooking pots with or without lids, with or without feet; one woman at least had a six-hole copper egg or cake cooker – it is now in the British Museum. She had iron spits and skewers, hooks, knives, spoons, ladles and strainers. She even had balances and weighing machines.

During the Middle Ages, after the break-up of Rome and her provinces, the range of kitchen equipment became limited, due to the more primitive conditions existing. Essentials only remained although their range was fairly comprehensive: plenty of cauldrons and jugs; knives, frequently carried and used as hunting knives; spoons, ladles, skimmers and so on. In passing it should be mentioned that, at the start, forks were suspect; one of the popes in fact condemned them as being unnatural. With the coming of the Tudors we begin to approach modern living. Trade with Europe increased dramatically, bringing with it an interchange of ideas and a broadening of the concept of civilised life. By the 17th century English settlers had begun to populate the New World. Many a young bride would have taken out with her sets of pewter spoons, some brass or copper cooking pots and, if she was wealthy, pewter plates (poorer people had wooden platters). In England, from the 17th century onwards, towns started to grow larger owing to a shift of population from agricultural work to industry. This brought with it an increasing demand for domestic equipment which was met by the centres of industry now forming. It is interesting to note that methods of modern industrial production started as early as the mid 18th century. Very slow at first, they gained impetus in the 19th century. For the collector of any metalware connected, however loosely, with the kitchen, the Georgian and Victorian periods are very good hunting-grounds.

A basic essential of any kitchen is a large vessel to heat water, cook stews, etc. From as early as the Bronze Age right through to the 19th century this was normally a great round pot of copper, bronze or hammered iron or, later in the 19th century, of cast iron, with a carrying handle. Turned upside down it formed an oven. Some of these pots had rounded bases to allow the heat to curl up round the side, some stood on three little legs. This is the traditional cauldron or cooking pot, familiar to us from numerous illustrations of country kitchens or of gypsy encampments or even of witches on the heath. In time people came to realise the advantage to be gained by hanging the cauldron from a chain above the fireplace, and from this idea was evolved that of the chimney crane. These cranes were right-angled brackets of wrought iron, often of very beautiful design, fitted at the side of the fireplace in a pivot and socket. They could be swung out into the room and the housewife could place her cauldron on an adjustable hook and swing it back over the fire. If she wanted to moderate the heat, she could pull the contrivance out, adjust it to a higher level and then return it to the fire. I have myself seen water heated by this method in farmhouses in Wales. Working very much on the same principle was the kettle tilter, by which water could be poured from the kettle without the necessity of removing it from the hook.

With many chimney cranes, pot-hooks would also be used. These, as the name indicates, were hooks from which a pot could be hung, and they were used in a tremendous variety of ways. By another method they were fitted on to an iron bar above

43 A basket spit being turned by a mechanism driven by large weights, an alternative to those worked by spit hounds and smoke jacks. 18th century. Cambridge and County Folk Museum.

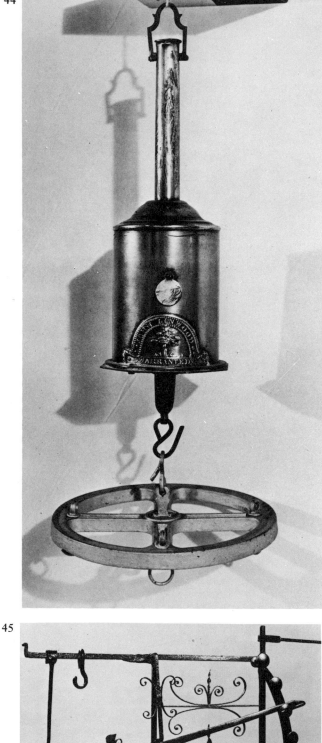

44

45

44 Brass bottle-jack. Mid 19th century. Brighton Museum.

45 Finely decorated wrought iron chimney crane and pot hooks. Early 18th century. Cambridge and County Folk Museum.

46 A close-up view of the mechanism driving the basket spit (see 43). The crank is used for winding up

the fire with links of chain which were gathered up to adjust them to the necessary height. Or one may find them used on two sliding bars with a series of holes through them which, again, could be adjusted to the required height, this time by means of an iron pin through any two of the holes. An even more ingenious way was to use a flat bar which had on it a series of teeth, called a rachet; over this was slipped a ring on the end of another vertical bar bearing the hook from which the cauldron would hang. Push it up several notches and the cauldron was removed from the immediate fire, lower it several notches and it was right on the fire. These arrangements were known by several names of which the most common were 'pot-hooks' or 'hangers'. As already stated they continued in use for a very long period. I myself find interesting the story that, when in Victorian times small children were set to learn and to write their ABC, they were given the task of drawing a page of 'pot hooks and hangers' i.e. Ss and Fs, etc.

After boiling, the next immediate need in the kitchen is for some means of roasting, and our forebears gradually evolved a remarkable range of gear to help them in this. By the late 17th century and continuing into the 19th century they had various types of mechanical jacks for roasting their meat. These frequently consisted of a spit to put the **43** meat on, held in a couple of grooves to control it, and a wheel at the end, turned by hand or operated by a small dog in a tread-mill. This little creature was put inside the wheel and trotted steadily on, turning the mechanical part. They were specially bred for the task and were called 'spit hounds'; the word is also found as a derogatory description of a man. In some noble households were to be found spits actually worked by the heat of the fire. They are known as 'smoke jacks', and a dismantled one is on view in the Anne of Cleves House Museum in Lewes, where one may study their interesting construction. In the chimney was placed a horizontal fan, geared to the mechanical spit. When the fire was lit, its heat, going up the chimney, would turn the vanes of the fan and, as this was geared to the spit, the spit would in its turn revolve, thus cooking the meat. As long as your fire burned your spit turned. An excellent example of it in action is to be found in the kitchen of the Royal Pavilion in **62** Brighton. This spit is, for the benefit of visitors, now

the weights, while the speed of rotation is adjusted by means of the large horizontal wheel at the top. Cambridge and County Folk Museum.

47 Four iron trivets. The two circular ones at the top revolve to bring different parts closer to the fire. 17th and 18th centuries. Sussex Archaeological Society, Anne of Cleves House, Lewes.

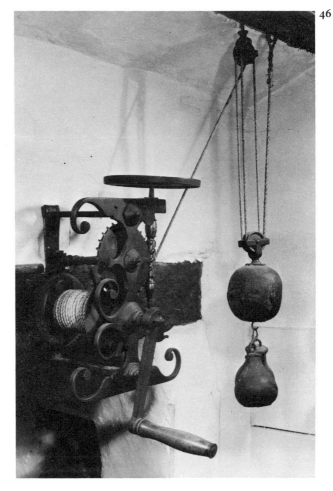

shown working with the model of a sheep revolving on it. (It is worked by electricity nowadays, owing to the danger of fire in this extremely ornate royal palace.) This utilisation of the power of hot air had been put to practical use hundreds of years earlier by Leonardo da Vinci but appears, like many of his ideas, to have been mislaid or forgotten.

By the end of the 18th century a very neat mechanical spring-driven jack was in use. It consisted of a spring in a brass container shaped like a bottle, with a hook underneath. Known as 'bottle-jacks', they were hung from a clamp called a 'jack rack' which was screwed to the mantlepiece above the fireplace. They were wound up like a child's clockwork toy and revolved slowly for an hour or so. These bottle-jacks can still be bought and are popular with collectors. They are found both in brass and in japanned metal. I have known people use them to operate a slowly revolving buffet at parties. I have also, within the last three years, known a family use one to cook successfully a turkey which was too large to go into their oven. One American collector surprised me recently when he told me that something

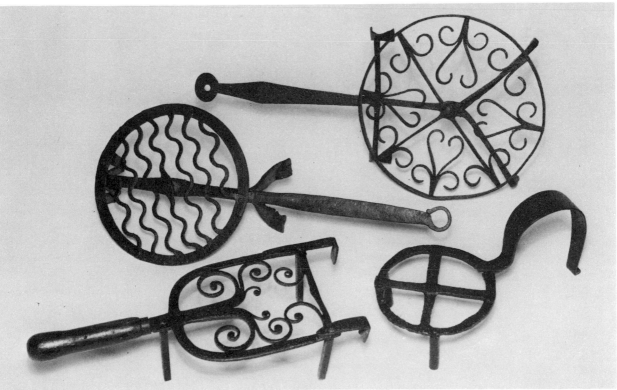

48 *left* Toaster from Derbyshire. *centre* Trivet with toasting fork from Derbyshire. *right* Spit, two forks and plate ring. All 18th century. Victoria and Albert Museum, London.

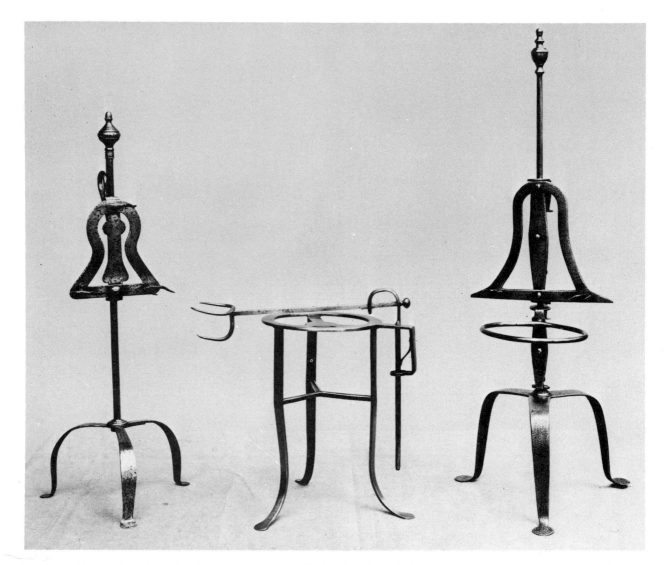

similar to this, driven by a 6-volt battery, was retailed by a prominent New York firm as a 'patent vertical rotisserie for barbecues'.

Gridirons, too, were used for roasting. Almost invariably of iron, they were intended to be put over or near the hot ashes. In the 18th century they normally consisted of a grill of hollowed half-round bars on which the meat was placed. In the cooking the gravy ran down the half-round bars into a container at the end. It was not a very good method of cooking, there must have been a great loss of good fat and good gravy. They are liked by collectors as they are often very interesting examples of peasant art. It is possible that, from using gridirons, the idea of trivets

developed. At the beginning these were three-legged stands which could be placed in the fire to put a pot or cauldron on, sometimes an easier method of boiling water than using a crane or pot-hook. I must emphasise the fact that they were three-legged because a three-legged thing will always settle steadily, very necessary when it has to stand in the ashes and cinders of a fire, which articles with four or more legs do not do so well. As the grate or fireplace developed, the trivet became grander and the legs became longer; it was fitted with a proper handle and, occasionally, a hook or spike to hang a piece of meat on. It was used next to the fire. By the 17th century trivets had developed into quite

47

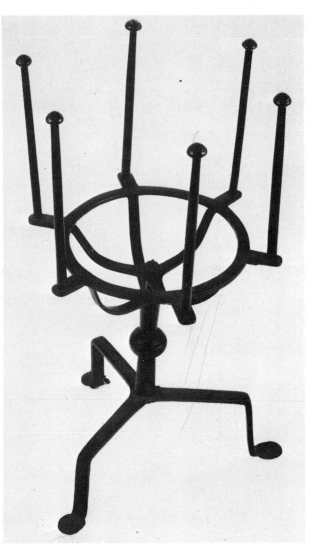

69 handsome pieces of hearth furniture, frequently patterned and of fine cut-steel and, towards the end of the 17th century, often overlaid with brass patterning. As the hearth begins to develop into a grate, the trivet gets larger until it forms an important piece of hearth furniture. It still followed its old function, now more often supporting a saucepan for stew or a copper kettle for water. By the 18th century the trivet—if it had four legs it was sometimes called a footman—still used in the kitchen had also become an essential part of the diningroom and indeed drawingroom so that the lady, when entertaining, could brew hot punch or make tea.

One of the most charming types in the 18th and 19th centuries is the three-legged trivet with pierced brass top, a handle and hook to attach it to the firebars of the grate. It could be used on its legs or, when the fire was very high, it could be hung on the top bar of the grate. In a period fireplace these trivets, accompanied as they should be by a copper kettle, look most attractive. Occasionally, as mentioned on page 34, one finds trivets incorporating a toasting fork on the far side.

From the 18th and 19th centuries one also finds, in japanned ware and often with a gold floral tracery, attractive little boxes reminiscent of a Dutch oven, normally on four small cabriole legs. These opened to take ten to twenty plates and were placed near the heat to get the plates warm for the meal. Another attractive form of platewarmer was called a 'cat'. It consisted of three legs and three arms and accommodated plates of different sizes. It was given its name because it always landed on its feet and it sat by the fire.

54 For use with a jack of any description, the 18th-century housewife had a 'hastener'. This was an open-backed hood of iron or tin sheet which fitted over the joint hard up against the fire bars; on the front was a door which the housewife would open to see how the meat was cooking. Its main use was to speed up the browning of the meat. Perhaps a more unusual method was to use a salamander, a long-handled implement normally round at the end, which was heated until red-hot and then held a short distance from any food that the cook wanted to brown rapidly. They were an earlier and a simpler form of hastener. A kitchen 'brander', also known in the 18th century, although it sounds similar to a salamander,

was in fact not so. Branders were suspended above the fire and had a pierced, decorated plate as a base upon which a flat oatmeal cake, for example, was placed for cooking. When it was browned on one side it was turned over. Griddle plates were similar but solid. They were placed on the fire on an object **50** remarkably like an early trivet, and the cooking was done on the flat plate. When not in use these plates, in smaller homes, were pushed against the back of the fireplace, making a fireback. They could be dragged out by means of a pair of strong tongs when needed. Other such plates, now collected, are the openwork oven plates from Victorian ovens, now appreciated as an art form.

50 Wrought iron griddle plate. Late 18th or early 19th century. Cambridge and County Folk Museum.

51 Copper Channel Islands milk jug. Private collection.

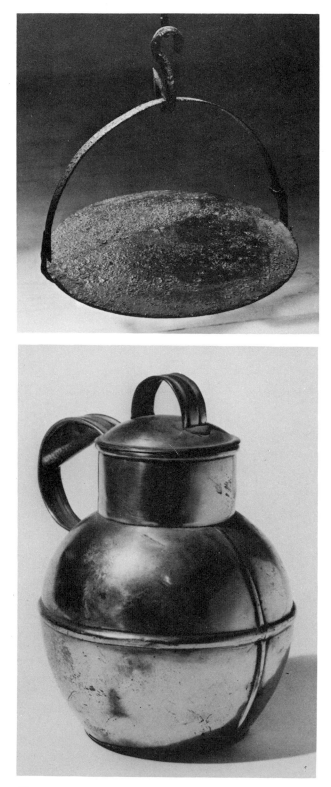

At an early date and certainly as early as the Tudors, brick ovens had been constructed adjacent to the fire, for baking bread. They were large; and long-handled spade-like implements were devised to remove the loaves from the back of the oven. These are known as 'slices' and are of interest to the specialist collector. One of these ovens can be seen in use (baking gingerbread) in the American Museum at Claverton Manor near Bath. It is in the room known as Conkey's Tavern, brought from Pelham, Massachusetts. Here, besides the oven, there is a fine collection of all manner of kitchen equipment, lighting devices, etc.

From the three-legged cauldron or cooking pot, and used concurrently with it, evolved the earliest of our saucepans, a heavy, bronze, three-legged pot equipped with a long straight handle. This is known as a skillet and is a most popular and attractive article. The maker's name is frequently found on the long handle, and sometimes there is a verse from the Bible. I cannot help feeling that, in the grim days of Puritan England, it must have disconcerted some maid in the early morning to find facing her an inscription such as 'The wages of sin is death' or 4 'Be sure your sins will find you out'.

Amongst the copper kitchen vessels, one which causes a certain amount of confusion, basically from its name, is the fish kettle. This is nothing like a kettle whatsoever but is an oblong copper pan, as long as two or three feet in length and with a handle at each end, intended to cook a large fish such as a salmon. Sometimes they were equipped with a strainer. It has given rise, somewhat inexplicably, to the expression 'a pretty kettle of fish', meaning a spot of bother, a muddle. Nowadays they are much sought after for flower arrangements.

Kettles themselves, in brass, copper or iron are 67 known from the 13th century onwards. They probably evolved from the aquamanile. These vessels, used as water containers either for washing the hands or for drinking, were known very early on in the Middle Ages and were found in all sorts of fantastic forms. One is of a knight riding a horse; you pick it up by the knight and pour the water from the horse's mouth. Others are in the shape of monsters, the water gushing out of the monster's mouth. More commonly they are cauldron-shaped vessels with two spouts and are suspended from a chain so that they

52 Pewter half-pint and pint measures of the 18th century.

53 Pestles and mortars, one brass, one bellmetal. Private collection.

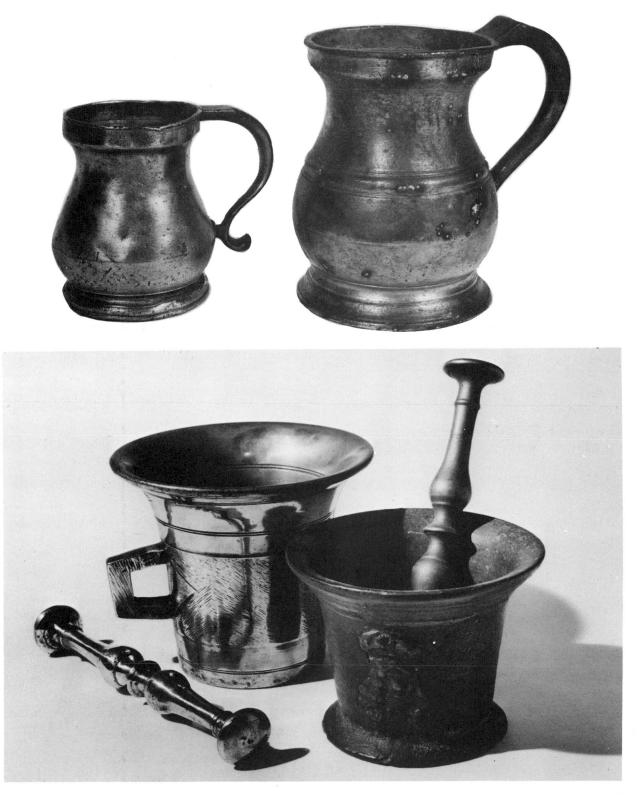

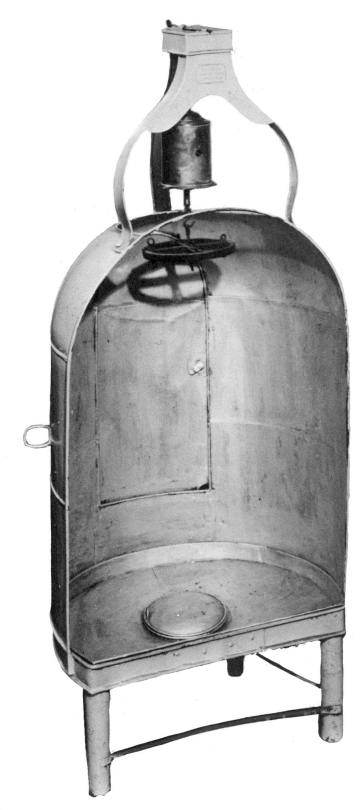

54 Hastener in sheet iron with brass bottle-jack in the top. Note the door through which the cook would observe the progress of the roasting. 1880. Cambridge and County Folk Museum.

could be tilted to either spout. Originally kettles were round vessels with a small hole at the top covered by a lid and equipped with one or more handles and a spout for pouring. Nearly all the ones to be found today are from the 19th century; very rare exceptions are from the 18th century. They are still practical items and are quite safe to use provided they are clean. They are extremely attractive.

Also necessary in any kitchen were copper bowls. One type was used for separating milk; these were wide shallow ones in which the milk would stand until the cream could be removed by means of a skimmer, a large flat pierced spoon. Deeper ones were used for beating cream and for mixing all types of food. By the 18th century there was an immense range of these bowls of all sorts and sizes, mercifully still available for the collector. Milk would, of course, be kept also in jugs, and one fairly rare group of metal milk jug is the Channel Islands milk jug which was 51 used up to about 1925 in Jersey and Guernsey. They are round cans with a small neck and a closely fitting cap which allowed the milk to be carried without spilling, even by a child. Both cap and jug were fitted with a handle; there was no spout. From their shape I suggest that they evolved from Dutch or Belgian vessels. They were in graduated sizes, normally in copper, tinned on the inside. Others were of tinned iron, probably the ones used on the farm.

Copper measures were also in graduated sizes, in the shape of jugs ranging from a pint up to an immense measure of three gallons.

Rare but well worth acquiring are superb full-bellied gunmetal measures which come in graduated sets. Like pewter measures, these must not be mis- 52 taken for tankards which in shape they resemble, the essential point of difference being that they always have a thick lip and, therefore, one cannot drink from them with comfort. A complete set would take time to find and would be very expensive these days. Pewter mugs with a two-ended use are occasionally encountered: they held a half-pint when standing normally and a smaller measure, perhaps a gill, when turned upside down. Obviously they were made for measuring wines and spirits and were more likely to be met in a tavern, although they might have also been found in the kitchen or servants' hall for measuring liquids. They may be compared with the thistle measures found in Scotland.

55 Six-hole Roman bronze egg (or cake) cooker.
British Museum, London.

56 A circular iron broiler and an iron toaster. The
tops of both revolve. American Museum in Britain,
Claverton Manor, Bath.

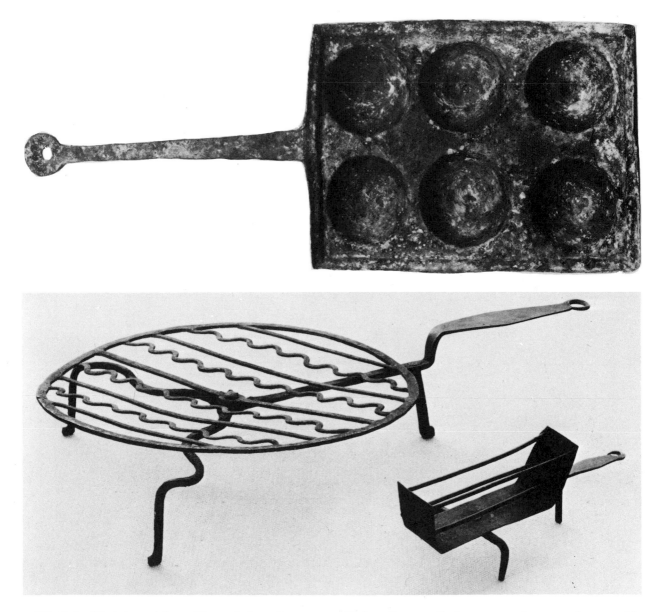

Of all the kitchen articles still surviving, the most
66 attractive probably are the metal moulds. There must
be thousands of these all from the 18th century or
later. They were nearly always made of copper,
tinned on the inside. There was a wide range for
puddings, fruit jellies, 'shapes', etc., but they were
also made for meat jellies, some rare ones, which
have been reproduced recently, having the shape of a
boar's head. They come in geometric patterns, floral
relief patterns and patriotic designs as, for example,
the English lion and the American eagle. They are in
all sizes from really large ones down to tiny moulds
the size of a large coin, which were also used for
making small cakes, etc. Particularly attractive are the
gingerbread moulds and cutters, in the shape of
soldiers, fircones, birds, etc. (Some gingerbread
moulds are in wood – but that is another story.) Great
houses, of course, would incorporate their moulds
into their collection of kitchen copperware or '*batterie
de cuisine*'. That of the first Duke of Wellington, for
example, consisted of over five hundred moulds of all
patterns and sizes, all marked 'D.W.L.' (for 'Duke

57 *left and centre* Pastry crimpers and wheels. *right* Pastry cutter and wheel. Brass. Late 19th century. Cambridge and County Folk Museum.

58 *left* Tin nutmeg grater. 1910. *right* Spring nutmeg grater in tin with wooden knobs. 1890. Cambridge and County Folk Museum.

59 Late 18th-century iron fireplace with a handle at the right to adjust the bars under the pot stands. Cambridge and County Folk Museum.

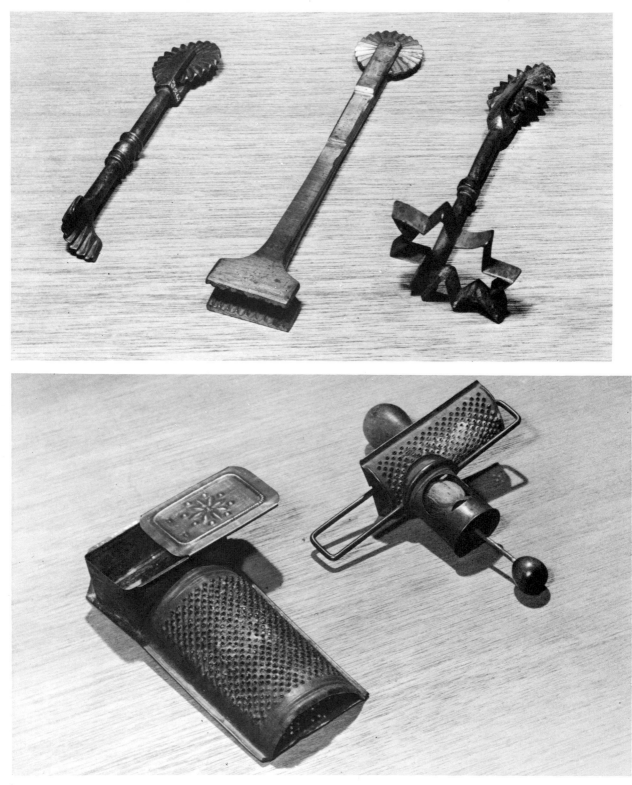

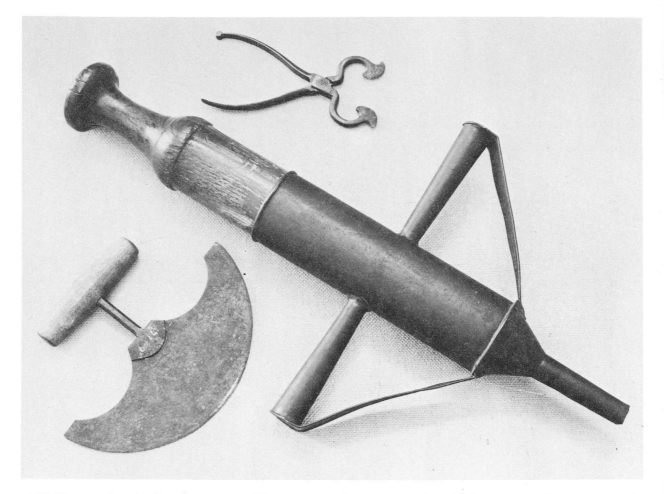

of Wellington, London') and a coronet. The greater bulk of this enormous collection is on show at the Royal Pavilion, Brighton. Incidentally, should a collector ever find any type of cooking vessel with a cypher and crown on it, it is worth trying to establish which family it belonged to. All great houses had these sets but they have very rarely survived in anything like their complete numbers.

All kitchens from the Middle Ages onwards were equipped with a mortar, a heavy bronze vessel in which sugar, spices and so on could be ground by means of a bronze pestle, hence the double name 'pestle and mortar'. These have continued in use up to the present day. They were nearly always made of bellmetal and indeed they were normally made by bellfounders. If you reverse an early mortar you will find that it is very much the shape of a small bell, and I would think that the early craftsmen used

the same moulds. Of interest, perhaps, to men is the fact that the mortar was used in early firearms experiments, and the word has lived on in the military sense (e.g. 'trench mortar'). The spices themselves were kept in spice boxes which were made in beaten brass, copper or, in the 19th century, japanned tin. Some speciments have a series of divisions inside to keep the spices separate, and they are normally equipped with a grater for the nutmeg. Due to the expense of the spices, they were equipped with a lock to prevent pilfering. From very early times nutmeg occupied an important position in the English household, being credited with a wide variety of powers. Apart from these dubious attributes, its obvious use was as a flavouring for food and mulled ale or wine. By the 18th century it had become so important that small nutmeg cases were made to be carried when travelling. These comprised a box for

61 An assortment of nutcrackers. Private collection.

62 *pages 52–3* The kitchen of the Royal Pavilion, Brighton, showing part of the superb set of copper kitchenware which once belonged to the first Duke of Wellington.

61 An assortment of nutcrackers. Private collection.

the nutmeg, a 'rappoir' for grating it and a container to catch and hold the powder. Very practical little Victorian nutmeg graters can still be found. Made in tin with great economy of design and material, they hang on the wall and hold one or more nutmegs in a little ventilated compartment at the top.

Charming general or specialist collections may be made of the smaller kitchen tools. There are pastry jiggers, for example, pretty little wheels used by housewives to decorate the edges of their pies; and biscuit and pastry cutters designed to reproduce all manner of interesting shapes. There are sugar 'nippers' and hammers, made in the days of the cone-shaped 'sugar loaf', which, incidentally, gave its name to the pointed Puritan hats known as 'sugar loaf hats'. The housewife bought her sugar loaf, hit it with the hammer and then broke the pieces down yet further with the sugar cutters, or nippers. These cutters

could still be found, enjoying a second lease of life, in sweetshops some fifty years ago. Shops that made their own sweets, especially toffee or any hard, brittle sweet, used nippers to cut up the blocks of sweet and indeed some sweet manufacturers actually issued the shopkeepers with company ones.

From the 17th century nutcrackers have been known. These were in two main groups, those which operated by means of a screw and those with a pair of handles between which the nut was pressed; a variation of this latter type occurred where nutcrackers were made in the shape of an animal or an old man with a jaw that could be opened and shut by some sort of lever mechanism. The screw type was normally the earlier. Either sort is, of course, still good for cracking nuts, and my wife adds the information that the handled type is first class in the kitchen for loosening a screw cap on a bottle.

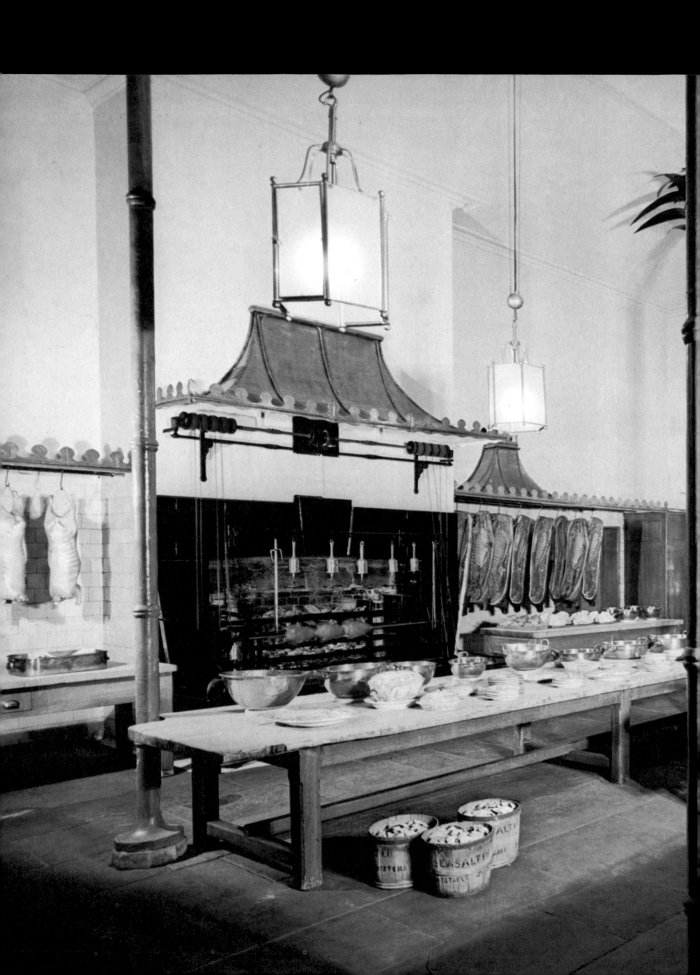

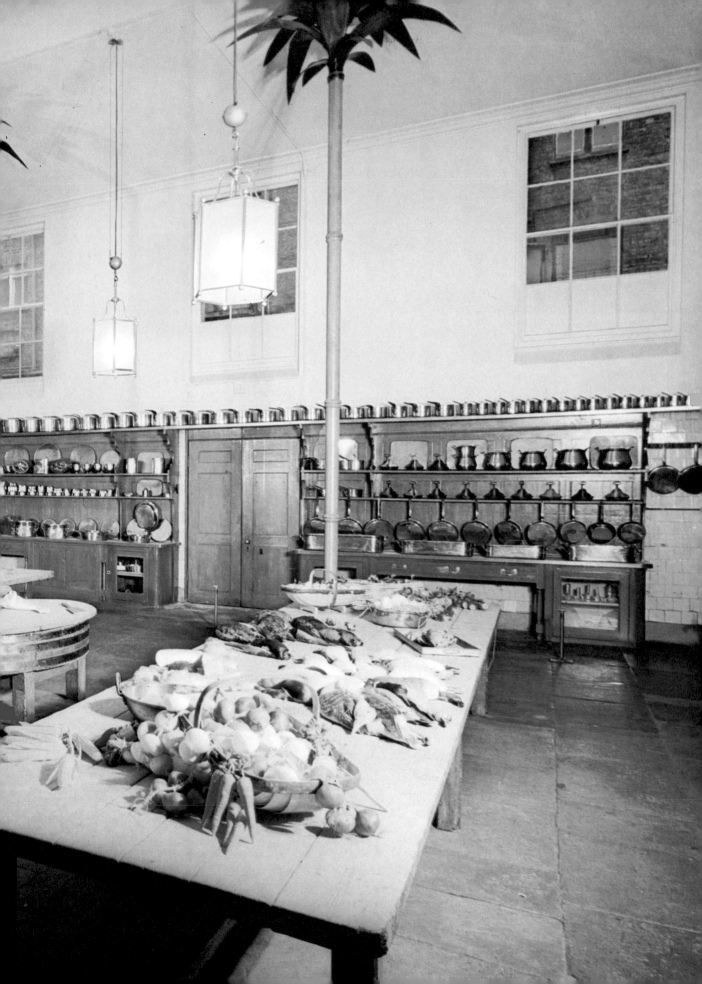

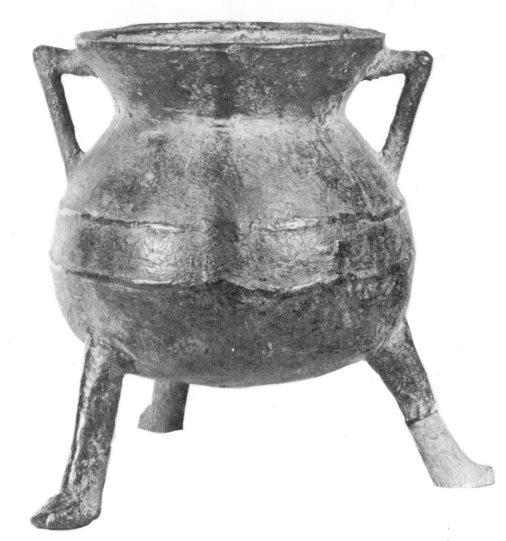

They come in a good variety of shapes, some quite elaborate, and from the collector's point of view they look delightful laid out in a pattern and framed.

65 From the 1840s, with the coming of tinned food, tin-openers became a necessity. Early housewives were advised to open their tins with a chisel and hammer, but, obviously, specific tools for this purpose had to be made fairly soon and some of the early ones are very amusing. One of these early models is of cast iron in the shape of a bull's head terminating in a curled tail for a handle. It is equipped with a spike for making a hole and a cutting blade for opening up the tin. There is a story I like of a group of archaeologists digging in the Middle East who unearthed one of these left behind by earlier diggers and in a highly corroded state. Not recognising what it was and as this was an area where iron is not normally found, their excitement was intense as their thoughts turned to early religious objects (often found in the shape of a bull) and to cult symbols. Fortunately, before this theory could be put into cold print, the tin-opener was recognised as such by

54

an English archaeologist who had been present at the earlier dig.

In the kitchen or adjacent to it was the wash-room or wash-house. Here a great pot for boiling clothes, called a 'copper', was bricked into a corner of the room with a space for a fire beneath. The fire was lit, the water brought to the boil and the clothes plunged in and pushed around. All this has disappeared, but the great containers, sometimes of iron, sometimes of copper (hence the name), have in some cases remained and are now sought after as collector's pieces. Copper ones especially, with the rim turned down, lion's head handles and three lion's paw feet added, become attractive containers for logs or coal or, polished inside and out, for newspapers and magazines.

Another collectable item is the 'iron'. This is an 64 implement of some antiquity. I do not know when they started but, in a museum in Germany, I have seen examples from as early as the middle of the 16th century. These early ones, known as 'box irons', are positive works of art. They are hollow and are made

63 A 14th-century bronze cauldron from Ribchester, Lancashire. Victoria and Albert Museum, London.

64 Two box irons. The metal blocks, made to fit the right-hand iron, were heated in a fire. Brighton Museum.

65 Tin-openers, including two with a bull's head and curled tail. Private collection.

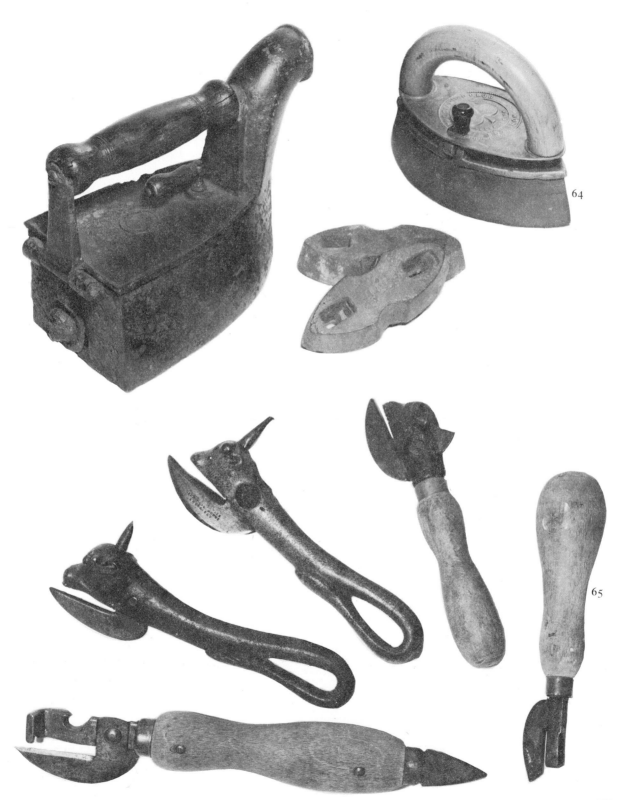

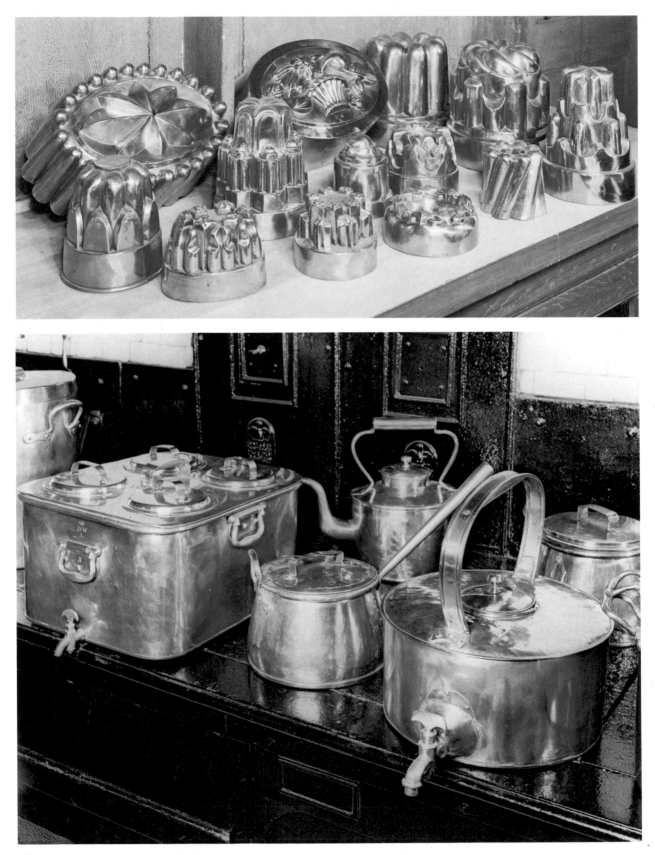

68 Painted tin tea caddies. Royal Pavilion, Brighton. 69 American brass trivet with an eagle design. 1780. American Museum in Britain, Claverton Manor, Bath.

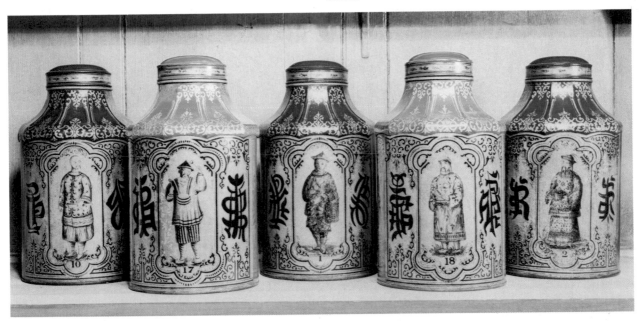

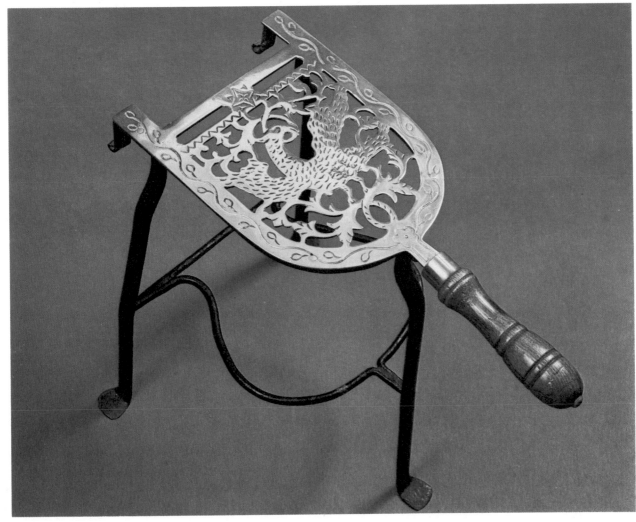

with a recess to contain burning charcoal or a hot block of metal. At the beginning box irons were probably made chiefly for the master tailor. The housewife would have used a wooden board to fold and press her linen or, alternatively, a glass smoothing 'dump'. By the late 18th century, however, she was using the 'flat iron', which had by then come into general use possibly with the improvement in manufacturing methods of the Industrial Revolution. This solid iron was heated by being placed hard against the bars of the fire or, indeed, on the red coals. Nowadays, in a country cottage, these flat irons make excellent door stops and often also paper weights or pressers. I have several in my own workshop which I use as forming blocks, weights when using glue, and the like.

A peculiar and sometimes forgotten bygone was the goffering iron. This was a cylindrical iron on the end of a bar, about the size of a slim finger, which was used for ironing elaborate ruffles or laces. When not in use it rested in a tube mounted on a stand so that it did not cause damage by burning. From these goffering irons came the idea of crimping irons in which two bars, one cylindrical and the other a half circle, are fitted together and used either to crimp linen or by ladies to curl their hair.

As irons were liable to burn both the material being pressed and the wooden stand on which it was being done, if left there for any length of time, metal stands were made for them. This is an extremely attractive small branch of collecting. Limited as they were to a triangular shape, the craftsmen managed nevertheless to get an amazing variety of pattern into the work, which was normally in cast brass or iron.

In my opinion there are two rooms in every house which should be absolutely modern: the kitchen and the bathroom. Even here, however, rooms can gain and can be embellished by old pieces of sympathetic metalware, many of which remain as eminently practical today as when they were made and most of which have great charm and versatility. The gleam of copper, brass or pewter is extremely beautiful, for example, against pine or monochrome kitchen walls. Old pots can still be used for cooking if—and this point must be stressed—they have been freshly tinned on the side coming in contact with food; and they can be adapted to many modern uses.

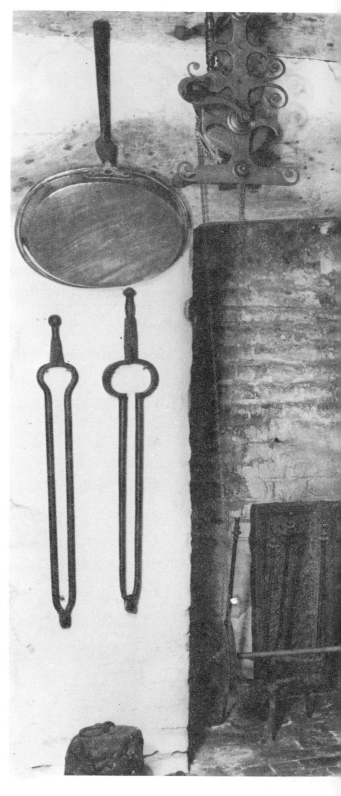

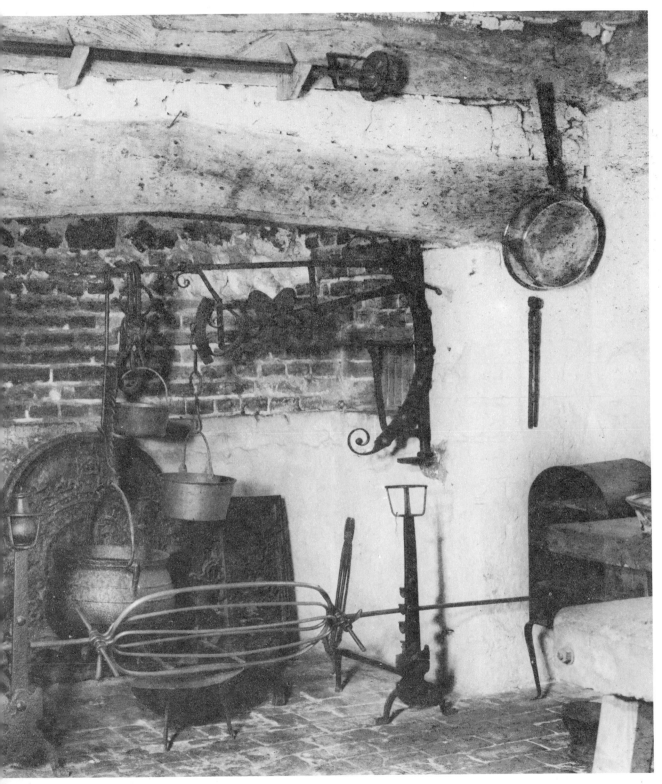

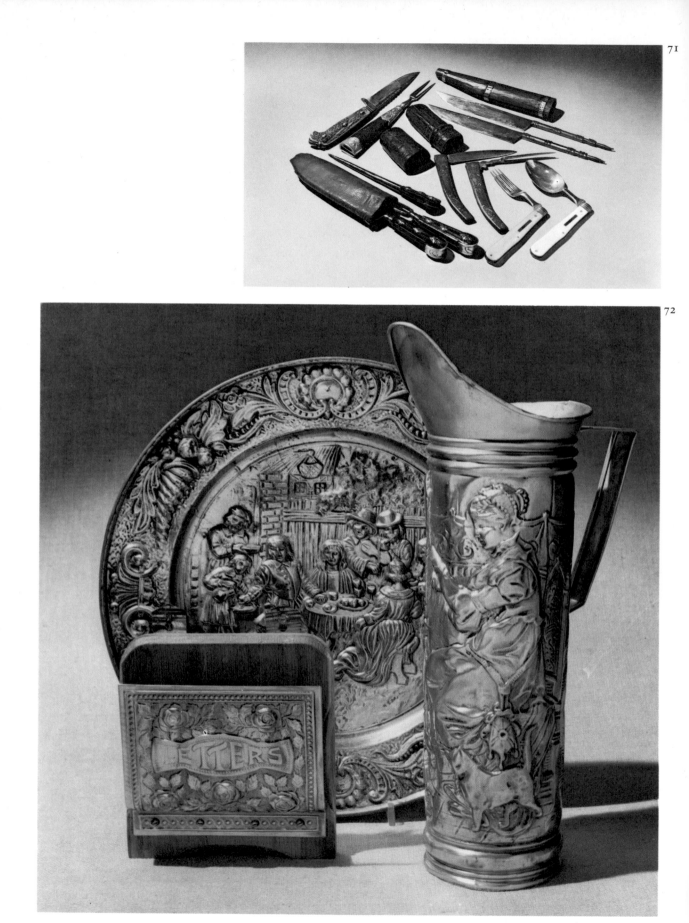

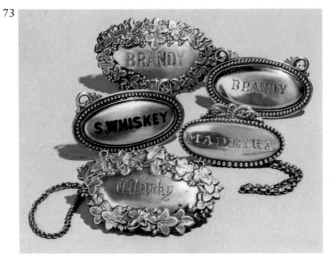

73

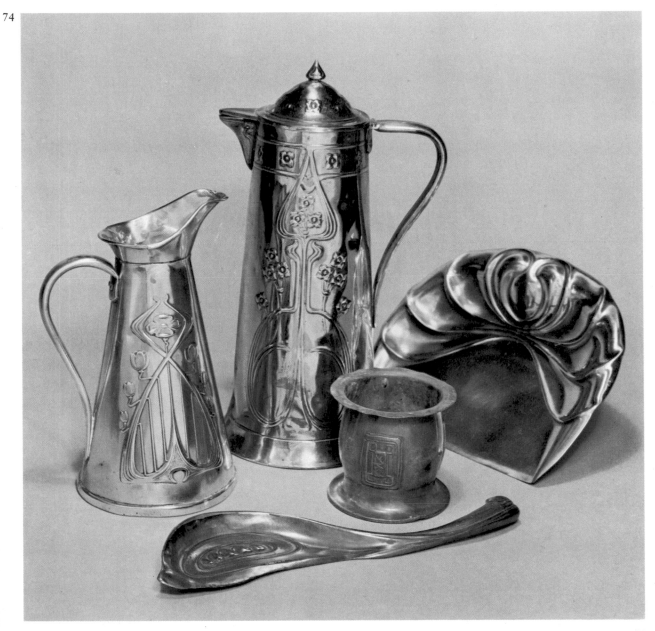

74

71 Travelling knives, forks and spoons. Private collection.

72 Letter rack, jug and dish with repoussé decoration. They are all 19th-century pieces, though the style is earlier. Private collection.

73 A group of wine labels. Private collection.

74 Art Nouveau metalware: two jugs, two crumb trays and a small pewter pot. Private collection.

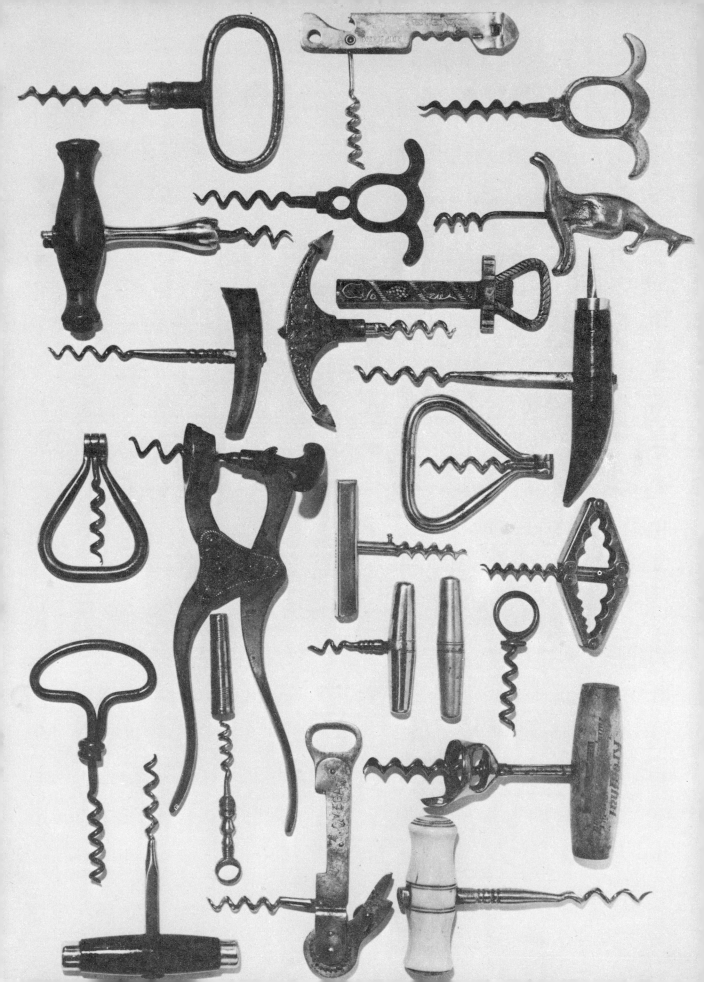

THE DININGROOM

From the collecting angle, the contents of the dining-room really start with the 17th century although pieces from this century are now, unfortunately, rare. There are, however, many fine pieces from the 18th and 19th centuries still available. The metal that comes into its own in the diningroom is pewter for, with the exception of silver and plated wares, other metals were rarely used. It is a beautiful metal with a most subtle sheen, and its instant appeal—when a 'garnish' of pewter is shown against a dark wood background such as a sideboard or dresser—makes for its present and continuing popularity. English pewter has always been considered superior to that of the rest of Europe and was always more simple and pure in line. As mentioned earlier, pewter was one of the first alloys to be used for domestic ware and was found in Roman times. It is a metal that can be cleaned easily and, when in constant use, does not tarnish. In addition, it has long been thought that it improves the flavour of liquids drunk from it. This has always struck me as a very odd idea, but certainly pewter tankards are still, even nowadays, used for beer. At one time it was considered to have another rather peculiar merit: it was said that, if wine was left in a pewter pot overnight, the resulting brew, drunk next morning, made an excellent emetic. I cannot vouch for this but would not be surprised.

Pewter has always been widely used for mugs, beakers and tankards and for the flagons and pitchers which held larger amounts of beer and ale. The tankard, perhaps, is the most attractive of these vessels and is a favourite with collectors. The shape of a tankard, including that of its handle, is important because it is possible for the keen eye of the experienced collector to assess its age from the evidence of its shape. As mentioned previously, pewter tankards should not be confused with pewter measures. While the measure obviously can be used for drinking, its lip is usually thicker than the lip of the tankard. Another means of distinguishing them is that measures come in graded sizes.

75 Corkscrews present an amazing diversity.
Private collection.

Incidentally, in the Georgian sideboard the cup-board at the side was frequently known as the pot cupboard. In this would be kept one or more pewter chamber pots basically for the use of the men after the ladies had withdrawn (to the withdrawing, now the drawing, room)

Pewter was widely used for plates also and for the large serving plates with a broad rim known as chargers. If the charger has a small recess in the centre it may have been intended as a tray for a flagon which would rest in the hollow, or it may have started life as an alms-dish in a church. It is difficult to be accurate on this point as some dishes 'escaped' from churches while others were given by church members possibly from their own family pewter. The use of pewter plates spread down from the upper classes in medieval times to all classes, and by the 17th century almost any family might own some pewter. Although the English variety is rarely decorated, coats of arms and sets of initials are to be found on plates. The coats of arms should be treated with reserve, as they may have been added to make the plate appear more interesting. Sets of initials, however, are nearly always right; they were frequently placed on the pewter at the time of a marriage. Early plates had no reinforcing rim, but by the 17th century plates were being made with a slightly thickened rim to make them a little more durable. Probably from the con-tinent came the idea of a reeded rim, a simple decorative motif and a very attractive one. Also from the continent came octagonal rims and ones with other simple but pleasing shapes. Hot water plates were also made in pewter as early as the mid 18th century. In general these had a double bottom and some means by which hot water could be poured into the hollow so formed, in order to keep the food hot. In another version the plate for the food was separate from, but made to fit into, the bowl for hot water underneath. It fitted by means of a steep foot rim. When parted from their hot water container, these plates look unusual and may give rise to con-jecture.

By the late 18th century, sets of covered dishes to carry food from the kitchen to the diningroom were known. Frequently these were in Sheffield

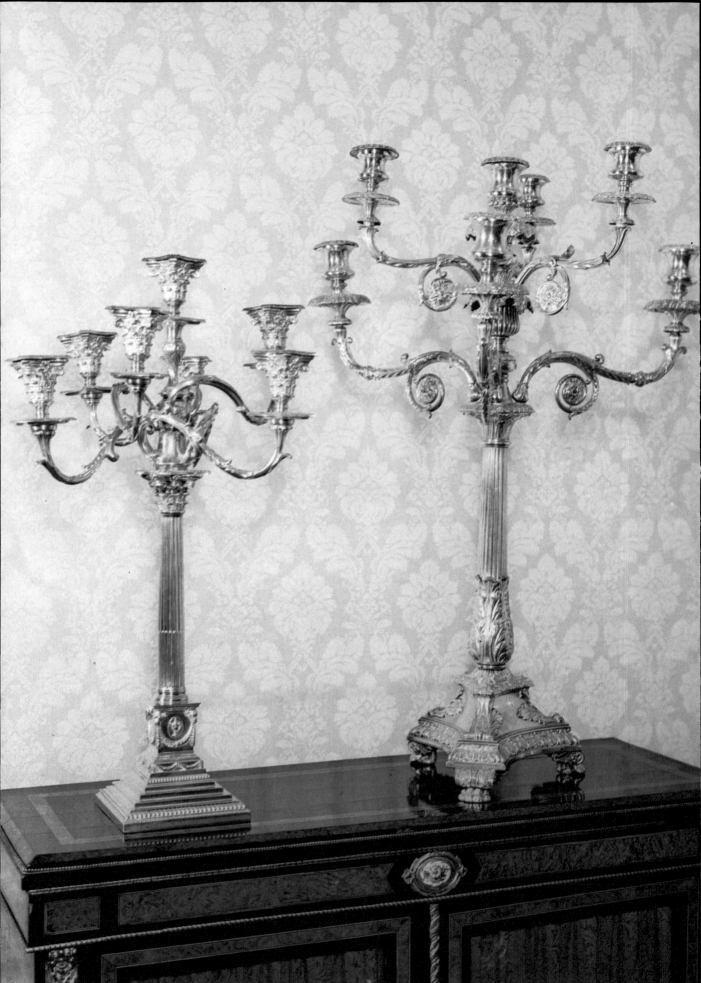

76 Two splendid candelabra in Sheffield plate. Royal Pavilion, Brighton.

77 Three fine pewter tankards. *left* Second half of the 17th century. Maker's touch of Adam Banches of Wigan, Lancashire. *centre* Late 18th century. Maker's touch of Pitt & Dudley, London. *right* Last quarter of the 17th century. Maker's touch R.S. in an oval shield. Engraved with portraits of William and Mary. Victoria and Albert Museum, London.

78 American pewter dishes, plates, jug and small bowl. American Museum in Britain, Claverton Manor, Bath.

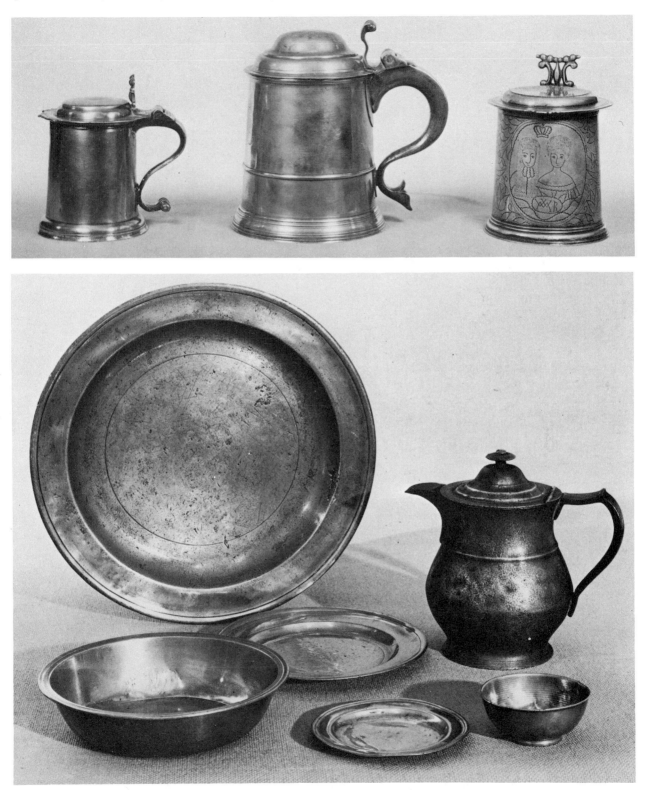

79 A pair of brass casters and a cream jug. Mid 18th century. Victoria and Albert Museum, London.

80 18th-century copper wine cistern. Victoria and Albert Museum, London.

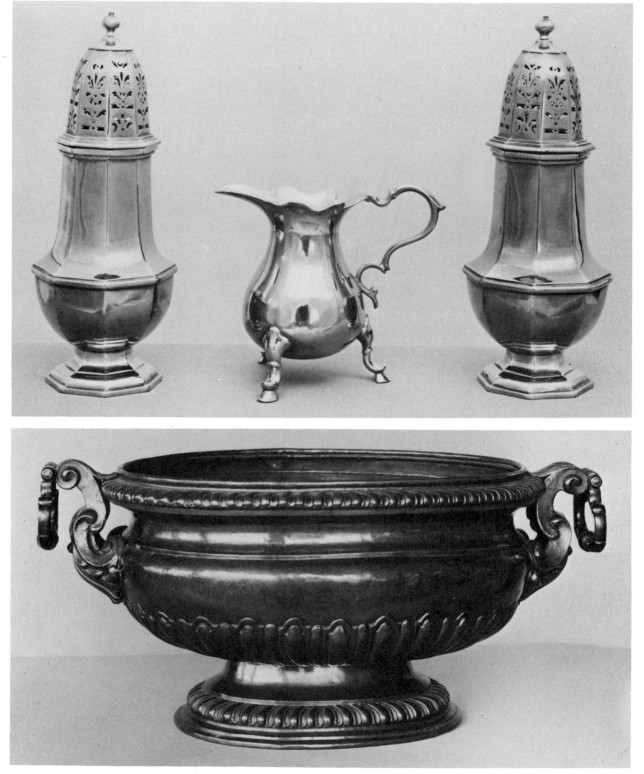

plate. The smaller sizes can still be bought and are attractive in use. The larger ones, however, have become scarce due to the fashion in the immediate post-war years of reversing them and turning them into flower holders or wall lights. A very popular pattern is the entrée dish, where a square or oblong dish has a cover which can itself be turned into an auxiliary dish by removing the detachable handle.

Also in the 18th century and onwards, the dining-table frequently had the addition of small sweetmeat baskets as an adjunct to a meal—it is possible that these were used between courses. These little dishes, which were made in Sheffield plate or sometimes E.P.N.S. were delightful little examples of the plate-worker's art. They were oval or round—occasionally square—and nearly always had hinged handles. The earlier ones were generally elaborately decorated with a pierced floral design; in the later 18th century they were decorated in a more austere classical style.

In passing one should mention that dinner services made of pure tin are also known but extremely rare.

79 From the 17th century onwards containers with pierced tops, known as casters, are known for spices such as ginger and pepper, and for sugar. Their general use was probably very limited because it was not easy, when you ground your own materials, to get them down to the required size. (Caster sugar is still with us as a special form of sugar.) Also at the table would have been containers for salt either in the shape of casters or as open bowls. A very popular one, starting in the 18th century, was circular and was supported on three little classic lion's mask feet. As a matter of interest it is possible to trace this particular pattern through a variety of very different materials and over a period of more than 200 years. It started in silver, and the almost identical pattern can be found in pewter, Britannia metal, Sheffield plate and E.P.N.S., and also in porcelain copying metal. Almost invariably, unless they were of very fine metal indeed, in which case they were gilt, salts (or cellars) were lined with a blue glass liner (this can be replaced nowadays if lost or broken).

Metal plays a small but important part in the drinking of wine. In the 17th century before glass became common, pewter or sometimes copper flagons, tankards and goblets of every description were used for wine. Quaiches, too, were used. This

was a shallow vessel, with two flat lugs, one on each side, to hold it by. It was a general-purpose article and was also used for spirits or broth, or even for porridge. The porringer, as its name suggests, is similar, except that it has two proper handles, one on each side.

Pewter and plate punchbowls are known and, if you are lucky, you may find a Monteith, a punch-bowl—normally of the 18th century—with an edge distinguished by a series of slots or indentations which, it has been suggested, were for carrying a set of wineglasses. It is said, by the way, to have been named after a Scottish adventurer who had a cloak with a zigzag (or notched) edge. When a punch had been mixed—it consisted of wine, fruit juice, hot water, sugar and spices—it was served from a punch-bowl by means of a ladle, called a punch ladle. This, too, can be found in plated ware and in pewter, its size varying according to the mixture being served. There are small ones known as toddy ladles for a rich strong drink and larger ones for a weaker wine.

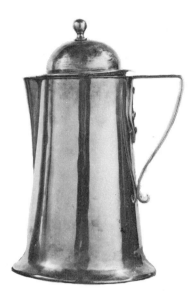

82 Two late 19th-century covered jugs in copper plate with brass fittings. Victoria and Albert Museum, London.

83 Spoons and a fork made of latten. 14th and 15th centuries. Victoria and Albert Museum, London.

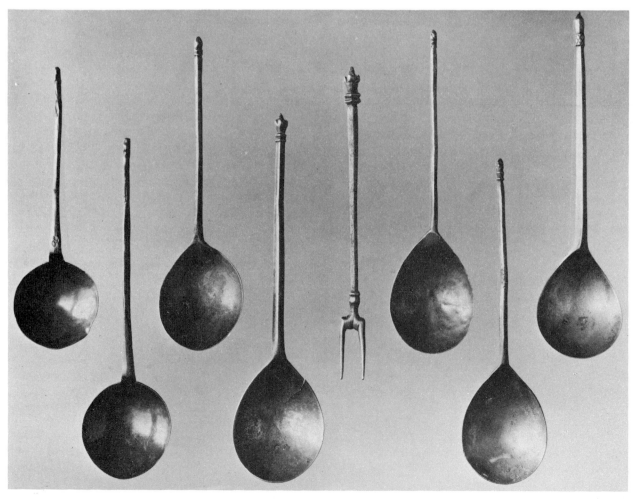

For the collector interested in this branch of antiques there are also numerous smaller items to be acquired. By the 18th century, for example, wine-labels were being made in pewter and in plated ware. These are pretty little ornamental labels made to hang round the neck of a bottle or decanter and occasionally pinned on a cask, bearing the name of the wine: sherry, sack, etc. Occasionally, to the delight of a collector, unusual ones are found such as 'methylated', 'spruce', 'mountain' or 'wormwood'. Coasters, too, are collected. These are small circular trays with a pierced gallery round them, frequently found in Sheffield plate. They held a decanter, and their purpose was to enable it to be pushed between the guests at table. They normally have a wooden base covered with baize to avoid scratching the table.

Wine funnels also are still available. Frequently made in copper but more often in plated ware and in pewter for taverns and inns, they were used when decanting wine into the bottle. Funnel-shaped wine strainers were also used when pouring wine; formerly wines were not as pure as ours today and frequently contained fragments of the grape which, unless strained off, would drop into the glass. Strainers were used again in making punch where fruit juices such as orange or lemon were crushed from the actual fruit and the pieces strained away.

75 Last but by no means least, there is the corkscrew, a field of collecting which is only now beginning to come into its own. Here the wine trade really excelled itself, producing all manner of shapes and sizes which have one thing only in common: a metal screw for driving into the cork. Gadgetry ruled supreme: you find them supplied with a wide variety of fulcrum devices, levers and springs, and with different housings made to fit the outside neck of the bottle. The screws may be concealed in metal anchors, keys and the like; sometimes they fold away inside metal cases which, when opened, act as the handle. You find them mounted with handles of carved wood, ivory or bone as well as metal. Some are equipped with knives to cut champagne wires, or with spikes to lever wires off. Some have brushes to dispose of cobwebs and sealing-wax. There are charming little 18th-century cut-steel ones for the traveller.

Less heady beverages, such as chocolate, coffee or tea, were also from very early on drunk out of metal pots, but the heat of the liquid made china a better

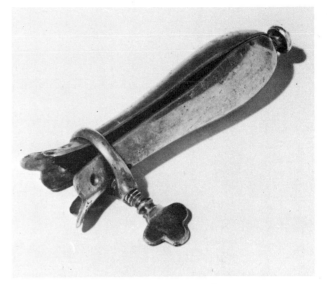

choice of material. There were, however, chocolate and coffee pots in plated ware and, in the 19th century, in Britannia metal.

By the 18th century tea had become a very favoured drink of the English, and the metalsmith was there to supply whatever was required in the way of a whole range of new equipment: teapots, sugar bowls, hot water and cream jugs and, in the grand houses, urns. These gracious pieces, inspired almost entirely 81 by the classical urn of the ancients, graced the sideboard and urn table of the better home. They appeared in pewter, copper, ormolu, plated and japanned ware. They were made primarily for tea or coffee and contained a tap for pouring from. In the centre of each urn was a recess, sealed off from the part where the tea or coffee was kept, and this had in its centre a small block of iron called a pig; several of these would have been kept in the kitchen fire so that, when it was necessary to replace a cool one in the urn, the servants could do so immediately with one already heated. These urns, having been out of use for some 80 years, are now back in favour again: many families, having had them replated on the inside, are now using them, without the pig, for dispensing coffee. It is a moot point whether or not one may have them fitted with some form of immersion heater to keep the contents warm. I have seen it done but do not myself like the idea. Properly cleaned and plated, they may also be used for serving iced punch.

85 Egg decapitator, much corroded. Brighton
Museum.

86 Quadripartite condiment carrier. Early 19th
century. Brighton Museum.

Tea in the 18th century was extremely expensive, due in the main to a government tax; and for that reason it was normally kept in the diningroom under the eye of the mistress of the house, and not, as one might suppose, in the kitchen. Incidentally this government tax was to provoke a 'tea party' in Boston which proved even more expensive not only to the government but the whole nation. The tea was kept in lead-lined wooden boxes or in pewter or plated containers called 'caddies' (from a Chinese unit of weight), a term which came in time to be extended to the wooden boxes, often very handsome, which contained several sorts of tea and a bowl either for sugar or for blending the teas. In the 19th century transfer-printed tin tea caddies made their appearance. These have increased in popularity over the years, being colourful and gay as well as useful. Special spoons accompanied the caddy, called 'caddy spoons'. They were small, had a short handle and were for measuring out the tea. They are sometimes found in interesting shapes, such as a leaf, a jockey cap, small shovels and spades, little scoops and so on.

It is interesting to note that in the 'equipages' for tea ('equipage' being the word used loosely in the 18th century for all the equipment connected with tea drinking) one of the most significant items was perhaps the teapot. Teapots were very much a reflection of their period, and their design and shape are most important for dating them. They range from the simplicity of the age of Queen Anne and the early 18th century to the austerely classical correctness of the Palladian period, through to the over-florid embellishment of the Victorian period and then to the final flowering of gracious living in the Edwardian age when, immediately prior to the First World War, the wilder exuberances of the Victorian period were beginning to be restrained.

As mentioned on page 39, basic articles such as knives and spoons have a very long history; they go back to the earliest times and continue with little real change up to the present day. As far as spoons are concerned, one finds a wide variety by Tudor times, and these are probably the first of our national spoons. Made in latten, pewter and occasionally tin, 83 they are normally more oval in the bowl than are the continental ones. The early spoons have a straight faceted handle, and very frequently the finial at the end of the handle is of interest, terminating in an image of the Virgin Mary, a figure of an apostle, the head of a saint, the head of a lion; sometimes

87 'The Cutler': an illustration from *The Book of English Trades and Library of Useful Arts,* London, 1824. Museum of English Rural Life, University of Reading.

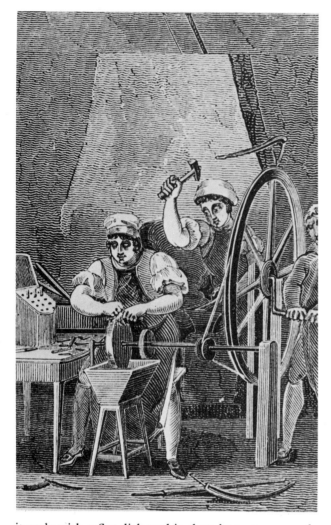

until the early 17th century. It was at the start two-pronged, and it may possibly be assumed from the sharpness of its tines that it was for holding the meat down while cutting it rather than for conveying it to the mouth. One cannot be sure of this, however, as the tines tend with age to become like needles. There was a period just before the 17th century when it was regarded as rather effeminate to use a fork. This prejudice gradually died out, and it became the normal companion of the knife and spoon; by the Georgian period the three-pronged fork was common and, by the end of the 18th century, the four-pronged fork. The knife, fork and spoon appear in the travelling sets which anybody of any importance would carry because it was by no means certain that a host would have adequate supplies of tableware and definitely no inn would. These travelling sets, especially the 17th-century ones, are rare, but if you collect tableware you should try to acquire a set or two. There are more elaborate sets, generally known as canteens, which contain in addition a drinking pot and holders for condiments; the whole is enclosed in a boiled leather or shagreen case.

In the 17th and early 18th centuries the domestic knife was merely a version of the sheath knife carried by a man, but by the mid 18th century domestic knives were being made in their own right, for carving and for table and kitchen use.

The 18th century saw the start of complete sets of tableware – knife, fork, spoon, carvers, etc. – cased in various wooden containers, sometimes shaped like a classical urn, to stand on the sideboard. Richer families had complete silver sets of tableware, and in the 19th century these were copied for the middle classes in various types of plated ware: Sheffield plate, French plate (silver leaf on steel), close plate (an English version of French plate) and many others, all trying to imitate silver and even bearing false marks. An extremely interesting and often amusing collection of these dubious 'plates' and 'silvers' can be made. I have seen many different types and I am always coming across fresh ones.

From the 19th century onwards there was a vast increase in all types of tableware, including gadgets and objects of dubious usefulness invented not so 8 much from necessity as from class-consciousness. Among such objects are all the different types of

it ends with a flat disk and is then known as a seal-top spoon. These are the most common ends, but there are many other different patterns. An interesting group of spoons occurring in the 16th century has no knop at the end of the spoon as this is cut off at a slight angle; these are known as slip tops. In the 17th century, when the style was basically Puritan and restrained in feeling, the plain simple end spread out, perhaps to balance the bowl, and from this, by the 18th century, the spoon is in design recognisably the same as we have today.

Obviously pewter spoons make delightful collections, especially when they hang in a specially constructed wooden rack as they did originally.

The fork was a comparatively late comer, arriving from Europe and not becoming popular in England

spoon, different sizes and shapes being used for tea, coffee, sugar, jam, pickles, snuff, salt, mustard, eggs, grapefruit, medicine, and, with its companion fork, for serving puddings, fruit, vegetables, salads. Among these latter are the spoons known as 'berry spoons', decorated with berries in relief; they were made in gold and silver and in plated ware and are now becoming scarce. There were different slices for serving fish, pastry, cake; and different knives and forks for eating them. Crumb trays, for clearing the tablecloth of crumbs after a meal, abounded and are now collected because they come in very pretty shapes.

From the late Georgian period onwards the hambone-holder was an article frequently found in the diningroom, and of these one very comprehensive collection already exists. They are elaborate, plated ware handles ending in an adjustable pierced funnel. The appropriate end of the bone of the joint was placed within this gadget, giving the person carving the meat something to hold on to. Another 19th-century innovation was the napkin ring, which held the napkin or serviette and was made of pewter, brass or plate. There is a wide variety of them; they are still used and, as with many old things, are often cheaper than new ones. Fork rests for the carving knife and fork to rest upon are found from the early 19th century; these are strange little bygones for which little use can now be found.

All these items are, however, slowly coming to the notice of the collector and, in my opinion, may well make the collections of the future.

LIGHTING DEVICES

All lighting in the past was based on oils or fat. The Romans had tall oil lamps, now called standard lamps, and small bronze oil lamps; and something like this continued on after the break-up of their empire. In Norman times, torches made of twigs soaked in oil or fat–these are called flambeaux–are known to have been fixed in castle halls, and lamps were improvised by floating a wick in oil in a metal saucer; a spout would be made on one side or the rim of the saucer would be bent up to make a lip for the wick. It was crude, primitive but efficient.

15 It was, incidentally, the basis for all Betty lamps, crusies (compare the widow's cruse in the Bible) and other lamps of a similar nature.

Also by Norman times, some form of taper had been evolved by taking the pith from rushes, drying it and dipping it in fat. Seafarers would possibly have used a short length of rope soaked in oil as a torch or flambeau, and a strand of this would have made a taper. These tapers, or rushlights, burned smokily, smelled unpleasant but gave a measure of light; enough, for example, to light a man along a passage. In a medieval hall they would be placed in a rushlight holder. The whole process may be seen at Michelham Priory in Sussex where the custodians have very sensibly made use of the rushes in their river to demonstrate the making of rushlights. Constant experimenting produced the slower-burning candle, made of beeswax and tallow. A short piece of rush was dipped or rolled in the hot wax and allowed to cool. According to the number of times that the rush was dipped in the wax so it improved in quality and size and became that much more expensive. In these early times and up to the Tudor period, candles were extremely expensive and were used only by the Church or the nobility. Poor people used a rushlight made with the slightest of dippings, the thinnest and cheapest kind of taper; these in time came to be known as 'farthing dips'. Incidentally, the visitor to Hatfield House in Hertford-shire, the home of the Marquess of Salisbury, may on occasion purchase there honey-scented candles, hand-made from purified beeswax, similar to those used at the court of Elizabeth I.

During the 17th century lighting was basically provided by candles of good quality for the upper classes and, for the working classes, farthing dips and crude oil lamps working on the principle of the crusie and sometimes burning whale oil. The same obtained for the greater part of the 18th century, but towards the end of that century, due to the inventions of a Swiss physicist named Argand, who 90 had a shop in London, a different type of oil lamp–a prototype of the oil lamps still used today–became a practical possibility. In England they were first manufactured by Matthew Boulton at his Soho factory in Birmingham. The whale oil lamps, incidentally, carried on well into the 19th century for both home and street lighting. They gave a good light but an unpleasant smell, and it was customary, in the kitchen or workshop, to hang a damp sponge near the lamp to absorb the fumes. There is an amusing story concerning whale oil lamps used in some areas of the London Docks. It was noticed that, at certain periods and particularly in the winter, these lamps went out earlier than had been expected. A watch being kept, it was discovered that sailors from the Baltic and the north had formed the habit of drinking the whale oil as they returned to their ships. Presumably to their disappointment, with the coming of gas this particular treat was no longer available.

In the United States throughout the 18th and 19th centuries whale oil lamps were in very general use in all classes of society. The most common were known as 'sparking lamps'; they were frequently made in 116 pewter and comprised a reservoir for oil and a tightly fitting burner with one or more tubes for solid wicks. But very sophisticated whale oil lamps, incorporating 118 classical stands and glass lustres were made for the music or drawingroom of an important house. The American Museum in Great Britain has a very comprehensive collection of whale oil lamps ranging from simple pewter ones to a pair of superb fashion pieces, their brass stands in the shape of sphinxes and the whole mounted on tall columns.

As can be expected, during the 18th and 19th centuries the manufacture of candles improved,

89 Student Colza lamp with height adjustment. Science Museum, London.

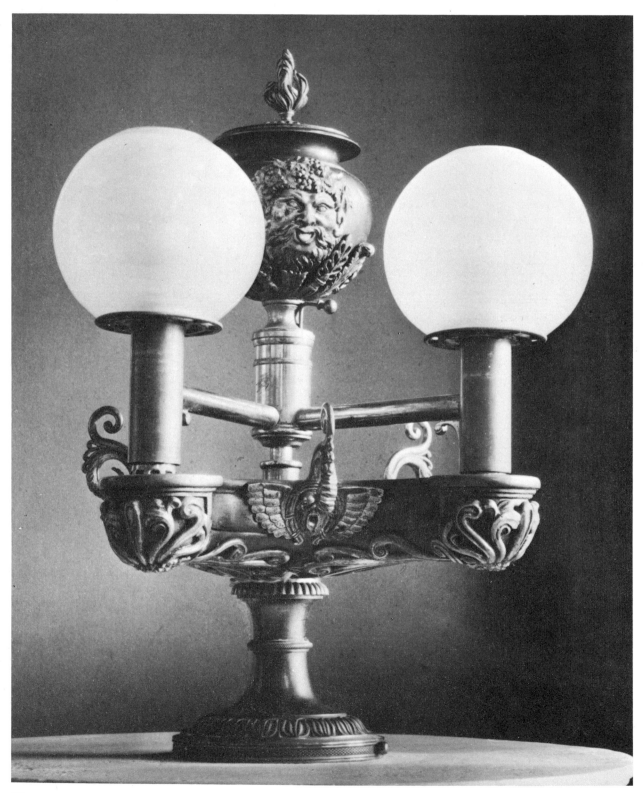

moulds being utilised in which the wick was tied at one end and the wax was poured in. These candle moulds are of interest to collectors and may still be acquired. With the coming of gas and electricity, however, the use of candles decreased and they became relatively unimportant. Ironically, in this 20th century, candles and oil lamps have quite frequently been called back into service to bridge the gap caused by strikes, power failures, national disasters and the like. Also, of course, their social charm has now come to be appreciated, a dinner-table lit by candlelight being often preferred to the more utilitarian electric light. In fact, what was well on the way to becoming a museum piece has returned as a reserve article of everyday use.

Of crucial importance throughout history has always been the ability to start a fire or make a flame for a light. In Europe an early method of carrying this out was by flint and steel. When the steel was struck on the flint, sparks were made which, dropping on to dry combustible material, could be blown into a flame. This was by no means as easy as it sounds, as anyone who has tried it will know. Everyone would carry with them this means of making fire. By the 18th century this was provided by small circular tin boxes which had a lid in the shape of a small candlestick and which contained flint, steel, some form of combustible material and, sometimes, the stump of a candle to be placed in the lid when lit.

For the wealthy in the 17th and 18th centuries, there were wheellock or flintlock tinder lighters, 91 working on the principle of the pistol. The cock and steel of the pistol mechanism engaged, causing a spark which fell on to a piece of punk (dried wood occasionally soaked in saltpetre), setting it alight.

There exists an extremely rare type of tinder lighter which looks exactly like a flintlock pistol. On pulling the trigger, two things happened simultaneously: sparks were deposited on a tiny pinch of some highly combustible material such as lycopodium, and a candle shot up vertically to be lit by the sudden flame. Exceptionally rare and mainly continental, these may occasionally be found.

As may be seen from the experimenting that produced these different methods, to obtain a light was a tricky business. This would be the pattern right through the 18th century; indeed in Boswell's London Journal there is an account of how he inadvertently put his candle out one night, did not know where to find a tinder lighter and spent hours

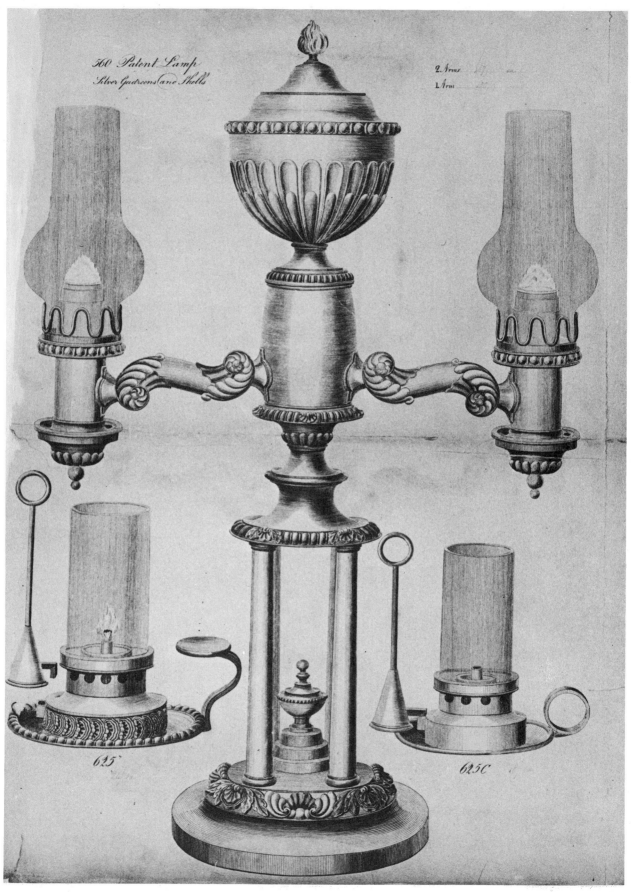

560 *Patent Lamp*
Silver Gadroons and Shells

2 Arms
1 Arm

625

625C

78

92 Elaborate oil table lamp and two chamber lamps with chimneys and extinguishers. From a 19th-century Sheffield plate manufacturer's catalogue. Sheffield City Libraries.

93 Coasters, taperholders and extinguishers. From a 19th-century Sheffield plate manufacturer's catalogue. Sheffield City Libraries.

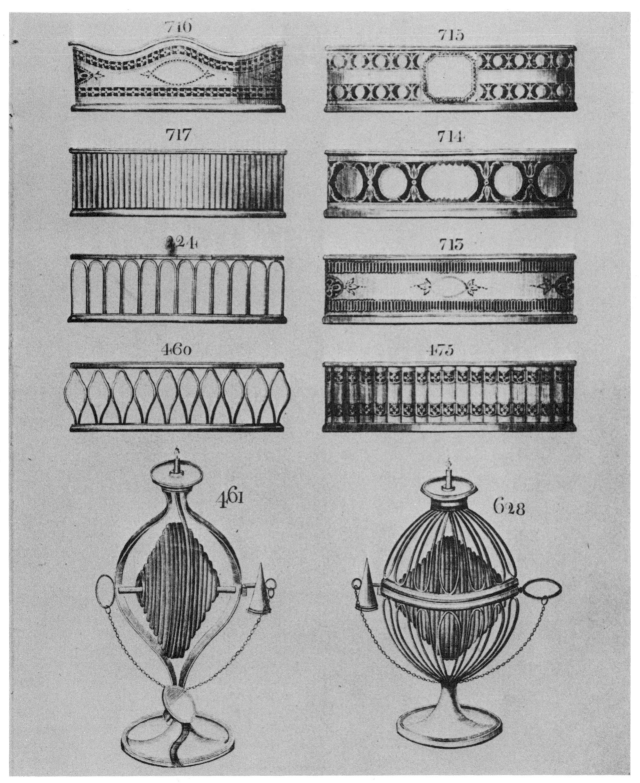

94 Early 18th-century candlestick from New England. The spike would be hammered into a convenient wooden upright in the house wherever it was needed. American Museum in Britain, Claverton Manor, Bath.

95 'Go-to-bed' matchboxes. Private collection.

in utter blackness before he could attract the attention of a passing nightwatchman who stopped and gave him a light, presumably from his own portable tinder box. To my mind, these few words in Boswell's London Journal evoke as nothing else, the black discomfort of the 18th century after dark for the person deprived of the means of making light.

Towards the end of the 18th century, various forms of matches were evolved, at first sulphur tipped and later self-igniting. Some of them were difficult and dangerous to use, and a metal box in which to keep them was essential. It is still possible 98,140 to make collections of these. They come in every type of metal and in all sizes from tiny ones to hang upon a watch chain to large ones which fit in a pocket.

Some even come equipped with a wick, impregnated to enable it to smoulder rapidly. There are many varieties of these metal matchboxes, as they were manufactured well into the present century.

One strange variety of matchbox deserves special attention. These were small receptacles, about $2\frac{1}{2}$ inches high, normally in metal although occasionally in hardwood or ivory. The matches were stored inside them, and there was normally a rough surface on the object for striking the match and a small hole incorporated in the design to place the lighted match in, rather like a tiny candle. They are known as 'go-to-bed matchboxes' or 'getting-into-bed match- 95 boxes'; their function was to burn for about 30 seconds and so allow a person to snuff out the candles on the bedroom mantlepiece and get into bed while the light held. It was considered safer to have this self-terminating flame rather than to lean out of the voluminous folds of a four-poster bed where there was danger of catching the fabric alight. There is tremendous variety in the patterns of these little pieces. I have seen at least thirty different patterns during my life, among them a castle tower, a turned cylindrical shape, a Napoleonic soldier of the Second Empire (the match was put in his rifle), a Gothic knight holding a torch, a little boy selling newspapers, the bear (the crest of the Warwick family) clutching his ragged staff, and so on. There are many others.

Where lighting devices are concerned, the largest group of antiques, and the one that can be collected most successfully, consists of candlesticks and can- 11 delabra. The earliest collectable pieces go back at least 800 years and come in all shapes and sizes. Among the earliest are those known as 'pricket candlesticks' from the spike in the centre upon which the candle was firmly fixed. It is unlikely that the collector will find a really early specimen of a pricket candlestick, but they were made for general use in

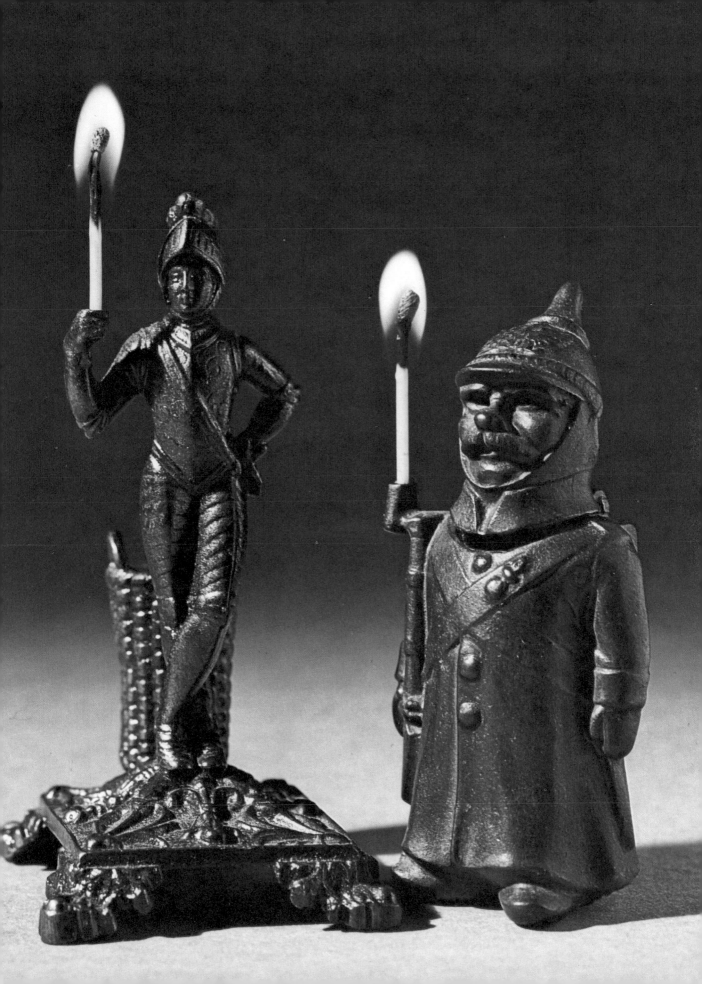

adopted – the basis upon which all candlesticks have since been made.

Many of the earliest sticks were of iron and were equipped with a spike to drive into a beam or a hook for hanging from a rafter. Others were mounted on a block of wood. Some combined the functions of both candle- and taper- or rush-holder. Together with candlesticks of this type were standards – an extension of the candlestick – needed to light a hall or a big room. Sometimes they were made to be adjusted so as to throw the light where it was most needed. This was found to be an ideal way of lighting a workshop and continued to be used up to the time of the Industrial Revolution.

In medieval times, because of trade between England and the mouth of the Rhine, a strong Flemish feeling can often be detected in our candlesticks although they remained comparatively simple: for example, the continental candlesticks often had a slot on the side of the socket so that the candle stump could be prised out, and this advance is not generally found in the English candleholder. Made in bronze, brass, latten and pewter, this medieval style continued with minor changes right up to the Tudors. With the coming of the Stuarts, holders became generally less heavy in style, and, with the arrival of Puritan feeling in the middle of the 17th century, they became comparatively restrained. Over these centuries one specific change can be noted. Early candlesticks relied on a very wide base to catch the wax; in time this was replaced by a broad disk half way up the candlestick, and by the 17th century this disk had risen still higher to become a horizontal flange at the top of the candlestick. This progressive upwards movement gave a better line to the shaft and base as well as being of practical use.

By the reign of Queen Anne the candlestick, as was the case with so much metalware, had taken its place as an artform reflecting the fashions of the time. It was plain, comfortable and dignified, I suppose a little like Queen Anne herself. A notable new feature is a push-up platform incorporated in a slot in the side enabling the end of the candle stump to be ejected. About this time there is evidence of a gadget called a save-all, which was a small socket with a spike in the centre; when the candle neared its end, its stump could be placed on this spike and

Mediterranean countries as late as 1900 and are still made for church use all round the Western world. I myself have a pair, bought in North Africa, distinctly Spanish in feeling yet meaner in execution than one would expect from European workmanship. They were made not earlier than the early 19th century and are probably of Spanish-Moorish origin.

When candles grew smaller in diameter, it was found that the base of the candle sometimes split, and it became necessary to support it with a collar, or socket, around the spike. In time the spike for the candle was abandoned and a socket candlestick

97 Pierced tin lantern from New England. Late 18th or early 19th century. American Museum in Britain, Claverton Manor, Bath.

98 *pages 84–5* A group of matchboxes and matchbox holders. Private collection.

the save-all placed in the candlestick, permitting the stump to be burned to the very end.

By the Georgian period England was completely engulfed in a wave of classicism; this gave place to the Baroque style and then there was a return to a more austere classicism in the late 18th century. In this latter style, full use is made of architectural motifs, and many candlesticks appear as classical columns, the shaft reeded and with a classical capital, Corinthian being especially popular.

One of the problems with a candle is that, as it burns down, it casts its light in a slightly different area. To combat this, various devices were tried out, such as small wooden or metal objects resembling little tables, known as candlestands. As the candle burned down the candlestick would be placed on one of these, thus raising the light. Another of these devices, patented at the end of the 18th century, was a candlestick with an extending shaft: it was known in those days as a sliding candlestick, and the principle was similar to that of a telescope. By this means it was possible to keep the light at the level required. It was especially useful for anybody requiring a candle for a considerable length of time.

It is interesting to note that the Victorian candlestick on the whole escapes the over-florid taste of the period, probably because designers concentrated on one of the new delights of that age, the oil lamp, the candle being relegated to the inn and the smaller family. Pewter candlesticks came back in the Art Nouveau period in the 1890s, and there are exquisite examples of this sinuous and wave-like style of art which lent itself admirably to the candlestick.

Out of the simple candlestick developed the branch candlestick, two- and three-branched sticks developing ultimately into the immense table centrepiece 76 called a candelabrum.

A set of candles suspended from the ceiling of a room is known as a chandelier. From the early primitive ones made out of two crossed swordblades or the rim of a wheel by a village blacksmith – very practical for farmhouse or small workshop – they developed into superb examples in wrought iron, too large and expensive for the homes of most of us. By the 17th century, there had come to us from Flanders the idea of a chandelier in brass or latten with the candlestick branches distributed around a polished brass globe. This would pick up the light

97

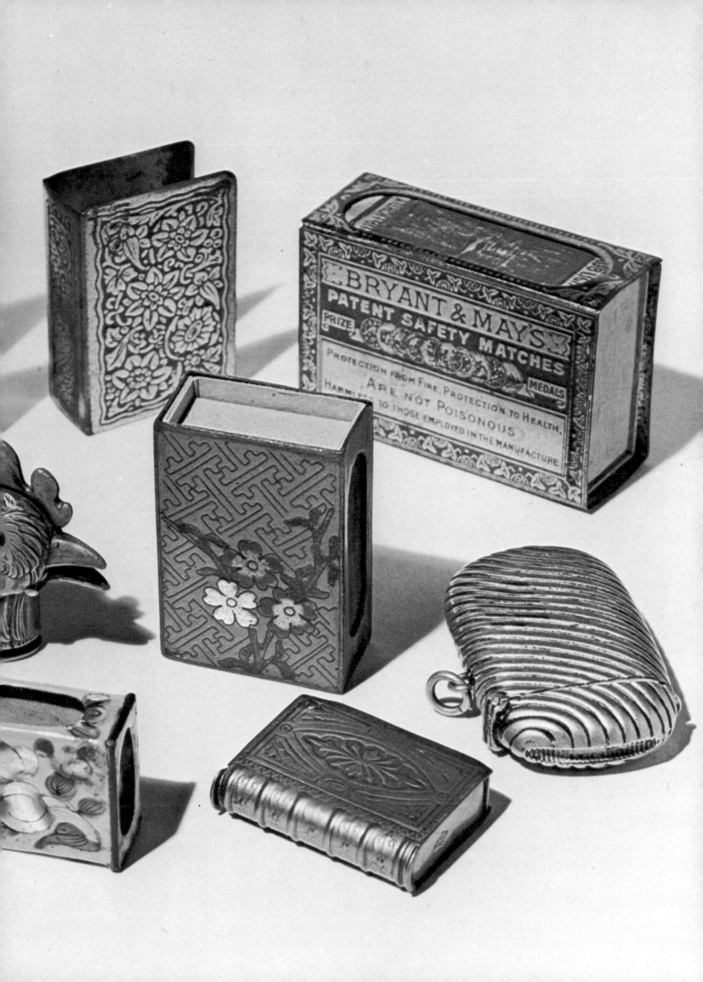

99 Early 18th-century brass candlestick with
bayonet catch to move the candle up as it burns.

100 Iron candleholders. Private collection.

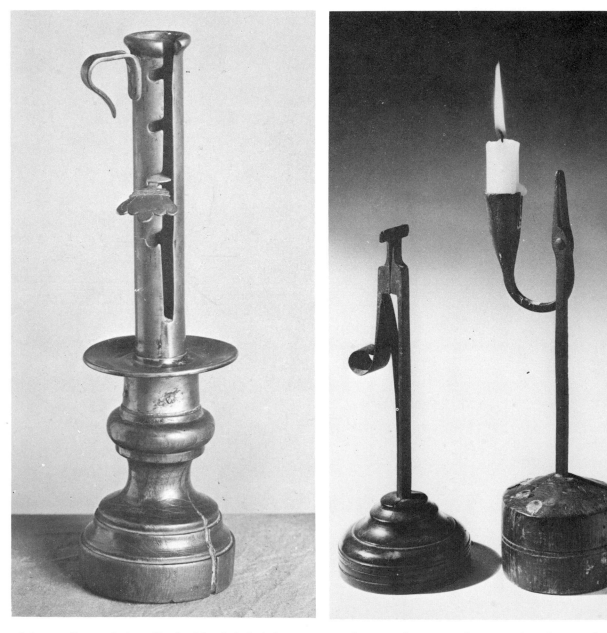

of the candles and virtually double their brightness. They were very attractive to look at and had a never-failing charm which has caused them to be re-introduced first for gas and then for electricity. They are sometimes known as Knole chandeliers from the fine specimens in that beautiful country house. In the 18th century great houses launched out, and chandeliers were made in many different materials including glass; very beautiful plated ones are known, incorporating acanthus leaves, honey-suckle motifs and the like. Throughout the 19th century chandeliers reflected pretty faithfully the various styles of the periods. Many of them have since been converted to electricity, their styles re-maining very popular.

From quite early times it had been recognised that a polished shield, hanging behind a torch, gave more light, and out of this evolved a deliberate

101 Whale oil lamp. Any drips from the wick in the upper 'spout' fell into the trough below, to run back into the reservoir. Brighton Museum.

102 Enamelled brass candlestick. About 1670. Victoria and Albert Museum, London.

103 *pages 88–9* A group of snuffers and extinguishers, with a pair of lazy tongs. The snuffer on the tray has a mechanism similar to the bottom one in the 19th-century catalogue illustration (see 12). Private collection.

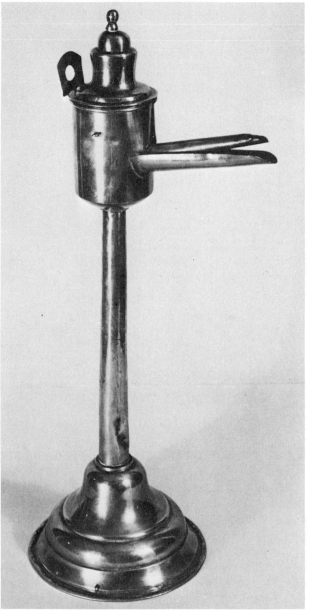

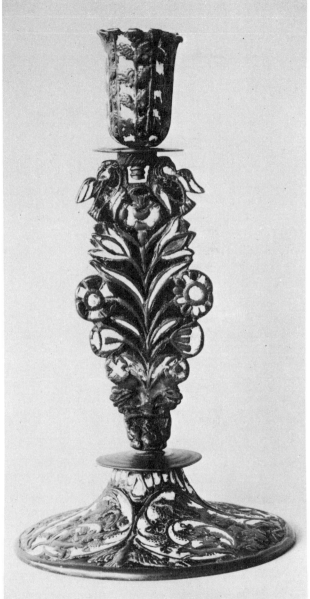

fitting to be placed against the wall. It was made in various metals including polished brass, pewter, tin, etc. The Tudors called these 'hanging candle-sticks'; the more common name today is 'wall sconce' or 'sconce', which incidentally is also the name given to the broad flange on a candlestick intended to catch the wax. Later, by the 17th century, a piece of mirrored glass would be put behind a light to give a better reflection. At this time, when mirrors were

becoming more popular and also cheaper, these sconces became known as 'girandoles', meaning a burst of light, a radiating shape. This word became strangely popular and was later used for a piece of expensive diamond jewellery. A later type of girandole is a mirror with a candlestick attached to each side. With some sconces the metal back – frequently of pewter or tin – is found to be un-polished; and it is very possible that its purpose,

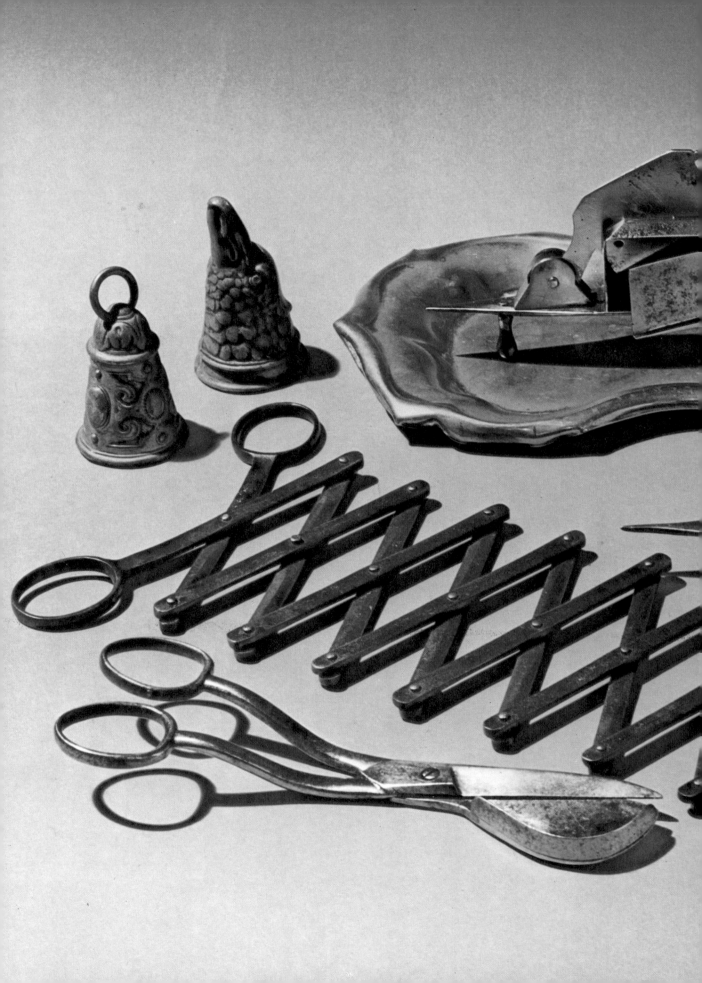

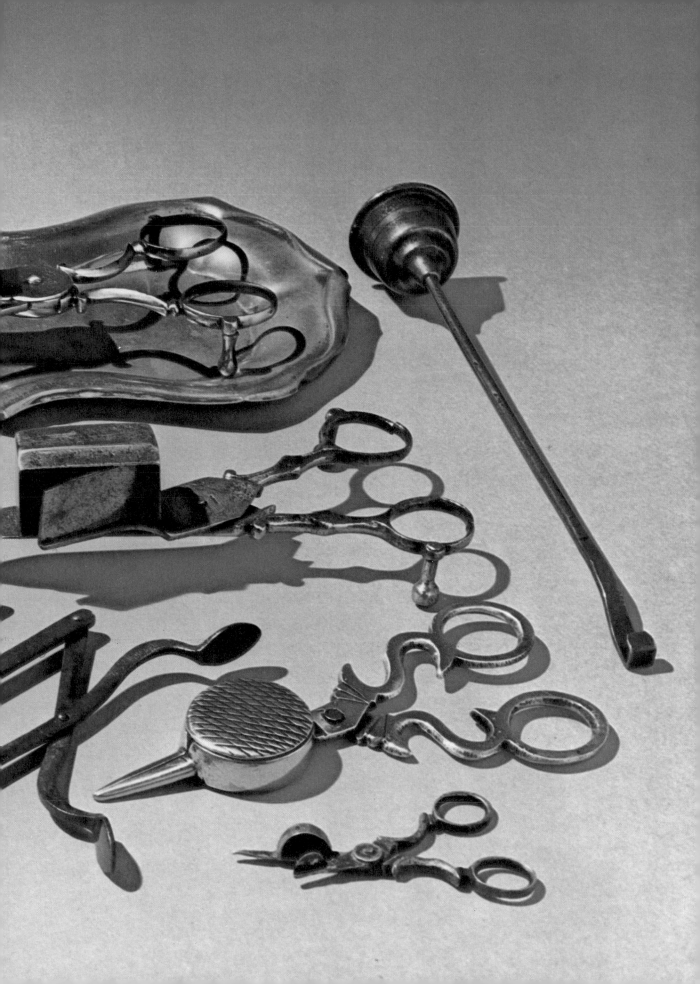

104 Early 19th-century perforated brass candlestick with chimney and extinguisher. Brighton Museum.

105 Early 19th-century oil wick lamp with storm glass. Brighton Museum.

106 Early gas lamps. *left* Kidd's Albo-carbon gas light of 1878. *left centre* Christiana burner by Sugg. 1874. *right centre and right* Two Argand burners,

the right-hand one having the large output of 300 candlepower. Science Museum, London.

107 Oil vapour lamps. *left* Coleman lamp, made in Canada, using petrol. *centre and right* A Tilly lamp and an Aladdin lamp, both using paraffin. Science Museum, London.

especially when used in a cottage constructed chiefly of wood, was more to protect the wall than to reflect the light.

By the late 17th century one finds low squat candlesticks set in a deep saucer. They are known as chambersticks and their main function was to light a person to bed. The earliest ones had no ring-handle to carry them by, but they gradually developed to incorporate a proper handle, a place for an extinguisher and sometimes, by the 19th century, a place for a box of matches or sulphur sticks. Chambersticks appear in all metals including, in the mid 19th century, electroplate. Some had a storm-lantern fitting so that a glass chimney could protect the flame from draughts. These chambersticks were in use up to 30 years ago in provincial inns and smaller boardinghouses. As a boy I can remember seeing them lined up in a hall together with candles and matches. A type of chamberstick which I came across when researching into the travelling habits of Englishmen on the Grand Tour is the traveller's

93,104

candlestick. These came in pairs and formed, when closed, an extremely flattened sphere, the two halves of which unscrewed to disclose inside two candle-sticks, sometimes an extinguisher and often, if space permitted, two candle stumps. The sticks screwed into the centres of the halves, making a pair of chambersticks. Wealthy travellers had them made in silver, the traveller on horseback in wood for light-ness, and a more economical and tough type is known in pewter or brass.

The lantern should be mentioned here. This has been known since Tudor times and was intended for protecting the flame of a candle when carried in the open. Originally it was known as a 'lanthorn' because the panels for illumination were made of sheets of thin horn boiled to make them translucent. This use of horn continued up to the present century on farms as, if the lantern were knocked over, horn, unlike glass, would not cut an animal's foot. The framework of the lantern was constructed of copper, brass or iron, with a socket for a candle. It could be carried

104

10

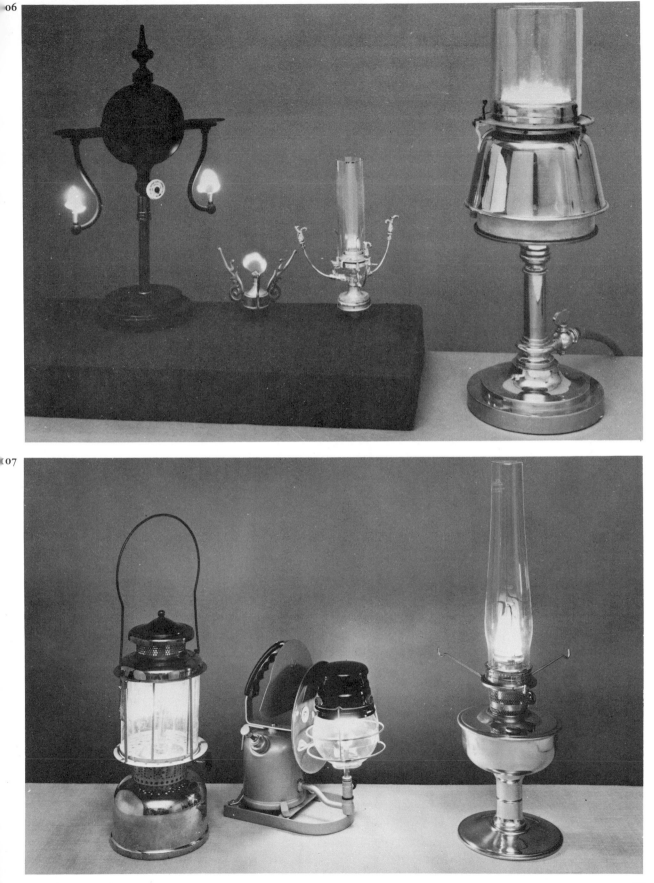

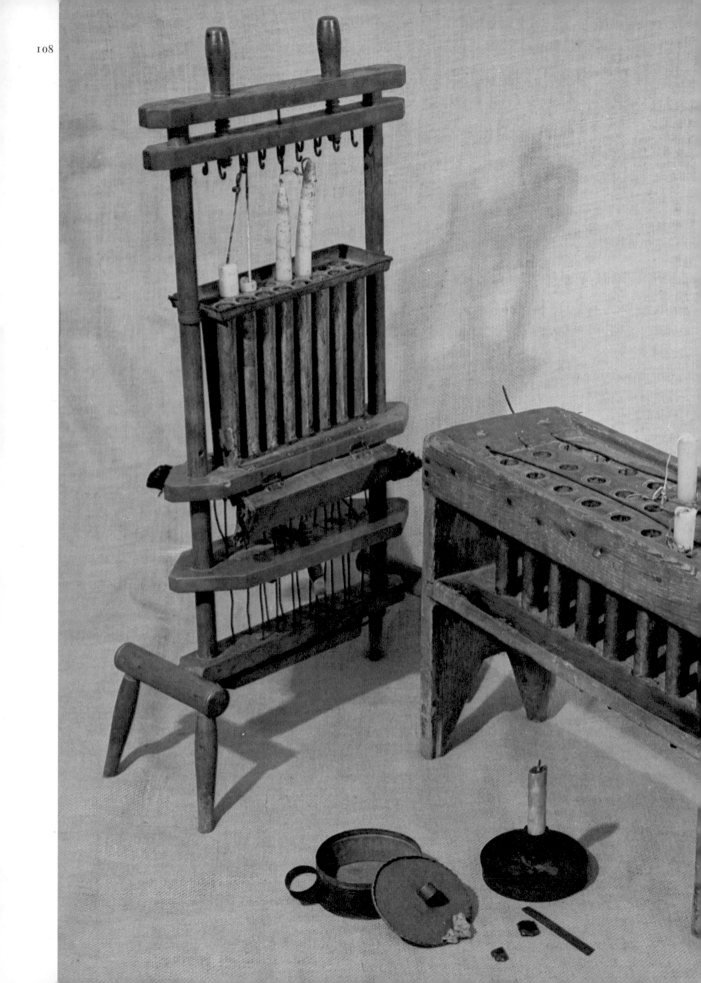

108

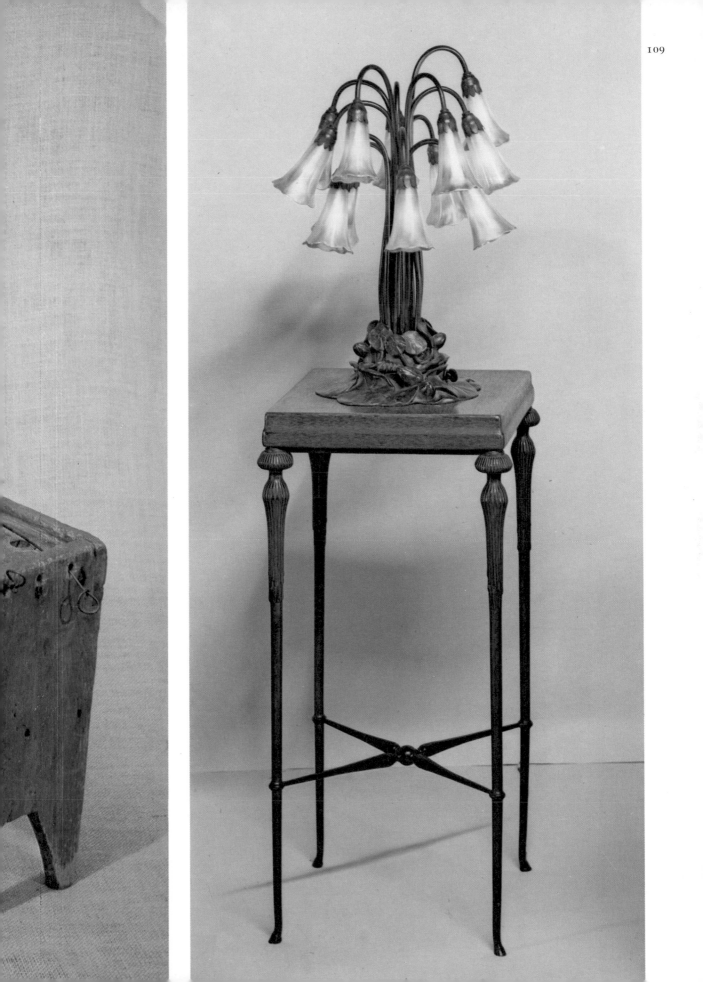

108 *page 92* Two candle moulds and a travelling tinderbox-cum-candlestick with flint, steel and tinder. American Museum in Britain, Claverton Manor, Bath.

109 *page 93* Bronze-legged table and electric lamp by Tiffany, New York, of about 1902. Lamp: Collection of Mr and Mrs William G. Osovsky, Oyster Bay, New York. Table: Metropolitan Museum of Art, New York (Rogers Fund).

110 Late 17th-century brass chandelier with three tiers of candleholders. This type is sometimes called a 'Knole' chandelier. Hampton Court Palace.

111 An advertisement from *The Ironmonger* in 1883 illustrates the hazards involved in using gas in the early days and the elaborate means devised for preventing a disaster. Museum of English Rural Life, University of Reading.

110

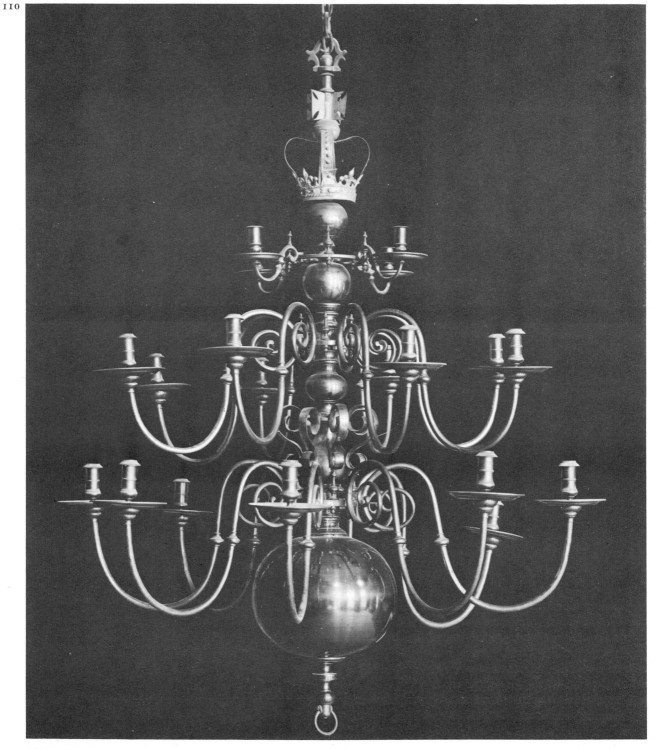

SOUTTER & SONS' PATENT
CHANDELIER WATER INDICATOR,
OR GAS EXPLOSION PREVENTER.

This Indicator is a glass cylinder fitted in the middle of the water-slide, which always shows the level of the water in the Chandelier, and if at any time the water disappears from the Indicator, immediate attention is drawn to the fact that there is danger of an explosion taking place, and an accident may thereby be prevented.

The inner tube is so constructed that it is impossible to draw it past the Indicator, even if the Chandelier slips down accidentally, or by the act of careless servants.

The Chandelier Water Indicator, or Gas Explosion Preventer, can be applied to any of our pattern Water - slide Chandeliers at a very moderate cost.

For hot climates, where rapid evaporation takes place, this Indicator will prove invaluable, and has already been highly approved by Merchants and Shippers.

ENLARGED VIEW OF INDICATOR.

William Soutter & Sons, Copper, Brass, and Chandelier Works, **Farm Street, Birmingham.**
London Offices and Show Rooms—J. J. SMITH, 28 Holborn Viaduct, E.C.

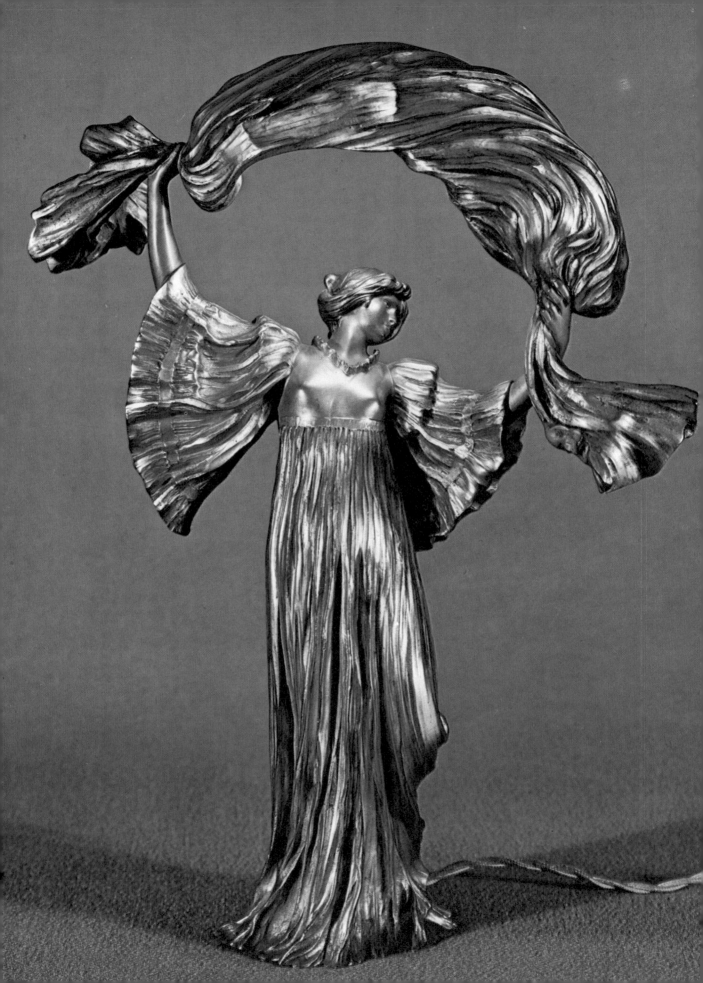

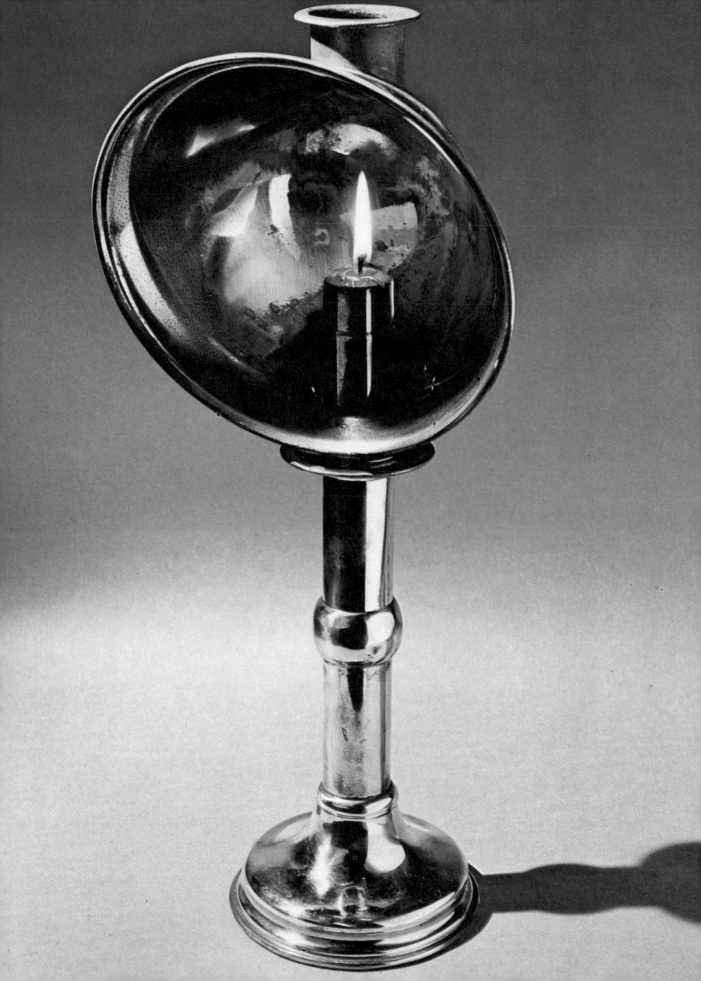

FRANCIS F. FOX,
PETROLEUM IMPORTER.
BRISTOL.

PETROLEUM, PARAFFIN, BENZOLINE, BENZINE, & GAZOLINE.
NATURAL AND REFINED MINERAL OILS.
SOLE PROPRIETOR OF

LUX BRISTOLIENSIS,
THE MOST PERFECT ILLUMINATING OIL,
White as water, quite Sweet, and guaranteed Safe.

Oils and Colours of all descriptions. Mixed Paint in 1, 2, 4, and 7 lb. tins.
FOR PRICES APPLY AS ABOVE.

REA & NEALE,
(Formerly REA & WEBB),
JAPANNERS
TIN & IRON PLATE WORKERS,
AND MANUFACTURERS OF
EVERY DESCRIPTION OF LAMPS,
St. Paul's Works, St. Paul's Square,
BIRMINGHAM.

WHITE HORSE CELLARS

PATENTEES & SOLE MAKERS OF THE
PATENT
"NO-CORK" OIL CAN,
For Oils, Paraffin, &c. Never requires a cork;
clean, useful, economical.

The Cheapest and Best House in the Trade for
BICYCLE LAMPS, OILERS, &c.

MAKERS OF
"COOPER'S PATENT" INEXTINGUISHABLE HUB LAMPS.

Send for Illustrated List.

ECLIPSE
"THE BEST LAMP OUT."

"Will-o'-the-Wisp."
Absolutely Indestructible.

None Genuine unless Stamped with
TRADE RNB MARK.
See Opinions of the Press.

REA & NEALE, St. Paul's Square, BIRMINGHAM.

112 *page 96* Electric lamp made by Léonard for the 1900 Paris Exhibition. The figure is Loïe Fuller, the famous dancer.

113 *page 97* 'Study' candlestick. Private collection.

114 An amazing variety of oil lamps is shown in this 1883 advertisement from *The Ironmonger*. Museum of English Rural Life, University of Reading,

115 18th-century Betty lamp from New England. American Museum in Britain, Claverton Manor, Bath.

116 American oil lamps known as sparking lamps. American Museum in Britain, Claverton Manor, Bath.

by hand or hung from a chain (it had a ring on the top and sometimes a handle on the side). Another type of storm-lantern was made of pierced sheet tin, the holes being grouped in patterns through which the candlelight shone; the effect was extremely attractive.

There is another group of candlesticks, known as student or reading candlesticks, which is quite interesting because these nearly always incorporated a patent device known as a spring-loaded candle: the candle was inserted from the bottom of the candlestick and held in place with a spring and a plate pushing against its base. The head of the candle protruded from the top of the candelstick and was gently pushed up by the pressure of the spring as the wax was consumed. The candle itself was concealed on all sides but one by a plated reflector hood which concentrated the light upon the book which was being read. Spring-loaded candlesticks were apparently first shown at the 1851 Great Exhibition by their inventor, a Mr Palmer.

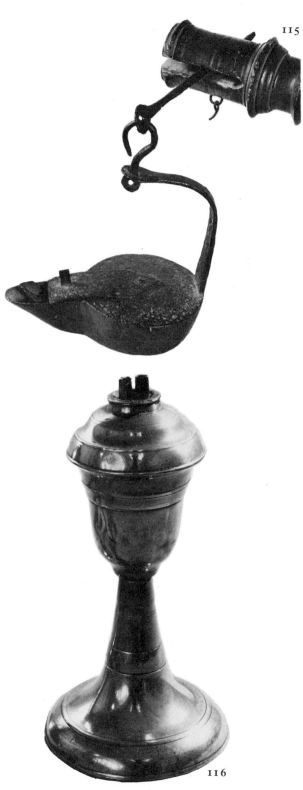

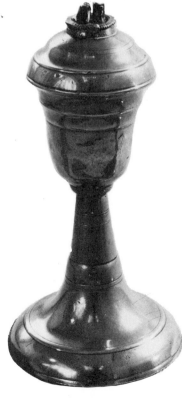

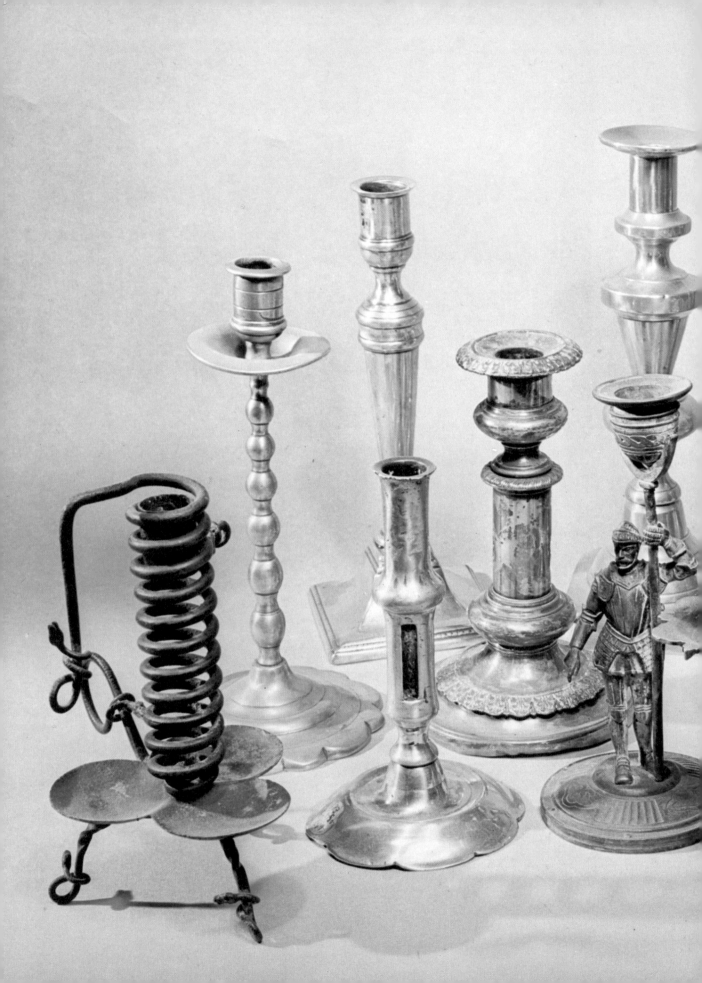

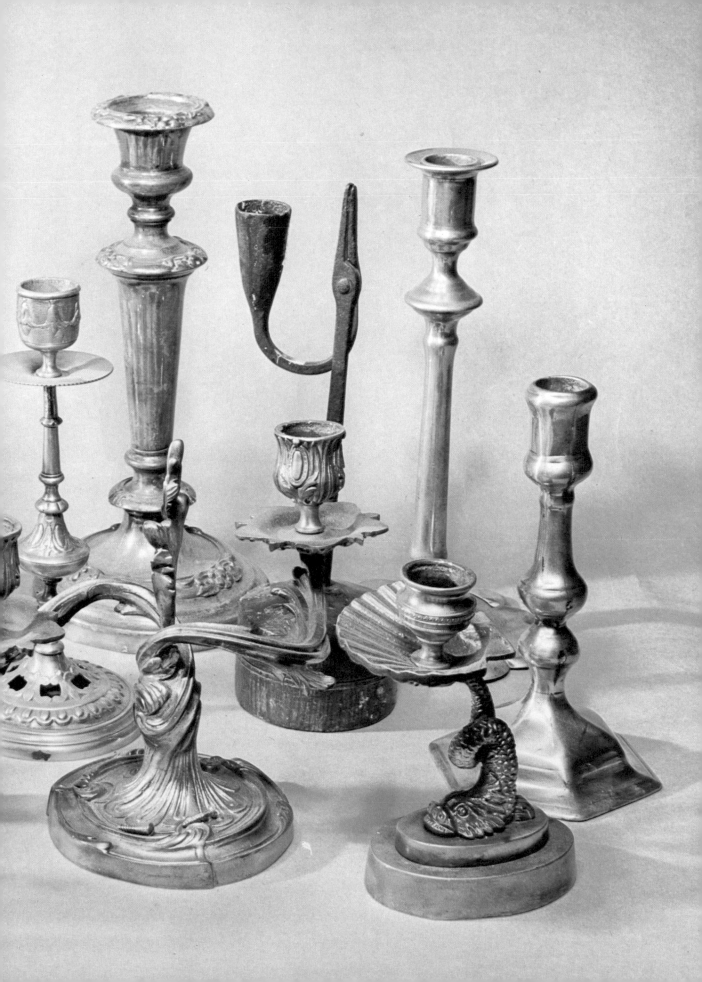

117 *pages 100–1* A group of candlesticks of all shapes and sizes. Private collection.

118 Whale oil lamp with separate shade, both adjustable for height. American Museum in Britain, Claverton Manor, Bath.

118

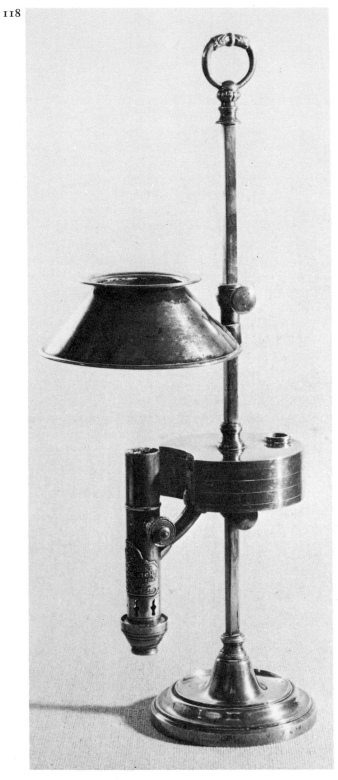

From the 17th century onwards there is a record of extinguishers being used for putting out a candle. The main disadvantage of a naked flame is its danger, and for this reason, as well as the equally important one of economy, candles were extinguished when not in use. Little conical hoods were made in brass, 93 pewter and plated ware, either independent of, or as an integral fitment to, the candlestick. There were also little scissor-like implements with broad flat ends which were used to pinch the wick and so extinguish the flame. The amusing name for these is 'douters'. For some reason they are extremely difficult to find outside a museum. Another gadget, also resembling scissors, is the candle-snuffer. Upon one 12, of the blades a box was fitted, and the purpose of the snuffers was to trim the wick and so stop it smoking, the charred end of wick being caught in the box. A less sophisticated form, sometimes called 'candle-shears' consists of a pair of scissors with one blade formed in a half-round shape with a small tray-edge fixed. These must have been the more popular ones because many more have survived than of the more elegant box-snuffers. For some reason the steel appears to be very much better than that of some scissors; I have never found a pair that was not first-class for cutting. Snuffers were often accompanied with a matching tray on which they rested.

In private houses candles were kept in candle-boxes, very frequently made of brass or japanned tin and hung clear of the ground away from rats and mice. These candleboxes illustrate an interesting fact discovered afresh by almost every collector of antiques, namely that any article that is practical and useful will often be found useful in more than one situation, and its last use may in fact be very different from that for which it was first intended. The candlebox was equipped with a well-fitting hinged lid which fastened easily, and it had two pierced strips of metal for hanging it on the wall. In time it came to be taken over by naturalists as a collecting tin or vasculum, to be hung on a belt at the waist and to house in safety specimens of wild flowers, etc. It was obviously admirably suited for this. Incidentally, this re-use of an object for another purpose is a possible explanation of the scarcity of some quite common articles.

In the 19th century with rapid improvements in lamps, wicks and mechanical contrivances, plus the

119 American sparking lamp with two detachable
bull's eye lenses. American Museum in Britain,
Claverton Manor, Bath.

120 A collection of 'go-to-bed' lights. The matches
are kept either inside the figure or in a separate
'basket'. Private collection.

introduction of improved oils, oil lamps really came
into their own, and there is a great range still
114 available for the collector. Until a few years ago
they were not greatly esteemed; now, however, not
only is their artform considered worthy of attention,
but they are appreciated for their practical use. One
very sought-after type is the 'student' lamp. Un-
fortunately these have been the subject of much
reproduction in recent years, but the early ones were
masterpieces. They could be adjusted to the desired
height and incorporated reserve cylinders of fuel,
presumably enabling the student to burn the mid-
night oil without any possibility of his lamp going
out.

If you are fortunate enough to secure a working
oil lamp in good state, please do not convert it to
electricity in such a way as to alter it. It is possible
to run a wire up the outside and still keep the original
article. The time is rapidly approaching when an
unconverted lamp will be an object of considerable
merit. This is a point that should be kept in mind
when dealing with any antique. If an article is in
perfect condition, nothing should be done to alter
that state of affairs, because anything that is done
will be tantamount to damaging it. If a conversion is
required, it is usually easy to find an article already
damaged which can be adapted.

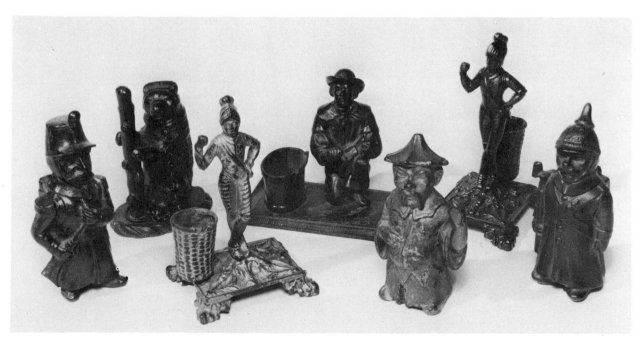

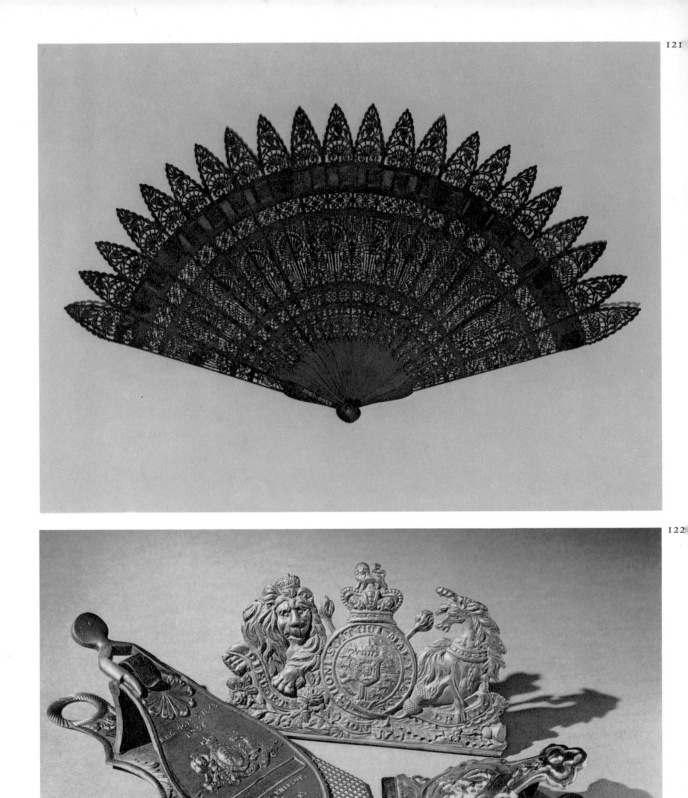

121 Berlin iron fan made in Ilsenburg-am-Harz by Edward Schott and exhibited at the 1851 Exhibition in London. Victoria and Albert Museum, London.

122 Paper clips. Private collection.

123 Cigar cutters. Private collection.

124 Edwardian ladies' cigarette cases. House of Pipes, Bramber, Sussex.

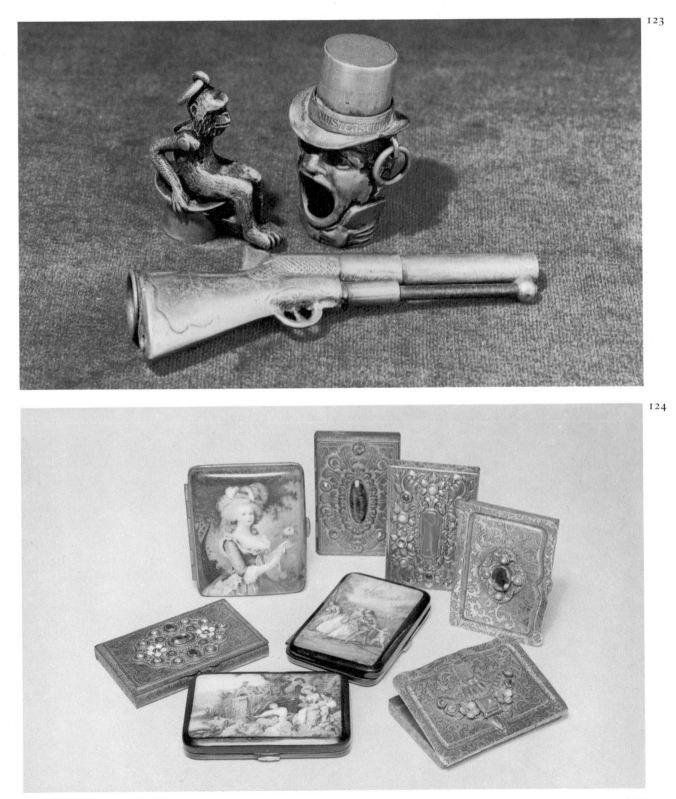

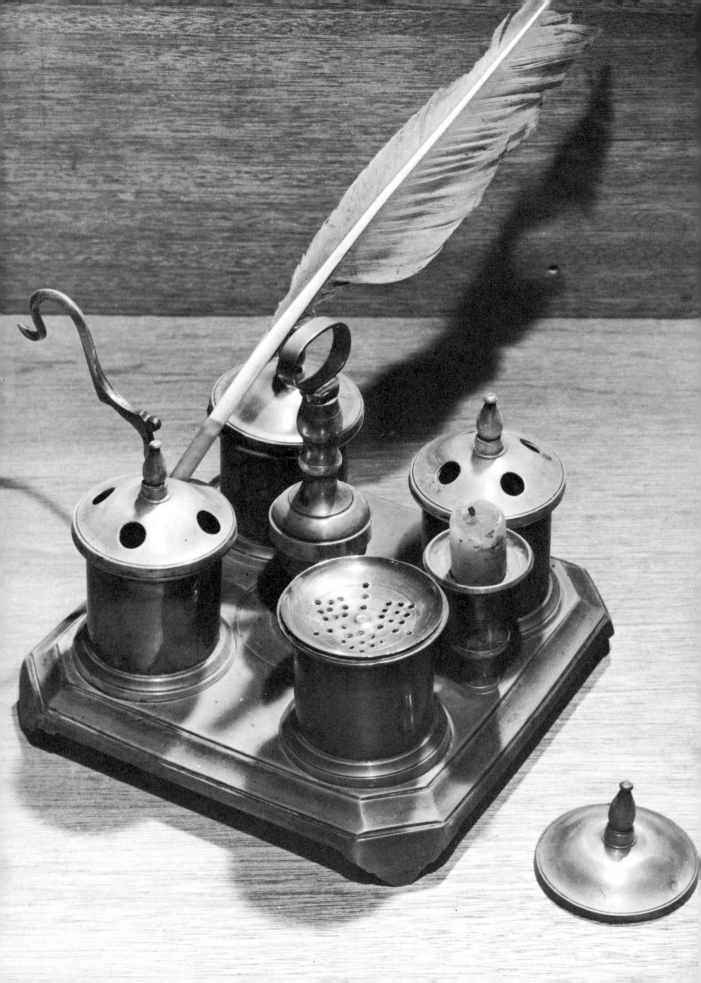

THE PERSONAL ITEM

Down the years human beings have been able to gather around them a remarkable amount of personal gadgetry; many of these objects had a short life, and therefore as time goes by they become rare. This is especially true with modern trivia because the tempo of life has increased so rapidly during the last 30 years that many gadgets have been superseded within a year or two of their being produced. These small objects that I have in mind are almost always influenced by the taste of their period and conform to the fashions of their time. However, the closer one is to a period the more difficult it is to distinguish it or to pick out its essential features, and as a result typical items of a certain style are not recognised as such until it is almost too late to find them. I should like to stress this point because it is a wise collector who can discern the antique of the future; who for example, made a collection of items such as powder compacts, cigarette-cases and match-holders in the years immediately following the First World War, when the vibrant impulses of jazz music, originally African in origin, combined with the geometric patterns, from equally exotic sources, to produce the style now known as Art Deco? This style, which has only comparatively recently been appreciated, left its mark on the whole life of the mid 1920s – the Jazz Age – and, like the styles of every other age, made use of new materials and affected even the smallest articles.

One of the advantages of collecting the personal item is that one can normally make a pretty comprehensive collection without too much space being required and, perhaps in this field more than any other, many of the pieces were made in the general workaday metals being considered in this book, metals of objects in constant use.

Let us start with the lady of the house. Her personal items, apart from jewellery with which I am not dealing in this book, in general reflect her duties around the house and in society. And they all may be said to come together in one particular piece, 127 the chatelaine. This was a compendium of useful gadgets suspended from a series of chains which she wore at her waist. The French word '*châtelaine*' means mistress or lady of the castle, and the word was transferred by association to this attractive metal object. Chatelaines come in the precious metals, and also in brass, German silver and in cut-steel, and they are beautiful examples of the craftsman's skill. They are equipped with a whole range of small familiar objects, articles such as scissors, a thimble, a pin-ring, a notebook, a pencil and almost always keys. There is little doubt that the chatelaine's original function was to provide a means for the housekeeper – whether she was wife or servant – to carry the keys of a great house.

Another article of practical use is the skirt guard used in the days of long skirts and dusty streets. This was a cramp fixed on the edge of the skirt, so constructed that it tightened when pulled; when the lady crossed the road she would lift up the chain, thus raising her skirts clear of the dusty street. There must have been quite a degree of skill in manipulating this in a discreet and practical manner. Normally of brass and German silver, they are often very decorative and are quite attractive. They are one of the few items so far mentioned that are not easily recognisable, and I know of no collector specialising in these interesting objects.

Flower-holders or posy-holders are other superb examples of the Victorian craftsman's skill. They were trumpet-shaped horns of pierced metal frequently plated, ending in a curved handle; across the centre of the trumpet-piece went a spiked pin. The little bunch of flowers was pushed into the horn and held in place by the pin. It enabled a lady to carry a small bunch of flowers without soiling her gloves or her hands. Larger versions would take a bouquet of flowers and smaller versions a spray or corsage. These have been sought after for many years by discriminating collectors.

Inevitably a collection can be made of fine buttons. 132 The late 18th century and the whole of the 19th century was a wonderful period for metal buttons of every description and in all types of metal, stamped, pierced, enamelled, in brass, German silver, cut-steel. Shown sympathetically against a piece of velvet

125 Brass 18th-century standish.
Folk Museum, Cambridge.

126 *pages 108–9* Opera-glasses. Private collection.

127 Three chatelaines of polished steel of the 17th and 18th centuries. The implements include paperknife, note pad of bone plaques, pincushion, corkscrew, purse, pencil, scissors and some objects of unknown use. Sussex Archaeological Society, Anne of Cleves House, Lewes.

128 The giant thimble is engraved 'ONLY A THIMBLE FULL' to trap the unwary guest (or host). Private collection.

129 American brass button of about 1789 with the initials of George Washington. Metropolitan Museum of Art, New York (Rogers Fund 1928).

they make an interesting collection. Incidentally, one of the best places to visit when starting a collection like this is grandmother's buttonbox. Housewives in the past appear to have kept buttons perhaps more than we do today, and these buttonboxes frequently provide enough examples to start a good collection. There are several dealers in England specialising in the sale of antique buttons, and on both sides of the Atlantic there are very keen button collectors. The Americans have a collectors' paper devoted totally to the subject; I do not know of an English version. The range and variety in this field is extensive and many collectors choose to specialise, concentrating on, say, military buttons or sporting buttons; a rare series that is greatly sought after consists of dog's heads in enamel.

The corollary of the button is the buttonhook, and collections have been made of these. They are remarkably attractive and come in all materials: large numbers were in nickel silver, in white metals or in brass, with the actual hooks in cut-steel or of plated steel. Some are equipped with patent folding devices. They are very frequently found en suite with dressing sets on a dressingtable or with travelling sets. They may even appear in a lady's writingdesk, the type that she would take with her when she went travelling. The long ones of a foot or more in length have found another use in this day and age: they are ideal for zipping up the back of a dress.

Another integral part of a lady's personal possessions was a collection of small boxes used for a multitude of purposes and made in many materials. They were used in the 18th century for carrying comfits, sweetmeats, small candies and especially patches. These patches or beauty spots were also known as court plasters and were a strange by-product of the 18th century. They started in the 17th century in the great court of Louis XIV and gradually spread over France, Germany and England. Due to the prevalence of diseases such as smallpox, even great ladies of fashion were not immune to blemishes on the face, and it became the peculiar fashion to place a small black patch on the blemish. Patches were also used to accentuate the natural charm of a face; a patch at the corner of the mouth, for example, was thought to increase its attraction. In time this strange habit was taken up by both sexes. The beauty spots were not always round: stars, flowers, crescents and diamonds are known and they were made in a variety of materials, adhesive on one side and resembling velvet upon the other side.

Patchboxes are frequently in metal, plain or enamelled, and are often equipped with a small mirror on the inside of the lid. Examples are found in Battersea, Bilston and Staffordshire enamels. 16 Many have a little motto extolling the feelings of the giver or referring to amorous pursuits: 'Esteem the Giver', 'The gift is small but love is all', 'A trifle from . . .' Similar boxes were used for cachous – themselves another attempt to make life more pleasant. Due to a lack of dentistry, bad breath was not uncommon in the past, and the custom arose of carrying aromatic sweets which were sucked when necessary.

By the end of the 18th century the range had increased considerably, and all sorts of boxes and

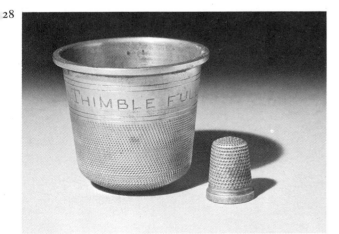

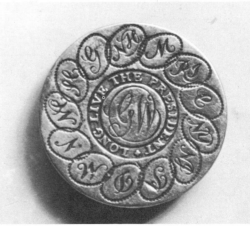

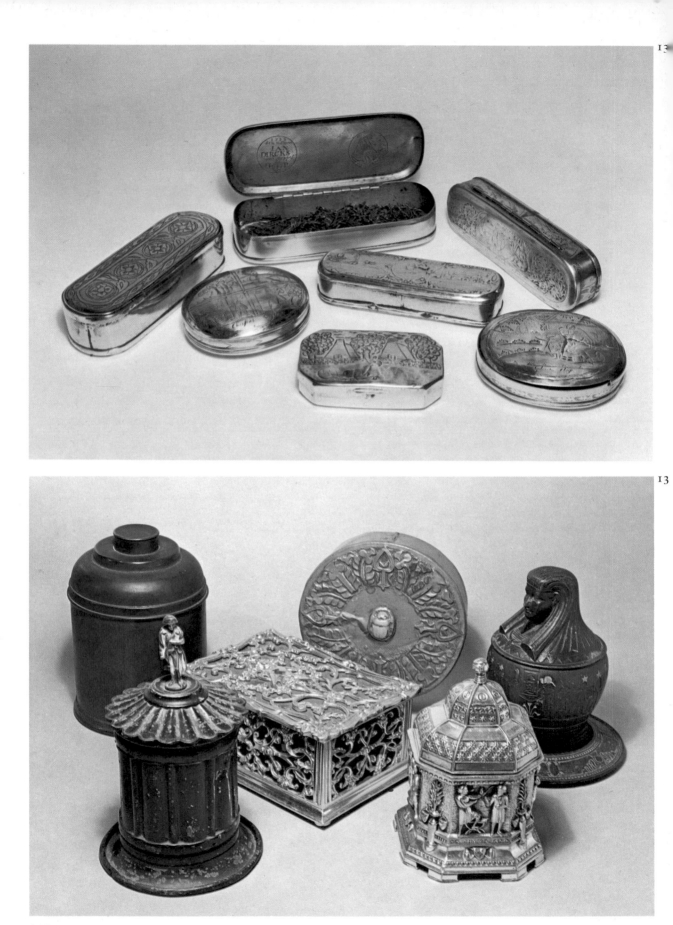

130 Dutch 18th-century tobacco boxes. House of Pipes, Bramber, Sussex.

131 Table tobacco jars and humidifiers of the period 1850–1920. House of Pipes, Bramber, Sussex.

132 Buttons. *top* North European peasant's button with toggle. *centre, left to right* German painted button. European painted button with glass dome. English livery button. Button of the Royal Flintshire Militia, in bellmetal with mercury gilding. *bottom, left to right* English button with cut and polished steel set into mother-of-pearl. English 18th-century button with paste in a metal setting. Mercury-gilt button commemorating the recovery of George III from one of his illnesses. All early 19th-century except one. 'The Button Queen', London.

containers are known: for example, spring-loaded sovereign and half-sovereign boxes, in which a lady could carry a considerable sum of money; also mesh purses made out of linked chain sometimes in two coloured metals, making a pattern. By the end of the 19th century powder compacts were known, make-up no longer being considered immoral. There is a rich field for the collectors here – they were produced in all metals and sometimes incorporated a lipstick-holder and a cigarette case as well. By the 19th century one may also find ladies carrying sets of needles, cottons, threads and the like for running repairs when anything inadvertently broke loose; they frequently had a screw-cap end which served as a thimble. Inside were little spools of cotton and an assortment of needles. For the lady travelling, there were more comprehensive outfits: boxes, sometimes covered with leather, containing a very full range of items for needlework and the toilet: articles such as nail-files, ear-scoops and the like. One curious one that I have seen was a cylindrical brooch decorated with an aventurine stone; the small cylinders at each end unscrewed to disclose spools of cotton and a container of needles. This strange little brooch was made entirely in gunmetal and was sold in a London market about 90 years ago. Travelling pens and pencils are known, frequently in the precious metals, much more rarely in gunmetal or nickel or japanned tin. These little items sometimes have a tiny glass bead set in one end; if examined carefully they show little views as, for example, of watering-places, which can be interesting or incredibly banal.

Of the late 19th century are dressingtable sets comprising a metal tray, brush, mirror, buttonhook, comb and a series of boxes all mounted in high-relief decorated metalwork in gunmetal or nickel. Originally these may have been plated or polished bright and lacquered. From the angle of sheer craftsmanship, good sets are worth keeping.

For sewing at home, a lady had a tremendous range of equipment by the 19th century: scissors,

32

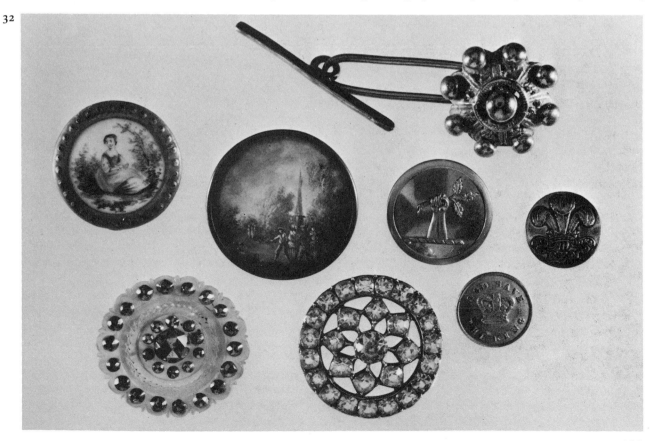

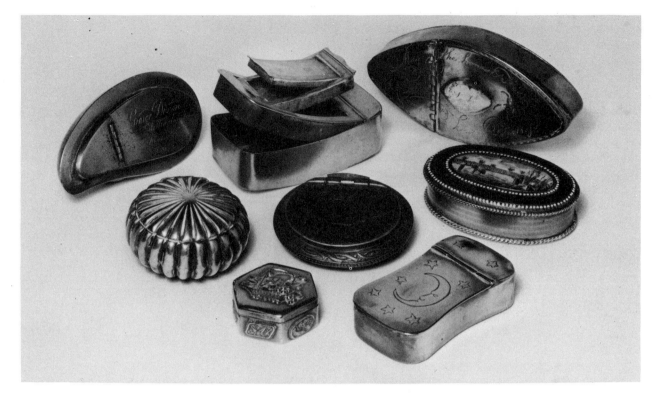

133 18th- and 19th-century snuffboxes, from the simplest to the most complicated. House of Pipes, Bramber, Sussex.

with or without ornamental handles and frequently in ornamental sheaths; fitted boxes containing a variety of tools; cottonreel dispensers in solid brass and ormolu of beautiful quality; brass-based pin-cushions with a fascinating variety of shapes – elephants, pigs, castles, etc. Last but by no means least there is a tremendous range of base metal thimbles in gunmetal, cut-steel, nickel and combina-tions of metal. Naturally they have a good range of size, but it is interesting to note that early thimbles are nearly always smaller than modern ones. A heavy Victorian joke may perhaps be mentioned here: very large nickel silver thimbles labelled 'Only a thimble full' are known. These were for drinking spirits from. They are now becoming scarce.

With the man, perhaps the equivalent of the chatelaine would be the Albert. Certainly at the time that the chatelaine achieved its greatest importance in the 19th century, it became the fashion amongst the middle classes for the men to wear a decorative chain spread across the waistcoat. The main function of this chain, known as an Albert, after the Prince Consort, of course, was to hang the watch upon. Gold and silver ones were made for the wealthy, but

they are also known in gunmetal, nickel and plate. From them could be suspended an incredible variety of small gadgets such as a seal, a matchcase, a cigar-cutter, sometimes a compass; in short, whatever suited the individual needs of the wearer. With the advance of interest in sport amongst the general public, various medals awarded for sporting prowess would also be hung upon the watch chain.

There is in point of fact a complete and separate field for collecting in these medallions. Their use was widespread and started surprisingly early, as far back as the Middle Ages. With the fashion for pilgrimages at that time, it became the custom for pilgrims to wear badges on their hats to show that they had been perhaps to Rome or Spain or Jerusalem. Others were issued for such sacred shrines in England as Our Lady of Walsingham or the tomb of St Thomas at Canterbury. In the Renaissance the old propagandist technique of ancient Rome was revived, and military and political leaders would produce medals to commemorate victories or treaties. The idea was taken up by great nobles on the occasion of a marriage when, in a marriage pro-cession, handfuls of commemorative pewter or tin

128

114

134 Table tobacco boxes of the 18th and 19th centuries in lead, brass, iron, copper and pewter, including one with a negro's head knob. House of Pipes, Bramber, Sussex.

135 Pocket tobacco boxes of the 18th and 19th centuries, one with the head of Nelson on the lid, one with a combination lock, some with painted scenes or city arms, some with engraved names or decoration and yet others left plain. House of Pipes, Bramber, Sussex.

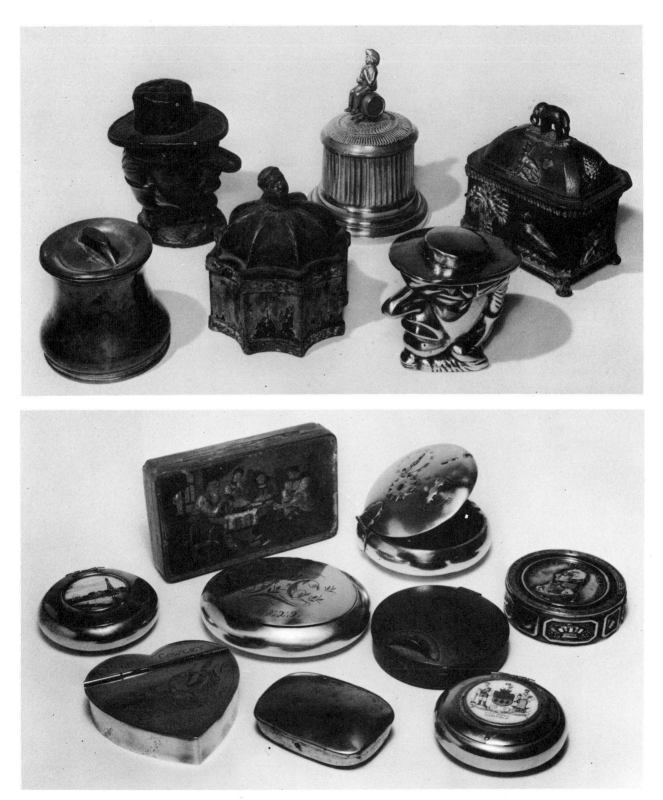

medals were thrown to the crowds watching the procession. Presumably some in precious metal were struck for the immediate guests.

An early medal issued in base metal to commemorate a notable event was the pewter medal issued by Matthew Boulton to sailors returning during the Napoleonic wars after the Battle of Trafalgar. These medals were not very well received and many of the sailors hurled them into the docks in contempt. It is possible that the term 'a putty medal', meaning a worthless thing, is a corruption of 'pewter medal'.

A great number of sporting and shooting medals, many in base metal, were produced in the 19th century. The variety is extensive and is still increasing: I have known collections of fine quality enamelled racing enclosure badges, of temperance, prohibition and generally 'anti' buttons and medals. In time political medallions or badges would be made – the Primrose League is an excellent example. By the time of the Boer War the English were producing small buttons with the features of notable military or political leaders on them, and the same idea was very manifest in the United States with 136 presidential campaign buttons: of these one of the most telling was the button produced after the last

war with the phrase 'I like Ike'.

Perhaps the biggest range of all of the personal items of the man is connected with smoking. When tobacco smoking became popular in the 17th century it became the fashion for numbers of tobacco-boxes to be made for carrying it. Most of these appear to have come from the Low Countries and Germany; 13 they are charming objects, and these early boxes are much sought after and, regrettably, have been frequently faked. They are usually long boxes with rounded ends for easy slipping into a pocket and are decorated with pictures of political leaders, or sometimes a cargo vessel, possibly a perpetual calendar or political slogans, occasionally a code or table useful to a man in his craft; floral work appears on the side, or pictures of houses etc. Many of the 18th-century ones had incredibly ingenious combination locks incorporating numbers or letters and 13 worked by a series of dials. Some are known with an 18th-century figure rivetted to the lid where the moving of the arms or legs opens or closes the box. To find one of these today at a reasonable price would certainly be a triumph, but it is not impossible as many thousands of them were made. As with everything else in the 19th century, one finds great variety when one reaches this period; boxes of different shapes are found, and there are improvements such as spring-loaded lids which open when squeezed. They are in a variety of metals and sometimes incorporate a compartment for a pipe and even a tinder lighter of some description or match container at the end. These boxes were for carrying tobacco. For keeping it in the home, tobacco-jars were used and frequently were made in metal which was considered a good material. Many of them were of lead and were often classical in style. They were fitted inside with a slab of lead as a presser to keep the air away from the tobacco. Early tobacco-jars were plain, austere, facetted boxes with domed lids terminating in an acorn or negro's head, this latter 134 being a reference possibly to the tobacco trade in Virginia or the Caribbean. After 1800 many of these tobacco-boxes began to bear references to English victories either on land or at sea. At this period smoking to a large degree died out amongst the upper classes but retained its popularity amongst the middle and working classes. The reason for this is not known and was probably purely fashion. The

137 Miners' tobacco boxes (for carrying tobacco to chew) and a miner's lamp. 19th century. Miners often chewed tobacco, a practice which saved many lives, for they spat out the injurious coaldust with the tobacco juice. House of Pipes, Bramber, Sussex.

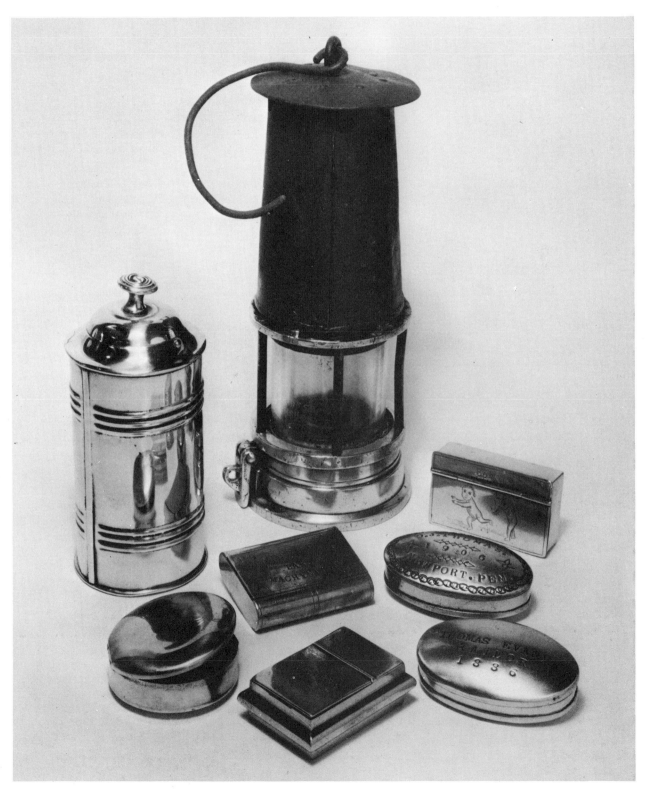

138 Mid 19th-century smoker's companions for carrying pipe, tobacco and matches. House of Pipes, Bramber, Sussex.

139 Combined ashtrays and matchbox holders of the late 19th century. House of Pipes, Bramber, Sussex.

140 Matchboxes or vesta cases. 19th century. The
'Punch' figure on the right doubled as a 'go-to-bed'
matchbox, while the shoe was also a cigar-cutter.
House of Pipes, Bramber, Sussex.

141 An infinite variety of tobacco-stoppers were
made in the 18th and 19th centuries. House of Pipes,
Bramber, Sussex.

142 Pipe rests. Private collection.

143 Pipe racks or kilns, including one with candleholder and spillholders. Sussex Archaeological Society, Anne of Cleves House, Lewes.

Crimean War seems to have started all classes smoking again. Perhaps from the example of the Turks, the returning officers and men brought back a new idea: cigarettes. This did not suit the *mores* of Victorian society, and separate rooms were established in the great houses in order that the ladies' clothing and indeed the houses themselves should not smell of tobacco-smoke.

In the taverns of the 19th century, fine brass tobacco-boxes were placed on the counter by astute publicans, and pushing in a penny or a halfpenny opened the device to allow a patron to fill his pipe with a measure of tobacco. I know one inveterate smoker who converted one of these boxes to take a modern coin so that, as he smoked, he saved towards his next purchase of tobacco. In many taverns in the 19th century, clay pipes were supplied free to patrons. If not taken away, the soiled pipes were collected and stacked in a circular cradle with a carrying 143 handle, known as a pipe kiln. The pipes were gently placed in the hot ash of the fire which burned off any pieces of tobacco making them clean and fit for another patron.

Both in the home and in the tavern, long tongs with spatulate ends known as ember tongs were used to pick up a hot coal from the fire in order to light a long clay pipe. Sometimes the handle would terminate in a pipe stopper to tamp down the tobacco in the bowl. These ember tongs go back to the early 103 18th century. Also known are 'lazy tongs': ingenious compact pairs of tongs only a few inches long made on a rivetted zigzag principle; squeeze the handle and they extend to two feet long to pick up a hot coal from the fire. There is a very fine collection of various types of ember tongs in the Anne of Cleves House Museum in Lewes.

Among the articles frequently displayed on an 141 Albert were tobacco-stoppers, a most attractive small field of collecting. They were made between the 17th and 19th centuries, and their function was to tamp down the tobacco firmly and evenly in a burning pipe, as obviously a man could not use his finger for this purpose. The earlier ones were small because the pipe bowl was small; later ones are larger. There is a tremendous range of subject: political, humorous, military. Favourite figures are the Duke of Wellington, Lord Nelson and Napoleon. The choice of the Duke of Wellington is amusing because he was

against smoking in the army, and the idea of using Old Hooky as a tobacco-stopper must have appealed to many a pun-loving soldier. They are nearly always in brass, occasionally in pewter. In time they developed into what is virtually a combination tool known as a smoker's aid, which incorporates a 144 tobacco-stopper, a knife blade and a spike, used by the smoker to maintain his pipe.

For resting a pipe when not in use, all sorts of pipe rests were made, some in the Victorian period 142 of cast brass, very reminiscent of a cottonreel dispenser, which I have mentioned earlier. By the end of the 19th century small boat-shaped stands were being made to accommodate an individual pipe. These were made in pewter. I have seen English, German and Danish ones, and they were probably made in other countries as well. The Scandinavian ones terminating in a bird's head are shaped vaguely like a bird's body. They are interesting examples of pewter, and some are still being made today.

Ashtrays should not be forgotten. The range is 139 limitless, and if you are a smoker you might well indulge your wife's or your family's taste in the materials that they like.

Cigar (or segar) cutters and piercers are another 123 small group that could well be collected. They became popular in the 19th century and appear disguised as the most unlikely objects. The French and the Belgians appear to have had a penchant for making both cutters and piercers in the shapes of miniature guns and revolvers. They are also incorporated in pairs of scissors and pocket knives and are found in shapes such as a man's face or a monkey.

On the subject of snuff, it is possible that some of the small enamelled boxes, especially the square ones, occasionally sold as comfit or sweetmeat boxes, were snuffboxes. They were made in a variety of materials 133 and are known in gunmetal, pewter, occasionally German silver, and in pressed or stamped tin sheet.

Until the advent of some form of portable match in the early 19th century, flint and steel had to be carried with him by the traveller if he wished to light a pipe. With the flint, steel and tinder a traveller could carry a packet of sulphur matches which consisted of rough pieces of split pine tipped with sulphur. These were excellent but were, of course, not able to ignite unless there was a little fire already lit. From the 1800s onwards, chemists and scientists

tried various mixtures of chemicals and acids to produce some rapidly igniting form of fire. By the 1830s various patent matches operating by friction were known, and these came to be carried in small 140 metal boxes, sometimes called 'vesta boxes' after the name of one of the early makers. A book could be written on these boxes alone; the patterns and varieties must go into many thousands, and they were made in every conceivable material including gunmetal, pressed brass, pressed tin and nickel silver. They are extremely attractive; some are small enough

to be suspended from an Albert, and the more workaday ones would fit into a greatcoat pocket.

Cigarettes as they are known today were pretty late on the scene: they did not start in Europe until the middle of the 19th century. Cases for them were 124 soon made, and from the late Victorian period there are many varieties in all sorts of base metals, some of them engraved, stamped out or enamelled.

One area where his and her personal items are shared is the writingdesk. This began life in the 17th century as a plain tray called a standish, 125

which frequently incorporated an inkwell and a pounce pot or sander to dry the letter, a penknife or cutter for a quill nib and, for important families, sometimes a seal. These early ink trays were made, of course, in precious metals for the nobles and in pewter for the people. They continued in use well into the 18th century when they appear in Sheffield plate. With the advent of the 19th century, everything takes a big jump forward. Steel pens are invented which will require penwipers to keep them clean; with the introduction of the letter post, scales will be required to weigh the letters, and fine quality letter- and paperclips will be made. Penwipers were frequently amusing little cast brass animals with the whole of their back made in the shape of a bristle brush: pigs were an obvious choice, but other animals are known, and so are shoes. With all ephemera of this nature, these articles are increasingly difficult to find.

122 The paperclips and holders have a tremendous range in size, pattern and design. One of the most sought-after today is the hand, a very popular motif in the Victorian age; others are distinctly Gothic in feeling; some, obviously made for office use, are slightly more restrained in pattern, efficient, strong and sturdy.

126 One personal item, used very much more in the past than today, is a pair of opera-glasses. These glasses are still obtainable at prices considerably lower than one might expect, and in view of the craftsmanship and decorative appeal of these charming objects I am amazed that they have not attracted more attention. Like everything else, however, they are now steadily rising in price. The heyday of opera-glasses appears to have been the last quarter of the 19th century when superb pairs were made in the capital cities of Europe, Paris inevitably producing the most attractive. They were frequently encased in fine enamelwork upon copper or in aluminium, at that time worth more by weight than either gold or silver. Finely patterned and designed in the styles of the late 19th century, this was the wonder metal which had just been discovered, and it was believed for a short period that it would supersede gold and silver as a precious metal. This, by the way, accounts for the vast number of aluminium picture frames, napkin-rings and the like found at that time.

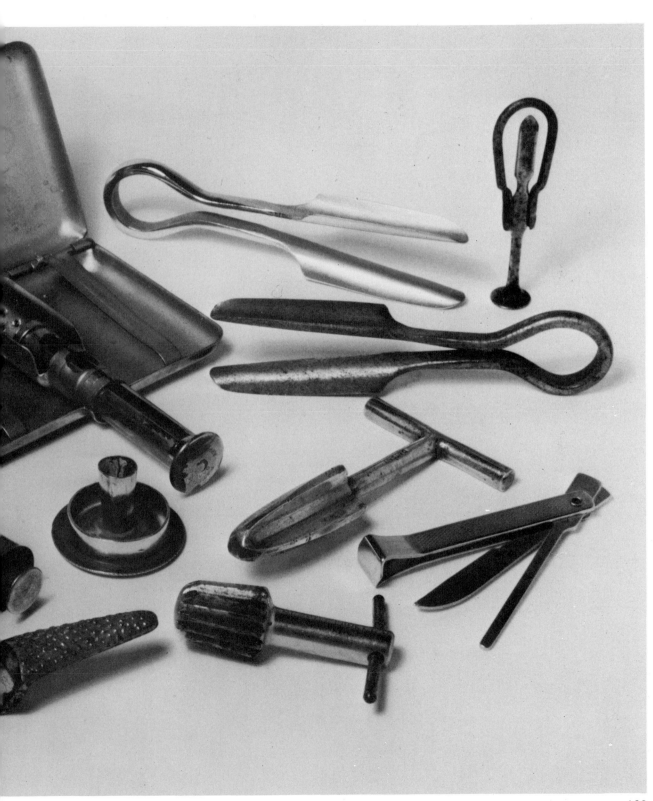

DOOR, STREET AND GARDEN

The metal for street 'furniture' and indeed for that of the approach to the house, whether by door or window, must obviously, in the first instance, be iron; it is hardwearing and strong and so can withstand the attacks of the elements as well as of raiders.

7 In early times the door was heavily reinforced with bolts, strong locks, studs and iron strapwork. I have heard that this strapwork, along the coast of East Anglia, was made of old sword blades taken from conquered invaders, but I think this unlikely: a good blade was far too valuable to waste on a castle or church door. There may, however, be a grain of truth in the legend, and certainly no one, after the amazing discoveries of Schliemann at Troy and Mycenae, would dare to refute totally local folk lore.

To summon the people within, a wrought iron bell-pull was usual; or a large ring knocker which probably evolved from the great handles on the early doors. Ring knockers still survive on many of our great churches and cathedrals: the splendid sanctuary 45 knocker at Durham is a famous example. From knockers of this nature, frequently made in bellmetal or gunmetal, was evolved the house knocker, vast on a castle door and modified for a town house. From the late 17th century onwards with the growth of town houses in London and in the great provincial cities of England, door knockers appear to have been in general use. Quite a number, surprisingly, are Italian of the late Renaissance. How these got to England is a mystery. It seems unlikely that they came in trade, and one can only assume that they were brought back by scholars, architects and gentlemen doing the tour of Europe (later to be known as the Grand Tour), or possibly by their agents sent out to purchase fitments for a new house. As a general rule, however, they were made in England in cast brass or iron, and in every possible pattern. The earlier ones are fairly simple: a reference to the owner's coat of arms, a dolphin, a lion's mask (an early example of this being the knocker on the door 163 of 10 Downing Street, London). At times one finds a strong classical feeling, e.g. a Medusa's head, a

145 Bronze knocker at Durham cathedral. 12th century.

shield, a lyre, an eagle, an architectural design. With the coming of romantic feeling later, there are wreaths of flowers or a hand clasping a bar.

One of the less reputable delights of the young bucks of the Regency period was to roam the streets of fashionable London, knocking off doorknockers. I do not suggest that this is the best technique for the modern collector to acquire his specimens, but I would recommend him to watch when old houses are being pulled down, as pieces may be acquired from demolition men for comparatively little.

As life grew a little more settled and towns increased in size, the need for strength lessened and was replaced by a desire for decoration. Other metals – latten or bronze and, later, brass – were used for knockers, knobs and escutcheons. Iron, naturally, remained for railings, for link extinguishers to snuff 146 out a torch and for grills over a window. It is from these grills, possibly, that the gracious balconies and balconettes, 'the poor man's balcony', developed, so typical of Georgian and Regency elegance.

Atop the houses of many people was the weather-vane. Incredibly this may be traced back to glorious Athens: there was one on top of the delightful temple known as the Tower of the Winds, just below the Acropolis. The vane was in the shape of a bronze Triton, pointing a wand in the direction of the wind. They were known and used in England from Norman times; and in the 17th century, in the great houses of merchants and nobles with shipping interests, they operated wind-clocks. The weather-vane – or weather-cock – turned in the direction of the wind and, by a system of gears, was connected to the wind-clock displayed frequently over the fireplace. 21 By this means, in a city such as London, a merchant or king could tell the prevailing winds, and it helped him to work out the time it might take his ships or men-of-war to make harbour. One can be seen in Kensington Palace.

In England the most popular motif appears to have been the cock, which is why they are frequently known as weather-cocks. But equally popular, and an obvious choice, is the arrow, often found in gilded metal. There are numerous famous examples of weather-vanes: one is the Father Time over Lords

signs originally displayed on the wall, and coal-hole covers formerly in the pavement where they provided a moveable cover to the coal-cellar.

Fire insurance originated in the 17th century and by the 18th century, with the growth of the business, it was customary for the householder who had entered into an agreement with an insurance company to display on the outside of his house a 'fire mark', usually of metal, which, since many houses had no formal address, served to identify the property insured. This mark, in addition, acted as an advertisement for the insurance company and also, as many of the companies carried out their own firefighting with their own fire brigades, as an indication that the householder was insured and, therefore, that this was the house to be looked after. The fire mark showed the trade mark or arms of the insurance company; 148 typical examples are the sun (a round face with rays), the phoenix rising from the flames, the liver bird. In addition, the early ones showed the policy number; obviously the older the sign the smaller the 147 policy number. Records still exist and policy numbers may in many cases still be verified. Until

150 Cricket Ground in London, signifying the end of play. Another is the grasshopper of Sir Thomas Gresham, the founder of the Royal Exchange in London. This was also used as a shop sign for grocers, Sir Thomas himself being a merchant grocer. And it was even transferred to the New World where a Boston coppersmith named Shem Drowne used the same motif for one of his most popular designs. One of his weather-vanes in beaten copper equipped with green glass eyes is still seen on the home of the Faneuil family. This grasshopper pattern remained popular in both countries for well over 100 years. Gradually the range of design widened and other subjects came into fashion: in America, for example, a trotting horse with sulky, or the figure of an Indian, often holding bow and arrows, and in either painted or gilded metal. For the sportsloving English country gentleman, an obvious choice was a fox and hounds in cry. Weather-vanes can be extremely attractive examples of folk art but, because of their size, are probably one of the things best collected in photograph form.

From the outside of the house there are at least two curiosities remaining for the collector: insurance

147 Lead insurance fire mark, with number, dated 1799. Sun Alliance & London Insurance Group.

148 Copper insurance fire plate. Late 19th century. Sun Alliance & London Insurance Group.

149 Insurance fire plate. Private collection.

about 1800 most offices made their marks in lead; later they used copper or iron and tin. Later marks, bearing no policy number, are more correctly called 'fire plates' and were used for advertisement only. These fire marks and fire plates are much sought after and many collections of them have been made. A word of warning: owing to their popularity, many copies of them have been produced.

51 Cast iron coal-hole covers–or coal-plates–are now collected. Strangely, only as they are becoming scarcer with the replanning of towns have people realised the appeal, from the point of view of interior decoration, of these pierced and decorated disks against a plain background. At least fifty different designs are known, nearly all vaguely 'Neo-Gothic' in feeling. They can be very effectively displayed accompanied by the long panels of decorated iron that protected the glass-panelled door of a Victorian house.

Of all the pieces of door furniture, the key is perhaps the most popular, and here the collector, if very fortunate, may possibly find Roman or medieval specimens, obviously in a corroded state, but re-cognisable and a great asset to a collection. It is unlikely nowadays that fine early specimens will be found as these are now mostly gathered into museums.

At this point I should like to stress the fact that the collector of antiques nowadays is in some ways rather like the big game hunter: he often has to be content to 'shoot' with his camera rather than his gun. The really fine specimen is probably not for him to own, but he can know where it may be seen and he can augment his collection with newspaper cuttings, notes, illustrations from museums and so on. This information adds to the interest to be gained from visiting galleries, museums and various displays, and it will certainly strengthen a collector's judgment. Another point that I should like to make is that one should not totally despise a copy of a work of art, provided that it is recognised as such (e.g. an official museum reproduction) and not meant to deceive. Such a piece may well be useful to complete a collection and also to learn from. I have dealt with these points more fully in 'Fakes, Forgeries and Reproductions' on page 167.

148

149

150 The famous Old Father Time weather-vane at Lords cricket ground, London.

151 Coal plate set into the pavement in Chelsea, London.

152 Door stoppers. Private collection.

153 Bedroom doorknockers. The one in the middle of the bottom row is a miniature replica of the great knocker at Durham cathedral (see 145). Private collection.

Keys are excellent examples of fitness for purpose 154 combined with unconscious rightness of design: the ring part of the key, known as the bow, balances the 'bit' – the name for the part that goes into the lock – and they are linked by the long shank. Frequently these became *tours de force* of the locksmith's art. Early keys, up to the 16th century, were normally plain and simple: any specimens that are elaborate are probably best viewed with reserve, although they may be apprentice pieces, i.e. made to pass a test for admission to a guild of master craftsmen. From the 16th century through to the late 17th century, the keys and locks of France were pre-eminent in Europe. England made locks as technically efficient but rarely put the amount of superb decoration on them. The French locksmiths' guild maintained this high standard up to the time of the Revolution, encouraged by the king, Louis XV, who, it is said, would have made a superb locksmith; he certainly had a great affection for metalwork and maintained many craftsmen at Versailles.

Locks, unless they have survived in use until the 155 last 100 years, are hard to find and, as with keys, French locks are probably the best; but by the late 17th century English craftsmen were producing fine locks, many of which still survive in country houses and in such palaces as Kensington Palace and Hampton Court. While the continental craftsmen liked cut-steel for decorative effects, the English cased their locks in fine chased and overlaid brass, frequently gilded. In the 18th century, with the arrival in England of mahogany as the most important wood for doors and furniture, there appears to have been a tendency to go over to steel locks. Inevitably they reflected the taste of the period and, towards the end of the 18th century, were efficient and restrained. This tendency continued into the 19th century when locks begin to lose interest for the collector – there being very few with sufficient decorative appeal to induce one to want to collect them. With the use of mahogany, doors were frequently made thick enough to conceal a lock within them; this was of the type known as a mortice lock and it gave a cleaner line to the door, leaving both sides clear.

From the 18th century onwards, the door was 158 usually fitted with a garniture of keyhole escutcheon, fingerplate and doorknob, all matching and the

design frequently inspired by the classical. If the designer was of the calibre of the brothers Adam, then the design would be en suite with the rest of the room. This meticulous care was the hallmark of a great architect-designer and it would even extend to servants' bell-pulls, curtain ties and the like. Of all the furnishings of the 18th and 19th centuries connected with doors, probably the most decorative are the fingerplates with their tremendous variety of art motifs. They are found in cast and pressed brass, in engraved steel and in cast iron. Of recent years there has been a fashion to use them again for their original purpose, and the earlier and finer ones are becoming difficult to obtain. With the demolition of older properties nowadays, cheaper fingerplates, and indeed sets of fingerplate, keyhole escutcheon and 155 doorhandle, made in the 19th century for the smaller home, are coming back on to the market. They are well worth including in a collection.

154 Curtain ties, mentioned earlier, were large U-shaped decorative fitments placed on each side of a great window to hold the curtains back when required. They were nearly always in brass or ormolu and had great charm. I have seen them used for their

original purpose. I have also seen them turned into bookends.

By the 18th century professionally made door- 15 stoppers were in existence – the old name for them was 'door porters' – and they appear in iron or brass or sometimes a combination of both. One of the earliest porters is a brass base, usually weighted with lead, shaped like a half bell, sphere, pillar or globe, with a long thin handle of about 18 inches. By the time of the Regency there was an extremely wide range of door porters, their designs frequently of classical or traditional inspiration, such as the Regency honeysuckle pattern, shells, baskets of flowers, a lion's paw and so on. By the 19th century one finds doorstops in the shape of popular figures from Dickens, as for example Pickwick, and also Punch and Judy doorstops, inspired by the magazine *Punch*. Incidentally, these doorstops were made considerably later than most people think; some were still being made in the 1930s.

At some undetermined period, doorknockers started to appear on inside doors and were certainly being hung on study and bedroom doors as early as 15 1880. From then on the popularity of these curious

155 An 1883 advertisement in *The Ironmonger* for a suite of door furniture. The prices are interesting to compare with today's. Museum of English Rural Life, University of Reading.

156 Keys and keyrings provide an endless variety of shapes and sizes. Private collection.

little knockers increased. The Birmingham souvenir trade eventually took them up, and cast brass knockers were produced in an ever-increasing variety of design. It is interesting to note that certain knockers were for sale only in the district for which they were made, e.g. the 'Dartmoor Pixie' was restricted to sale in Torquay, the 'Public Library New York' was restricted to New York, and many Canadian and American towns and colleges such as Quebec, Toronto, Cornell and Yale imported them for this sort of restricted sale. There were over 250 patterns, to my knowledge, being manufactured up to fifty years ago by one Birmingham firm alone. The designs incorporated city arms or objects of notability such as the Lincoln Imp, the Durham sanctuary knocker, Shakespeare's House and the Houses of Parliament. There was an heraldic range, a Shakespearian range, a Dickens range and one for colleges and universities. There was a marine group comprising ships in sail of various periods, and the heads of famous seamen such as Nelson, Raleigh and Drake. One surprising one is the Declaration of Independence with Lincoln's head in a plaque as the knocker.

157 *pages 132–3* Penny toys of painted tin, made in Germany for the English market. About 1890. London Museum.

158 A magnificent set of lock and key with a pair of hinges in pierced and engraved brass over blued steel. Made by John Wilkes of Birmingham in the early 18th century. Victoria and Albert Museum, London.

159 Brass 'detector' lock made by John Wilkes of Birmingham in about 1700. Victoria and Albert Museum, London.

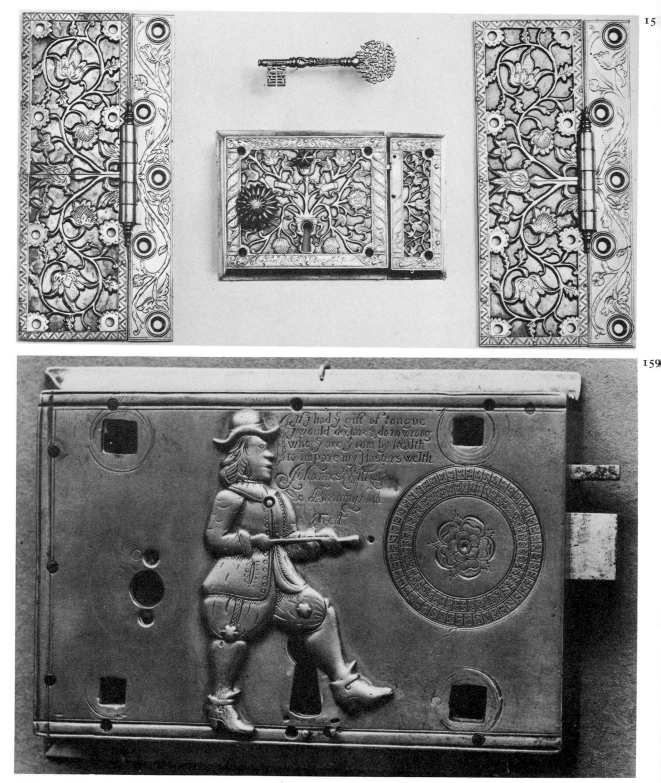

160 An iron door stop. Brighton Museum.

161 *pages 136–7* A collection of coin scales, coin cases and a special coin tester, with nine slots, which was once set in the counter of a shop. Private collection.

With articles of this nature which were virtually mass-produced, the earlier specimens are much more finely finished than the later and therefore that much more collectable. Curiously enough, many of these patterns also turn up on toasting fork handles of the period, probably being made by the same firms; here too the finer quality ones are the earlier and these too are now becoming rare.

In many respects these brass knockers are comparable to fairings, Staffordshire or German pottery figurines which were sold at fairs as keepsakes. Both groups are a mirror of the popular taste of the time.

Another collectable item that is now becoming scarce is the panel of bells found 'below stairs' in old houses. Ruthlessly ripped out in conversions and demolitions, some of these sets of bells have been saved and made into individual table bells; they were often very well made and gave a fine note. If a small set should be found on a panel, it would be well worth cleaning and polishing, as the bells form an almost abstract art design displayed against a plain background.

Very attractive cast iron chairs, seats and tables have been made for use in the garden, conservatory and on the terrace. Their manufacture started in Birmingham, Sheffield and Coalbrookdale in the late 18th century when the idea again came to mind of using metal for constructing furniture and not merely to strengthen or decorate it. Decorative cast iron shoe scrapers and umbrella stands were also made to stand at the entrance to a house. Metal furniture is eminently suitable for outdoor use, and occasionally one finds unexpected and very early examples of its use in the home. There is a folding chair in wrought iron on show in Wilton House in Wiltshire, dating from Roman times and in use, I understand, up to the 17th century; and in the Victoria and Albert Museum **162** there is a folding, finely decorated iron chair of the mid 18th century from the great Russian industrial town of Tula. Occasionally through the 18th and 19th centuries, interesting experiments were carried out with house furniture made entirely in metal. Sprung steel chairs, for example, were made in Birmingham in the late 18th century which are incredibly modern in design and feeling; and in 1833 John Louden in his *Encyclopaedia of Cottage, Farm and Villa Architecture and Furniture* was advocating metal chairs, beds, sideboards and tables for farmhouses and villas.

160

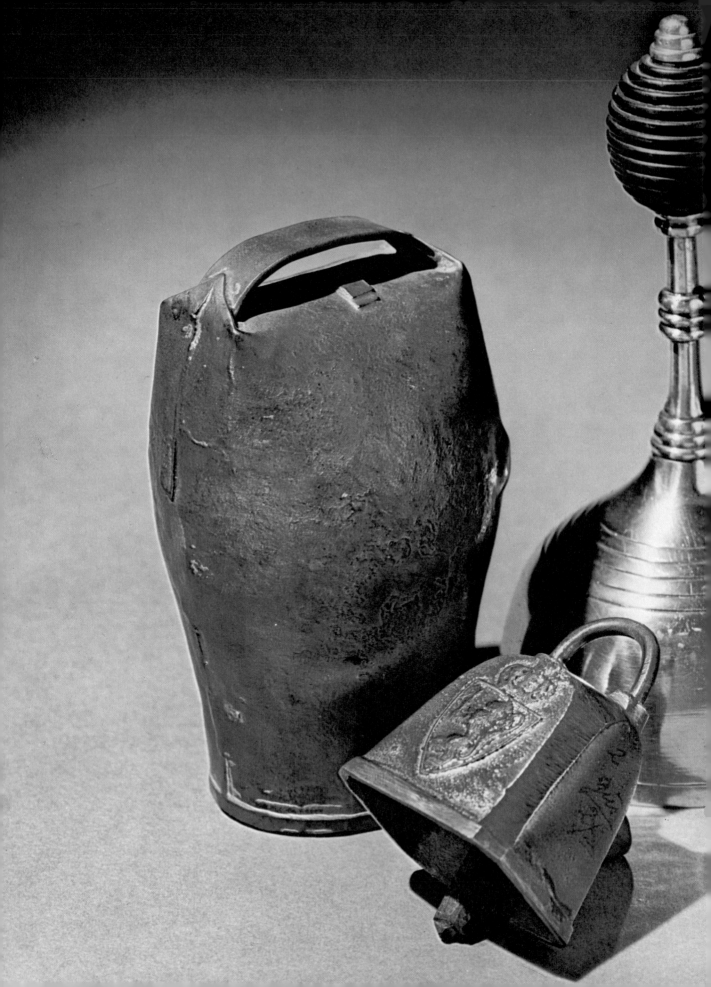

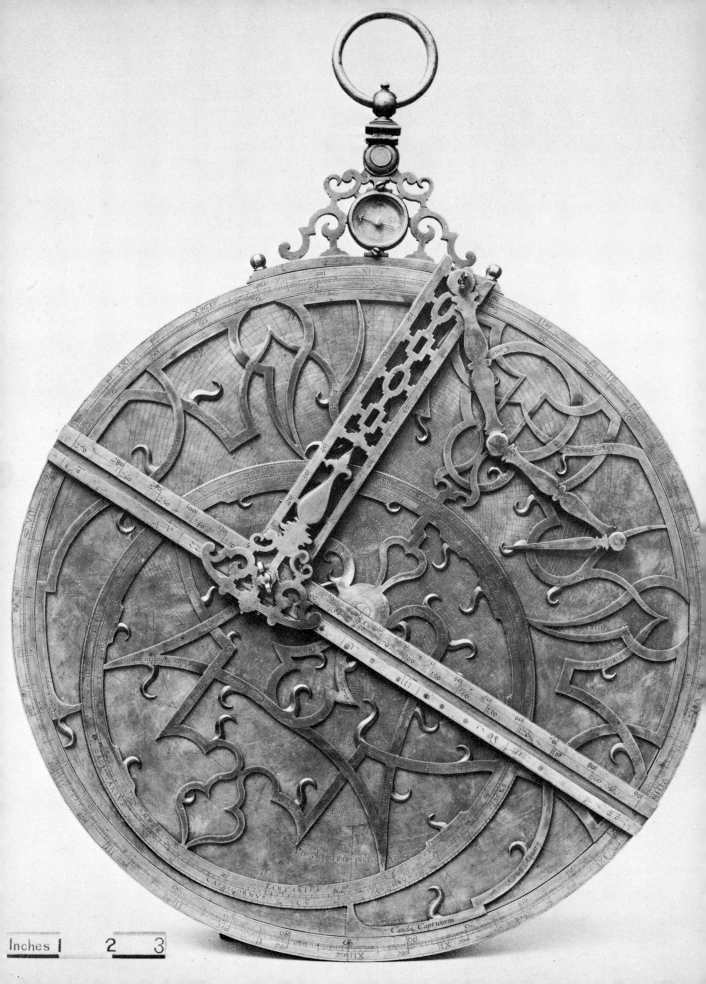

Inches 1 2 3

SOME TOOLS AND IMPLEMENTS

Tools and implements cover such a wide, and at the same time specialised, field that it is possible in this book only to touch on a few and rather to make suggestions as to the direction or form that a collection of such items might take.

It is a specialised type of collecting in that it often depends upon a person's professional knowledge as well as his tastes and interests. I know, for example, of several doctors with interesting private collections of early surgeons' and dentists' tools and of a chemist with a most comprehensive collection of articles connected with the dispensing of medicine. Other such specialist items in the medical field are barbers' shaving and bleeding bowls. Until the mid 18th century, the barber carried out some of the offices of the surgeon. It was in 1745 that the two interests parted, the barber being allowed to retain the red-and-white pole, the symbol of an arm bound for blood letting; the brass cap on the end of the pole signified a cupping dish or bowl to catch the blood. These bleeding bowls are rare and worth obtaining as are the great bowls with a half-round cut in the rim used by barbers for shaving a customer. These bowls have been copied in modern times, unfortunately. In this field of medical implements there is the important Wellcome Historical Medical Museum in London, a private collection, the greater part of which is open to the public.

There is also a field for specialist collecting in artists' and architects' drawing instruments. Early pairs of compasses and dividers are especially beautiful, many being elaborately made in the shapes, for example, of two dolphins, of a man and a woman or of a pair of legs.

Several collections of this type that I know have started through the actual use of an inherited tool, and this is especially true of such everyday tools as the hammer. I have known other 18th-century tools rehafted and still continuing in use, especially with the finer trades such as watchmaking, inlaying and the like, up to the present day. Across the centuries

166 **Planispheric astrolabe made by Ferdinand Arsenius of Antwerp in about 1610. Science Museum, London.**

the skill of one craftsman is recognised by another craftsman, and respect is paid. Occasionally it is possible to trace the actual tools known to have been used by a famous craftsman. Two excellent examples of such tools continuing in use are those of Stradivarius, now owned and used by a famous London firm of violinmakers and, I understand, the lathe of Thomas Tompion, the great clockmaker of the 17th century, which is still in use with a famous firm of clockmakers. I myself have the checkering tools of Tranter of Birmingham, the inventor of the Tranter revolver.

What other people may be attracted by is the thought of a collection which reflects the past of their locality and here the collector will be limited to a certain extent by the size of his house as well as that of his pocket. People who are lucky enough to live in the country will realise how rapidly the tools of old crafts are disappearing. Blacksmiths' and farriers' workshops still turn up the occasional strange tool or unusual implement, as does the old-established farm. All of these things are worth collecting if you have the interest and space. Remember that any collector is basically a benefactor to his community inasmuch as he holds in safety not only the bygone articles and antiques of his own day but also, if he is discerning, those of tomorrow. With the rapid increase of technology during the last 20 to 30 years the mortality rate amongst old tools and implements is assuming alarming proportions. As far as England is concerned this will increase yet more rapidly when the country goes completely metric because most old tools, and this applies also to the threads on screws, have some connection with the old measurements of feet and inches. Fortunately many provincial museums have wisely foreseen this and have been stock-piling these articles; an excellent example of this is the Hampshire County Museum Service which has accumulated a large quantity of folk pieces, including many tools which take their place together with the bygone ephemera of the kitchen and the parlour as objects mirroring the past. Not only does the skill and efficiency with which the pieces were made appeal to the collector but, surprisingly, in many cases they may be compared with modern

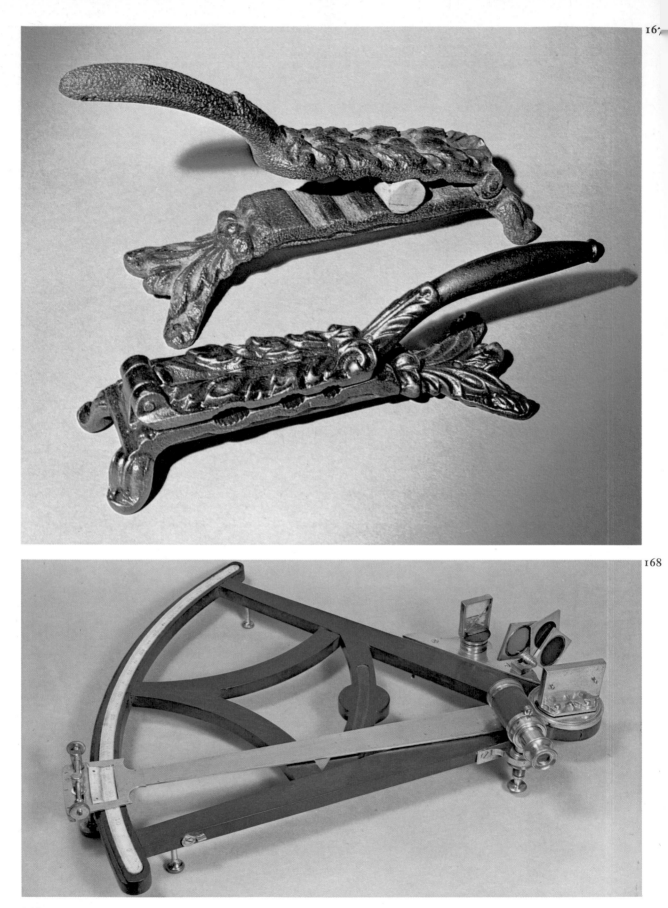

167 Cork-shapers. Private collection.

168 Sextant of the type used by Captain Cook during his survey of Labrador and Newfoundland. National Maritime Museum, Greenwich, on loan from the Ministry of Defence (Navy).

169 Some pharmaceutical implements: a pewter caster oil spoon of 1870, a brass and lignum vitae pillroller with boxwood finisher of 1890, and a cork-shaper of 1900. Cambridge and County Folk Museum.

169

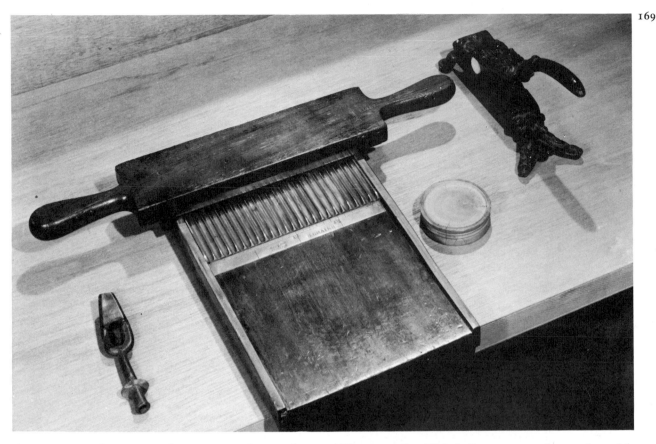

abstract art. 19th-century planes are good examples: the combination of clean steel, fine wood and polished brass makes for a remarkably handsome article. I was amused recently to see one put in the place of honour on a coffee-table as a 'conversation piece' and, in the ensuing conversation, learned that this was of the type known as a 'mother-in-law plane': the shavings came out of the mouth in unbroken ribbons. Planes are still to be bought but are rapidly coming into the collecting field as fairly expensive items.

Less easily recognisable but equally fascinating are the many specialist tools that were made by a craftsman for his own use in an individual trade. One variety of such tools is that known as the 'combination tool'. This was a tool made to adjust to several different uses, certainly used by gunsmiths and watchmakers and probably by many other trades. These tools are well worth studying, collecting and preserving. Equally interesting to many collectors is the fact that one may find almost identical tools called by different names and classified under different trades. This is because a tool, popular with one trade in one district, was found to be of use for other trades whose craftsmen then adopted it, making slight modifications where necessary.

It is a fascinating fact that the general pattern of primary tools was laid down some 2000 years ago: there is an easy comparison between a Bronze Age adze and the steel one of today, and the Roman plane is uncannily like our own planes. It was this capacity to make tools which enabled man to progress, fairly slowly for the first 1500 years of our era but more rapidly from the time of the Renaissance. By the 19th century tools of the most complex and ingenious kinds were being produced.

A good source for tracing early and unusual tools is to be found in workmen's private notebooks of trade secrets and in early trade catalogues, published now for nearly 200 years. As early as the late 17th century, some Parisian craftsmen, for example Hollandois and the famous Berain family of father and two sons, were publishing patternbooks of

170 Horsebrasses with some typical designs,
including the sun, moon, stars, hearts, etc.

171 A much used waggonjack. American Museum
in Britain, Claverton Manor, Bath.

designs; and reference books giving the use of tools were also known at this period. There are similar books which describe the different techniques of working, sometimes with illustrations of the actual tools used. Perhaps one of the richest sources for tracing unusual old hand-tools is the great encyclopedia of Diderot. This vast mine of knowledge has page after page of illustrations of tools of the gunsmith, wheelwright, carpenter, cannonfounder, etc. Journals, diaries and country magazines, too, often provide useful information. In England, one of the best sources for this sort of information is *Country Life*, a magazine which encourages, in its correspendence columns, reference to and photographs of

172 Bells, including cow and sheep bells. The frame with the three bells was made to fit into the harness of a carthorse. Brighton Museum.

173 Billhook blades. Museum of English Rural Life, University of Reading.

unusual objects. Again, many of the county anthologies produced by genuine lovers of the countryside in the 1900s are frequently of use. Although the approach is sometimes over-sentimental for our day and age, the authors often put on record descriptions of tools and techniques which by now might otherwise be forgotten. An excellent example of this occurs in a book that I was recently reading on Sussex. Written in the 1900s, it describes in considerable detail and with a photograph the tool used to place protective brass knobs on the horns of oxen used for ploughing at that time. It is most unlikely that such a tool, if found today, would be recognised without such an explanation.

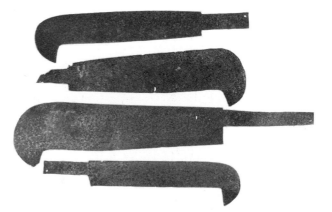

Broadly speaking, tools fall into well defined groups such as agricultural, professional, nautical, etc. Sometimes the groups, if large, may be broken down further, as for example in the case of agriculture, where you will find farm implements, smiths' and farriers' tackle, thatching tools and the like. In one section alone of agricultural implements, the cutting tools, there is a tremendous variety to be found in scythe blades, sickles and bill- or hedge-hooks. While there remains a great deal of research still to be done on this subject, we do know that one of the reasons for this variety is that, in the old days of hand-forged implements, certain notable smiths in each county evolved their own individual styles and types. Certain museums show a good range of farm artefacts, notably the Museum of Rural Life at Reading which has a most comprehensive display of agricultural implements and especially of 173 sickles. Billhooks have always exercised a fascination because of their thrilling ancestry, going back, as they certainly do, to the 13th century. Between then and the 16th century, before the forming of a modern army, the king would raise, when needed, his 'Shire Levies'—Welsh bowmen from the lands of the

Marcher Lords and billmen from the English counties, who would rehaft their hedge- or billhooks upon a long pole, thus making a fighting weapon. These pole-arms, or bills, were called Brown (or Black) Bills because they were tarred or painted possibly to reduce the shine. Some years ago I was shown a 19th-century agricultural catalogue which specified the different bills it had for sale: the Northamptonshire Bill, the Hereford Bill, the Northern Counties Bill, and, to my great interest, they were all slightly different in shape. It is possible that these county shapes are the descendants of the old Brown Bills carried by Englishmen up to the time of the Tudors.

An object very popular with many collectors because of its decorative value is the horsebrass, but it 170 is a little difficult to know how to catalogue it because, while very definitely a part of everyday working life, it is patently an ornament. Like so many items we collect, its origin is difficult to discover. This is all the more surprising since it is only during the lifetime of many of us that these brasses have started to disappear from the daily scene. It is probable that, from the time when man first tamed the horse, some sort of decoration similar to the brasses we know has been used. Their basic shape is round, and to all early peoples this round shape, which was probably the origin of the horsebrass, was a symbol of the sun. In early times, men worshipped the sun, whose warmth brought crops and comfort, all over the known world, from the Mediterranean lands to the Scandinavian north. Danish Bronze Age girls wore a sun disk, and something very similar appears on the harness of Mycenean war horses. At the same time the sun symbol is found in countries as far apart as China and Scandinavia as a sign of rank and, possibly, to ward off evil. By the medieval period, knights were decorating their harness with metal lozenges and trappings, possibly influenced by the development of coat armour (enamelled plates are known with the device of a great family on them). It is out of beginnings as simple and as distant as these that the amazing range of horsebrasses known to the collector today has probably developed. Horse-brasses as we know them really had a very short life, lasting from the late 18th century to the early 20th century, roughly the period when the power of the Industrial Revolution reached its peak. The field of

175 Official sets of weights and measures. *left, front* Cast bronze 7 lb wool weight of George IV. *left, rear* Three standard brass weights from Rye, Sussex. *centre* Four small 19th-century brass weights in a special case. *right* Three bronze standard liquid measures dated 1826. Sussex Archaeological Society, Anne of Cleves House, Lewes.

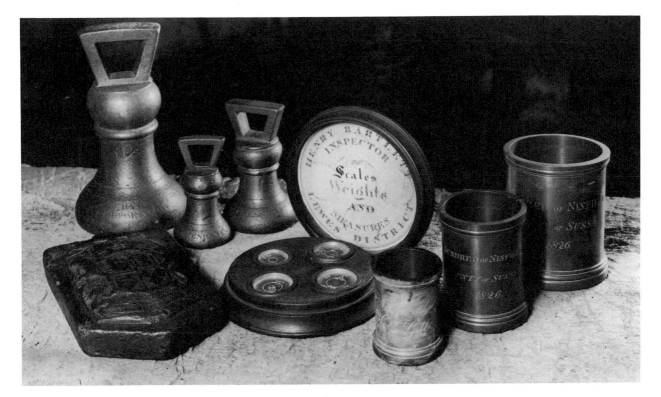

design is almost limitless and well worth tracing. Workers on the great estates would adopt the arms of local important families and, in the same way, carriers and carters would take various emblems such as those of the national arms (lion, unicorn, rose or shamrock) or of the county or city arms (the Gresham grasshopper, for example, is known as a horsebrass). Cart horses can still be seen decked in all their glory at the annual parade in Hyde Park in London.

There are other pieces of brass finery in addition to a large number of brasses worn by a working horse. These are even more specialised, such as terrets or swingers worn above the horse's head, hame plates fitted in the collar and martingales below the collar on the chest. In the great days of wagon transport, carters and carriers sometimes had what was virtually a peal of bells atop the horse. Highways and lanes were leafier than now, and it was necessary to have audible notice of the approach of a haywain or wagon driven by a team of horses. Each man had his own tune, known to many on the
172 road. Some horse harness incorporated small bells called 'rumblers'.

The long straight coaching horn, frequently two or three feet long, served the same purpose. It was carried near the coachman in a wickerwork bottle or holster in which it rested and was drawn and blown to signify the approach of a stage coach to a market town–to warn the innkeeper to get the food and wine ready–and on approaching crossroads to let people know that a stage coach or carriage was approaching. Its smaller brother, the hunting horn, is still used today and goes back well into the 18th century. It is possible that it evolved from the curled French horn, becoming ever smaller and more neat to carry easily while hunting.

Bells in general are pieces of equipment of which 156 the smaller examples can make a collection in themselves. Known in Europe for at least 1500 years, the great bells of church and hall have been used to mark many national, religious and social occasions: as an alarm in war or peril, for rejoicing in victory and in festivity, for weddings and funerals, to record the time in religious and other houses. The great bellow (yes, it is the same word) meant much to people without our modern means of communication. When casting became the normal method of making bells,

176 South German cup or chalice sundial dated 1596. Science Museum, London.

177 Butterfield-type portable sundial by Baradelle of Paris. Science Museum, London.

178 American pewter sundial. American Museum in Britain, Claverton Manor, Bath.

more attractive and older. They were, of course, made by professional bellfounders who in many cases used moulds dating from the 18th century. Horse, cattle and sheep bells are also important and are now becoming extremely hard to find. They are made in both bellmetal and in hammered iron. The shape, size and variety are surprising and so also is the note. The range of notes was early realised, and complete sets of bells with leather grips were made for use by church bellringers. They were used to practise the ringing of complicated 'changes', and this developed into a social form of entertainment in many parts of the country. Teams of handbell ringers would attend at weddings and festivals and indeed still do in some places.

Akin to bells, of a similar shape and almost certainly made by bellfounders, are mortars. These have already been mentioned among the kitchen equipment (page 50), but here I should like to draw attention to apothecaries' pestles and mortars. They were, of course, essential in chemists' shops, and an apothecary would often mark his personal mortar with his initials and a date; some of these initials may be traced in apothecaries' lists in the Wellcome museum in London. Among other essential items used by an apothecary were pillrollers – small blocks 169 of fluted brass, usually mounted on mahogany. On these blocks the pills were rolled: gilded pills for the very important, plain for ordinary folk. Cork-shapers 167 were another indispensable article. These were usually made in cast iron and consisted of a series of ribbed circular holes of different sizes, designed to squeeze the shape of the cork down to the requisite size. They are attractive items, and I have seen them turned into knockers, appropriately for a chemist's door.

England and the Low Countries both became famous for the skill of their craftsmen, and from these countries master bellcasters would travel to where bells were needed. In time smaller bells were made, and in court and manor house these became popular as an immediate method of calling a servant. Over the centuries an amazing variety of these smaller domestic bells became known: dining- and drawing-room bells, table bells, school bells, horse and cattle bells, A.R.P. bells. These last, used by Air Raid Wardens in Britain during the Second World War, are fairly scarce today because some antique dealers carefully erased the letters 'A.R.P.' to make them look

Early chemists' scales were all of polished brass and are now very much sought after. So too are the scales used formerly in grocers' shops, some of which had fine brass pans and frames. The weights used with them were frequently in brass, and these too are collected. Individual ones make fine paper-weights and the larger ones doorstops. In the 18th and early 19th centuries, nearly every merchant carried pocket scales and balances for weighing 161 guineas and sovereigns. These may still be found and also – but these are rarer – the brass counter-fittings used in a shop to detect a forgery or wrongly 161

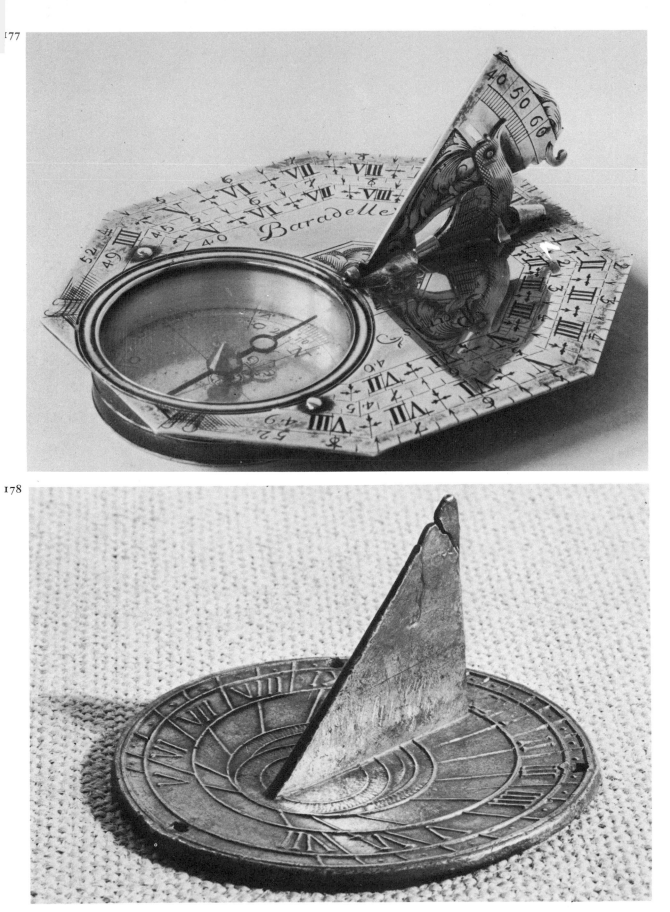

179 An American collector, Mr Don Taylor of Wichita, Kansas, with some of his 600 'sticks' of barbed wire.

180 Some of the hundreds of different kinds of American barbed wire. Reproduced from *The 'Bobbed' Wire Bible* by Jack Glover of Sunset, Texas.

181 A group of ancient hand-forged nails. Museum of English Rural Life, Universty of Reading.

The weights and measures of the city of Winchester comprise the finest civic collection in the country and include weights for wool dating back to the 14th century. The name 'Winchester' is still given to a series of measures, e.g. 'a Winchester gallon' or 'a Winchester quart', because of the former importance of this city, second only to London in the south of England.

Time-measuring instruments are of interest, especially the small 'ring dials' and other portable sundials used by travellers up to the 19th century. 176 Continental ones are often extremely comprehensive; some of them give tables showing the equivalent times in most of the capital cities of Europe, and some also give the current rates of exchange, curious evidence of economic stability.

In a range of their own and much sought after for the sheer beauty of their construction are sextants, 168 astrolabes and compasses. In the 18th century the 166 British excelled at making marine equipment of this nature.

A form of collection which has not received the degree of importance that it merits is the collecting of nails. Such a collection can range in time over the whole of the Christian era and has the advantage that, like for example barbed wire, also neglected 179, until recently, it takes up very little room. It is not impossible, even now, to find perfect Roman nails; for instance, some years ago a quantity buried by the quartermaster of a withdrawing legion was discovered in England. The nails were of such importance as potential weapons–they could have been forged into spears or swords–that they had been buried in order to prevent their falling into enemy hands. They were in excellent condition. Nails have always been important and, strangely, at different periods and in different countries have been used as currency. In the 18th century they were used for small change in Scotland and, again, in the 19th century in the United States. As the frontier of America advanced at that time, they were of vital importance, and one finds them referred to as a 'penny nail' or a 'threepenny nail'. This, of course, may have been the price of a pound of nails, but we do know that needles, for example, were a dollar each on the frontier. Nails were usually made in iron but occasionally in brass or copper where it was vital that corrosion be avoided. Hand-wrought ones are now 181

sized coin. A suspect coin would be placed in the slot of the counter-fitting which had weighted balances underneath; if the coin went through it was genuine. Connected with weighing are of course steel yards, both portable and large shop versions for weighing sacks of grain. These worked upon the principle of sliding a weight along the beam until balance was achieved, the beam being graduated with a scale.

Many important towns formerly had their own sets of standard weights, and sometimes these are in the 174 form known as bucket weights. These weights, in the shape of pots, were graded from very small to large and each fitted into the next size. The whole was encased in a container with an elaborate handle incorporating sphinxes or lions with a carrying grip fixed in the mouth. The name of the town is sometimes stamped on the rim, and on the base inside the weight is sometimes a guild stamp as well. These are normally made in gunmetal or bellmetal, are extremely handsome and greatly sought after. Individual ones are sometimes found used as ashtrays or as forming blocks in workshops.

Also made in bellmetal and frequently of an imposing design are the town measures for corn, ale, etc. Sets survive in many old towns and may frequently be seen in county museums as, for in-
175 stance, in the Anne of Cleves House Museum in Lewes and in the Westgate Museum in Winchester.

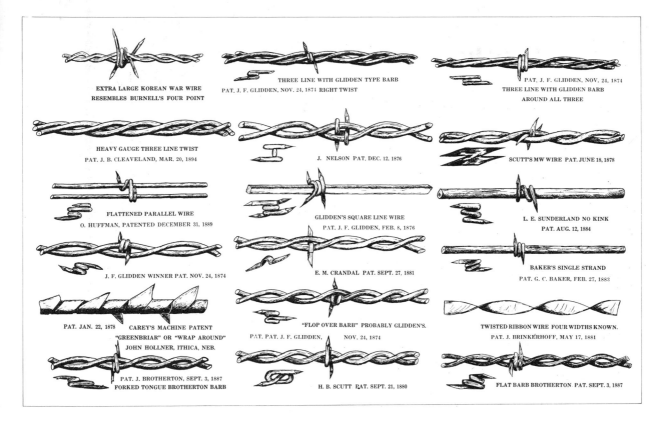

EXTRA LARGE KOREAN WAR WIRE
RESEMBLES BURNELL'S FOUR POINT

THREE LINE WITH GLIDDEN TYPE BARB
PAT. J. F. GLIDDEN, NOV. 24, 1874 RIGHT TWIST

PAT. J. F. GLIDDEN, NOV. 24, 1874
THREE LINE WITH GLIDDEN BARB
AROUND ALL THREE

HEAVY GAUGE THREE LINE TWIST
PAT. J. B. CLEAVELAND, MAR. 20, 1894

J. NELSON PAT. DEC. 12, 1876

SCUTT'S MW WIRE PAT. JUNE 18, 1878

FLATTENED PARALLEL WIRE
O. HUFFMAN, PATENTED DECEMBER 31, 1889

GLIDDEN'S SQUARE LINE WIRE
PAT. J. F. GLIDDEN, FEB. 8, 1876

L. E. SUNDERLAND NO KINK
PAT. AUG. 12, 1884

J. F. GLIDDEN WINNER PAT. NOV. 24, 1874

E. M. CRANDAL PAT. SEPT. 27, 1881

BAKER'S SINGLE STRAND
PAT. G. C. BAKER, FEB. 27, 1883

PAT. JAN. 22, 1878 CAREY'S MACHINE PATENT
"GREENBRIAR" OR "WRAP AROUND"
JOHN HOLLNER, ITHICA, NEB.

"FLOP OVER BARB" PROBABLY GLIDDEN'S.

TWISTED RIBBON WIRE FOUR WIDTHS KNOWN.
PAT. J. BRINKERHOFF, MAY 17, 1881

PAT. J. BROTHERTON, SEPT. 3, 1887
FORKED TONGUE BROTHERTON BARB

PAT. PAT. J. F. GLIDDEN, NOV. 24, 1874

H. B. SCUTT PAT. SEPT. 21, 1880

FLAT BARB BROTHERTON PAT. SEPT. 3, 1887

becoming scarce but were certainly made up to the 1900s in Birmingham. As with so many other trades in the 19th century, conditions for the workers were bad; and nails were frequently made by married women and young children working in sheds or the kitchens of their homes. Probably the last to be made by hand were the nails for horseshoes. With the increased use of machinery in the 19th century, machine-wrought nails superseded the hand-forged. 'French' or wire nails also occur; these were made of wire of the appropriate size, put through a machine and then given a head.

In the 18th and 19th centuries, before the principles of steel were fully comprehended, it was found that worn-out horseshoe nails could be used to make a good gun barrel. It was held that the galloping up and down the roads of England tempered the nail heads; it is, however, more likely that in the course of time the nail absorbed carbon from the horn of the hoof, and so added a toughening agent to the metal. Such gun barrels are found marked 'best stubs twist', referring to the stubs of horseshoe nails which had been laboriously collected and reforged to make the gun barrel. A good source for obtaining old nails is in old dwellinghouses which are being pulled down in the march of progress. The contractors frequently heap the timbers together and set fire to them – in the ash can occasionally be found 17th- and 18th-century nails.

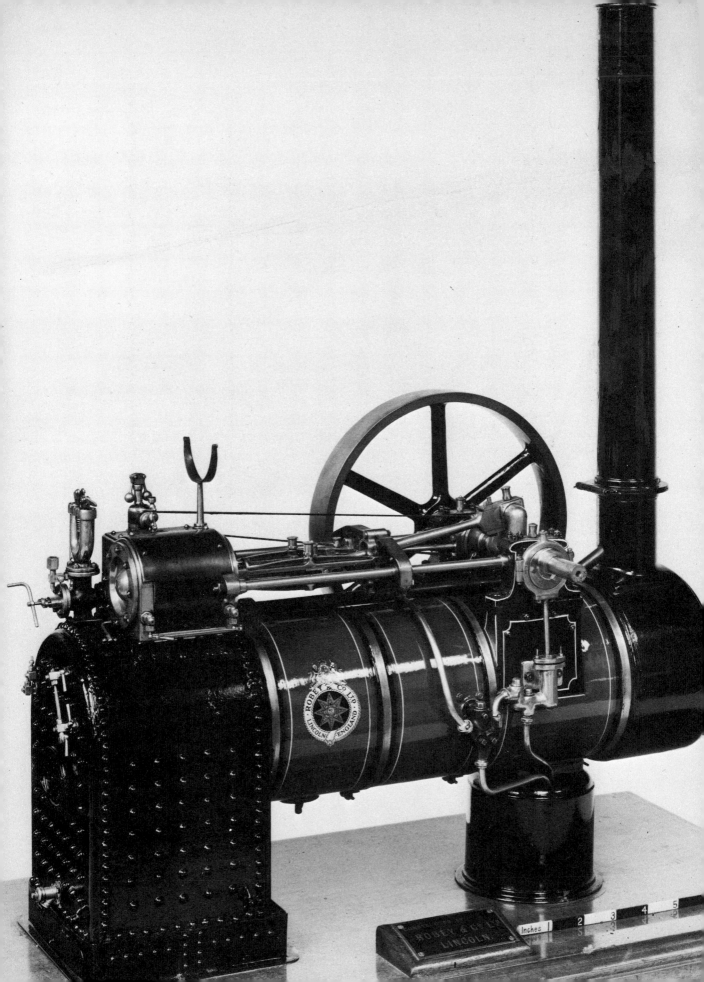

SOUVENIRS AND SAMPLES

In the early 18th century the English began to look further afield beyond their own shires, their ultimate destination being Rome, then believed to be the centre of the old classical world. Later, of course, they would aim for Greece, but at the time that country was still very much a part of the Ottoman Empire. The pattern for foreign travel was established, and the English milord started to lay down the travel routes that we still use today. Landing at Calais, some would go through Germany and over the Alps down to Rome; others would choose to travel through the château country of France and so to Rome. Frequently they would take the reverse way back, enabling them to make quite literally a grand tour. It is interesting to note that by the end of the 18th century American travellers are recorded as having done the Grand Tour, and they of course included England in their itinerary.

Although the travellers went well equipped with a comprehensive variety of goods, it is very probable that they would reinforce their equipment with pewter pots, dishes, wine or water flasks, candlesticks and various pewter boxes including, of course, both snuff and tobacco containers, all purchased on their journey. In addition, the Continental, whether he was in Germany, in France or in Italy, soon realised that there was a market for 'curios' to sell to these travellers, and in time a wide variety of these goods also started to percolate back home. Obviously many of these goods were in metal, much of which has survived. The Rhine and the Low Countries had a fine reputation for the production of good pewter work, certain towns such as Nuremberg and Strasbourg being important centres. The Low Countries also, and particularly the area of the Meuse, had been famous for several hundred years for their brass ware, known as Dinanderie in the medieval period, from the town of Dinant which was the centre for this work.

These pieces, purchased for use or of necessity—plates, beakers, wine flasks—were frequently decorated with the arms of the town or of the town guild, and sometimes with details from the life of a local saint or ruler. This would cause comment back in England, and it is possible that from this trade would develop the continental trade in souvenir goods. An early example of such souvenirs is provided by the small brass cannon marked 'Waterloo', 202 which were sold to the English tourists after that battle. A Belgian museum official once told me that it is believed that these were sold as early as 1816, just one year after the battle. In addition to manufactured souvenirs, the Belgian peasants were not averse to making what they could out of the recent struggle in other ways. There is a superb painting in Apsley House, London, showing either Belgian peasants or gypsies proffering to English visitors in their coach a collection of breastplates, helmets and broken swords as souvenirs of the great battle of Waterloo; in the background can be seen a ploughman busily ploughing up more relics on the site of the battle. Here is an excellent example of how the trade in antiques or curios started in the Low Countries.

The wealthier peasant family in the Low Countries had long been used to dishes, bowls and chargers decorated by hand in relief with repoussé patterns. The subjects chosen for this decoration were frequently inspired by Dutch paintings of the 17th century, by perhaps the coats of arms of guilds and towns, and sometimes by the floral patterns on their Delft plates. From this tradition of hand-craft there had developed by the 19th century a form of stamped brassware—ewers, jugs, plaques—which became very popular. The subject-matter frequently shows tavern scenes with peasants carousing, spurious coats of arms, women peasants spinning and weaving, etc. The general style is 17th-century in feeling but obviously 19th-century in manufacture. The popu- 72 larity of these pieces was such that several English firms, probably in Birmingham, started to make them and the trade in this style has continued to the present day. The earlier examples, as with so many articles that we have discussed in this book, are well worth considering as collectable objects: their quality was good, the metal used was heavy and the patterns had immediate appeal.

182 Model of Robey's semi-portable over-type engine. Science Museum, London.

In Italy, as will be seen in the chapter on forgeries (page 167), a vast number of pseudo-classical pieces were made. It is possible that some of the pieces were deliberately made for the discerning antiquary who could not afford an original but would be satisfied with a meticulous copy. Unfortunately, all sorts of peculiar objects were produced, all under the cloak of antique pieces, some good, some bad. An excellent example is a little table-dish inspired by the pieces being excavated in the late 18th and early 19th centuries in Italy, the centres of which were of course the great excavations at Pompeii and Herculaneum. This particular one is patinated to a dull brown to simulate the antique, but there are many variations of this font or table. One superb example is dated 1811 and was made by Luigi Manfredini in ormolu, lapis lazuli and silver-gilt.

193 For those intrepid travellers who ventured south beyond Rome and down to Sicily, extremely attractive puppets were to be acquired. They were normally made to depict battles between good and evil and were shown as knights dressed in beaten brass to simulate Renaissance armour; the earlier – and in this case the later ones also – are well worth collecting.

If the traveller returned through Germany, he would frequently pass through Nuremberg, long established as a centre for metalwork, including both pewter and brass, and famous for intricate mechanical contrivances especially complicated locks for both chests and guns, and clock mechanisms incorporating moving figures to strike the hours. By the 18th century a great trade in metal toys had developed in this city – pewter dinner services and doll's house

183 furniture for little girls and complete regiments of soldiers for boys. By the 19th century this trade

192 embraced the making of clever pressed tin toys which, when wound up, would dance, shuffle, play a musical instrument and generally entertain. These clever toys and their English counterparts are now very much sought after and have become a specialised branch of collecting.

187 Pressed tin toys go back to a much earlier date than is generally assumed. By the mid 18th century an American firm by the name of Patterson Brothers of Berlin, Connecticut, was making such toys, possibly as an offshoot of the tole ware industry, and in the early 19th century, after the Napoleonic Wars, the French started to make little mechanical automata

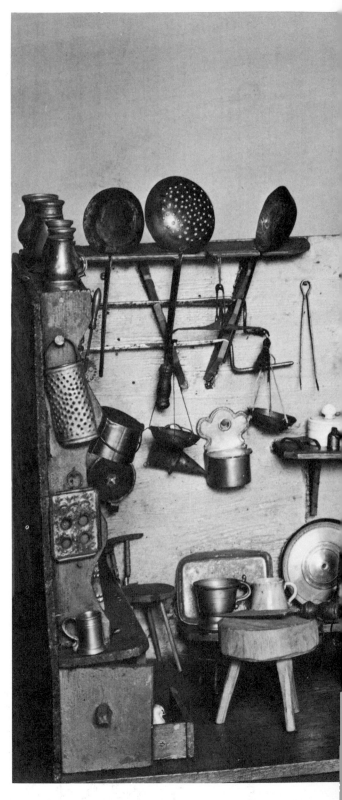

156

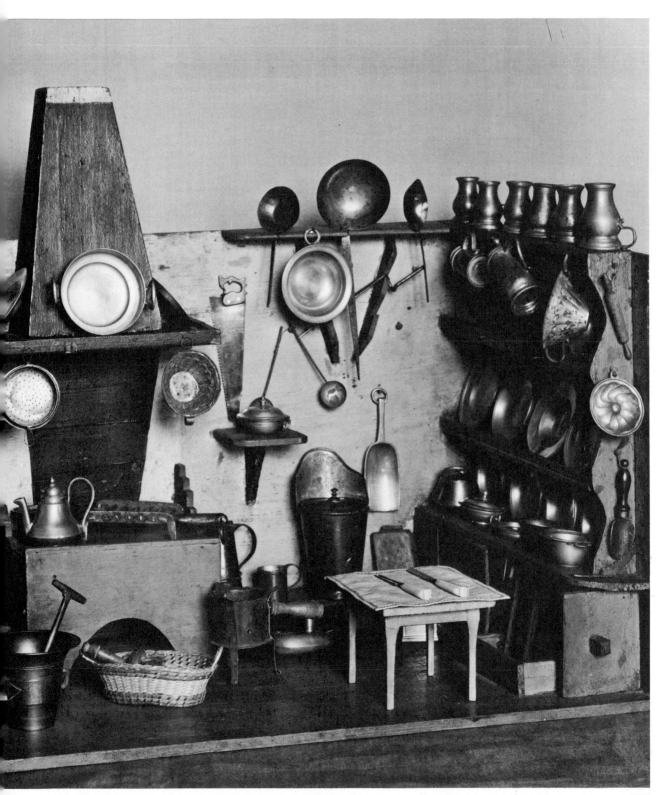

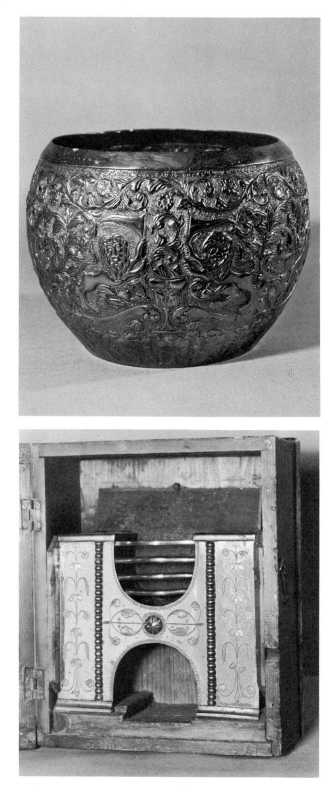

184 Benares brass bowl. Private collection.

185 Miniature engraved steel grate, of late 18th-century type, in a glass-fronted case. This is almost certainly a traveller's sample. Biggin Hall, Northamptonshire.

out of surplus war materials. By the mid 19th century many millions of toys were being produced by known 157 firms. If toy collecting is your bent, you should also consider the collecting of modern toy ephemera such as Dinky or Matchbox toys, showing such pieces as 191 veteran car models, aeroplanes, coronation coaches, all of which are now increasing in both interest and value at a remarkable rate. It is interesting that from its inception the shape of the motor car has been universally popular for toys and ornaments as well as for useful domestic ware and has inspired the makers of teapots, pincushions, trinket boxes, table lighters and ashtrays, among other things. All of these items are of interest to car enthusiasts as is also old car gear such as lamps, horns and mascots.

It is possible that some of the more complicated mechanical toys started as serious aids to scientific experiment. During the English Civil War in the 17th century when the court of Charles I was at Oxford, young cavaliers met elderly scholars, and from their interchange of ideas an interest in scientific experiment was established, giving great impetus to the Royal Society. Models were made, a good example being that of Newton's experiment with suspended spheres, now an amusing toy, but in the 17th century a strange experiment. In the same way, later, in the age of steam, British engineers would make superb models of large engineering plant to be sent as 182 prototypes to countries such as Russia who were considering the purchase of such machinery. When these became obsolete they formed the basis for toys; originally made for scientific instrument makers they were sold as educational toys and soon became popular. Similarly, travellers' samples made in cast iron by firms in the Midlands were taken over by children and nowadays are sometimes mistaken for toys. Small scale models in metal are known of 185 fireplaces, kitchen ranges, fenders, garden tables and iron chairs, which were carried by journeymen travellers in the 19th century to show prospective customers what their firms were making.

After 1816, brass and pewter chess sets are known with Napoleon and his marshalls on one side and Wellington and the allied generals on the other.

By the 19th century the middle classes were touring through Europe, shepherded by the great firm of Cooks, and the souvenir trade received an additional impetus. Cathedrals and religious centres on the

186 American cast iron penny banks: *left* Tammany and *right* Creedmoor (1877). Pollocks Toy Museum, London.

187 Tin animals made in Nuremberg by the Hilpert family in about 1780. Germanisches Nationalmuseum, Nuremberg.

188 American miniature pewter 'pigeon-breasted'
teapots. Early 19th century. American Museum in
Britain, Claverton Manor, Bath.

189 War souvenirs. Private collection.

continent started to produce souvenir medals,
medallions and models in both brass and spelter (a
commercial name for zinc), and the earlier, crisp,
ones are delightful. Desk sets and moneyboxes are
also known in cast brass in the shape of cathedrals,
famous town houses and other buildings of interest
to the visitor. The age of thrift in the 19th century
produced a vast range of moneyboxes and mechanical
banks of every type. They were made all over Europe
and even more in America where some 300
different patterns are known. There are imposing
ones in the shape of magnificent Gothic edifices.
There are purely functional ones known as stills,
which were cylindrical boxes, made by German
craftsmen; one fed in the coins and when the cylinder
was filled the last coin released the lid. There are
numerous amusing mechanical contrivances such as
a Negro who throws a coin into his mouth; a
footballer who kicks a coin into a slot; a hunter who
shoots at a tree—you place a coin at the end of his
rifle, he bows his head to take aim and when you
press his foot the penny is shot into the tree and the
marksman looks up to see how good his aim was.

These American penny banks are a field of collecting 18
all on their own, but the acquisition of one or two
specimens is very well worth while. They are fre-
quently found in aluminium; these are obviously
modern copies. Some biscuit- and toffee-tins also
were intended for eventual use as moneyboxes, a
favourite shape for this being scarlet pillarboxes,
coins being posted instead of letters.

Akin to cast iron moneyboxes are knock-down fair-
ground targets in cast iron. These were made in the
shape of kings, policemen, Chinamen and other
popular or recognisable figures, and a good shot
could knock the head off with one shot and then
operate the mechanism to make it go up again with
another. They are interesting little pieces of folk life
of the 19th century.

A strange branch of collecting now coming into its
own is the souvenir from World War I made from 18
shell cases or bullets: vases, ashtrays, paper knives,
desk sets, candlesticks, cigarette lighters and button-
hooks are all to be found. Made by individual
soldiers, some of them have a distinct folk art appeal.

As England consolidated her overseas possessions

190 Dinky toys of the 1930s: *back* reconnaissance
car, *left* Daimler, *front* Jaguar sports car,
right Bentley. Meccano Ltd, Liverpool.

which in time became known as the Empire, many
native crafts were adapted for the new governing
power. Prominent amongst these was the beaten
brass ware of India which has become known as
184 Benares ware. There is hardly a home in England
which does not possess some examples of this work,
either a tray, a vase or a pot. The design, normally
slightly repoussé, is usually floral, but there can be
detected in it a strong Hellenic feeling shown in
tightly scrolled foliage and acanthus-like leaves,
dating back to the days when the world was young
and Alexander the Great brought his armies through
from the West and over the Indus. The influence of
other great art sources can be seen as well, grafted
on to the indigenous Indian feeling: China and Islam
contributed and, at the other end of the scale, an
English influence can also be traced. The small brass
pot shown here has rampant lions waving banners;
these are patently inspired by the East India
Company's arms. The influence of 'John Company'
obviously was very strong in India in the late 18th
and early 19th centuries. This pot, in addition, shows
admirably the Hellenic influence in its acanthus
border and scrollwork.

This Benares work is common in England due to
the vast amount brought back by English families
during the days of the Imperial Raj. For this reason it
is, perhaps, not valued as highly as it is, for example,
in a country such as Sweden which never had an
empire. It is interesting to note the very great
difference in price between a Benares tray in London
(say £5) and the same article in a European capital
city such as Stockholm (say £12). I do not normally
mention prices because they are such a volatile
subject, unfortunately constantly rising, but Benares
trays seem to have established their own set price at
between these figures for some time now.

More unusual are copper trays which, in the form
that we know today, emanated from the Balkans.
Although these were in the Ottoman sphere of in-
fluence, deviations in pattern appear: fishes, human
beings, hunting-dogs, which normally one would not
expect in the lands of Islam. These trays were
originally made for a family meal and not for the use
that they are put to in this country of serving tea
or drinks from; the greater portion of a sheep with
bowls of rice and vegetables would have been served
on a tray of this nature for the entire family or
tribe to eat from.

Another very distinct group of metal articles from
India are the well known cobra candlesticks. The
earlier specimens are the better made, as with every-

191 Royal Mail van and an open lorry in the 1930s
Dinky toy range. Meccano Ltd, Liverpool.

192 *page 164* Tin piano-playing toy. Private
collection.

193 *page 165* Sicilian puppet. Private collection.

thing else made before the tourist trade really
developed. They were made to dismantle and fold
flat in a similar way to travelling candlesticks in
Europe. Originally essentially functional, they were
used by English regiments upon the march who
would unscrew them and pack them in the wagon
trains or bed rolls during the day to be reassembled
at night in order to light the table of the officer of the
day or stand near the bed or desk of the officer
writing his report. They were efficient, useful and
had a certain appeal. From this workaday beginning
they were introduced into England to join the ranks
of pairs of candlesticks of every description, bringing
with them a slight touch of the exotic East.

Another Eastern technique in metal to which the
English became heir is cloisonné. This word is
derived from the French word 'cloison' meaning a
small cell or compartment. The technique was to
solder or braze a ribbon of metal upon a metal
surface into little curled compartments incorporating
any design that the craftsman wanted; into the
patterning was poured enamel which was then baked.
This was the technique of making cloisonné; it
should not be confused with 'champlevé' where the
surface was either cut out or cast leaving raised
pieces in between the colours (see page 15). Many

thousands of cloisonné pieces were brought home to
England from the East; the technique was most used
in China, though other nations knew it. The greater
bulk of cloisonné found in England is 19th-century,
but if you are fortunate you may find an earlier and
rarer piece. There exists one group which puzzles
me a great deal. They are veritable cloisonné pieces
but the design motive is Egyptian: pyramids,
Pharoahs and obelisks. How this strange amalgama-
tion of feelings of the later art forms of Egypt came
to be combined with the techniques of the Far East
I do not know. It has been suggested that Chinese
craftsmen actually worked in Egypt round about
1900, but as yet I have no proof of this. While not
serious examples, these pieces are indubitably
cloisonné, and many collectors find them amusing.

Other pieces that came our way in the Far East
were all-over enamel pieces generally called Canton
enamel ware. This ware is similar to the European
type known as Limoges enamel but is normally
decorated with fascinating little scenes of Chinese
life; bowls, ashtrays, tea-dishes were made. Those
pieces with the words 'China' or 'Made in China'
stamped on the base are normally fairly modern.
Superb hand-painted pieces were sold at Liberty's
in London in the 1930s at a few shillings a piece.

READING LAMPS AND HOODED CANDLESTICKS

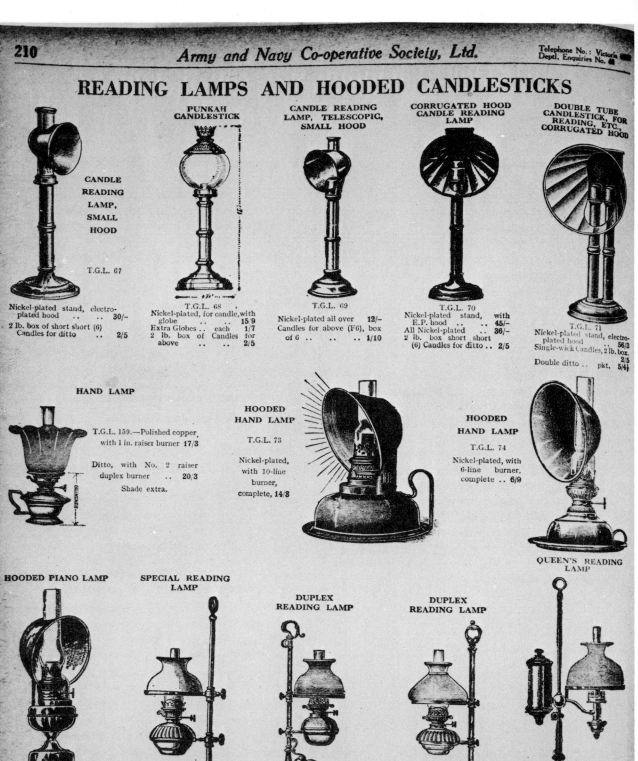

CANDLE READING LAMP, SMALL HOOD

T.G.L. 67

Nickel-plated stand, electro-plated hood 30/-
2 lb. box of short short (6) Candles for ditto .. 2/5

PUNKAH CANDLESTICK

T.G.L. 68

Nickel-plated, for candle, with globe 15/9
Extra Globes .. each 1/7
2 lb. box of Candles for above 2/5

CANDLE READING LAMP, TELESCOPIC, SMALL HOOD

T.G.L. 69

Nickel-plated all over 12/-
Candles for above (F6), box of 6 1/10

CORRUGATED HOOD CANDLE READING LAMP

T.G.L. 70

Nickel-plated stand, with E.P. hood 45/-
All Nickel-plated .. 36/-
2 lb. box short short (6) Candles for ditto .. 2/5

DOUBLE TUBE CANDLESTICK, FOR READING, ETC, CORRUGATED HOOD

T.G.L. 71

Nickel-plated stand, electro-plated hood 56/3
Single-wick Candles, 2 lb. box. 2/5
Double ditto .. pkt. 5/4½

HAND LAMP

T.G.L. 159.—Polished copper, with 1 in. raiser burner 17/3

Ditto, with No. 2 raiser duplex burner .. 20/3
Shade extra.

HOODED HAND LAMP

T.G.L. 73

Nickel-plated, with 10-line burner, complete, 14/3

HOODED HAND LAMP

T.G.L. 74

Nickel-plated, with 6-line burner, complete .. 6/9

QUEEN'S READING LAMP

HOODED PIANO LAMP

T.G.L. 75.—Nickel-plated, 30 c.p. "Mikado" burner and chimney 22/3
Ditto, smaller Lamp, with 10-line Kosmos burner and chimney 13/6

SPECIAL READING LAMP

With Duplex Burner.
T.G.L. 76.—Stand, polished brass, No. 2 duplex burner, with opal shade and chimney, complete .. 60/-

DUPLEX READING LAMP

T.G.L. 77.—Polished brass or bronze metal container, green shade, complete 75/-

DUPLEX READING LAMP

T.G.L. 78.—Polished brass or bronze, glass container, green shade, complete 67/6

T.G.L. 79

Polished brass, with opal shade and chimney 38/3
Ditto, nickel-plated .. 39/3
Green cased opal Shade for above 3/6

In ordering chimneys and wicks for Reading Lamps it is necessary to state if for duplex or Queen's Lamp.

ALL PRICES ARE SUBJECT TO MARKET FLUCTUATIONS

FAKES, FORGERIES AND REPRODUCTIONS

The question of fakes, forgeries and reproductions is an interesting one, and the implications are considerably wider than at first one might suppose. Fakes are, generally speaking, counterfeit antiques, fraudulent imitations intended to be passed off as genuine. Forgeries, too, are intended to dupe the unwary, probably more often in the field of writing or painting. Reproductions, on the other hand, as for example copies made by a museum or reputable firm and labelled as such, may be considered as quite ethical.

Such authorised reproductions are on occasion well worth acquiring. One reason for this is that a perfect copy of an 18th-century brass candlestick or enamelled patchbox might well prove a good investment, with a better secondhand value than might be attached to a modern object. Another reason is that there is no better way of filling a gap in a collection, especially if the object is a rarity and unobtainable, than by having a museum reproduction for study and comparison. Museums, incidentally, are usually very happy to help the collector both in identifying a problem piece and also in recommending useful references. The officials will not value a piece but will give an opinion as to its age, provenance, etc. In addition, for one's own protection, it is not a bad idea to make oneself as fully aware as possible of all standard museum reproductions. In the past these have frequently been made in brass or silver and, over the years with normal household usage, many have mellowed in an unexpected way; occasionally they now appear in auction rooms or antique shops with perhaps a larger degree of optimistic description than the piece merits. It should be stressed that an authorised reproduction is originally always labelled as such but that the labelling mark or touch may be deliberately obliterated at some point in its life.

Another example of an innocent reproduction is where a good and practical style grows into a traditional pattern and is repeated as such at a later period, or where, as actually happened with early American pewterers who could not afford to discard old moulds, the same tankard shape continued thoughout the whole of the 18th century. Patterns which have become traditional are to be found in certain practical candlesticks, knockers of classic design, typical pewter mugs and spoons, and plated teapots and coffee pots. These patterns seem to override the vagaries of fashion and are repeated generation after generation, obviously with no intent to deceive on the part of the maker. They become fakes only when someone tries to sell them or catalogue them as originals of the earlier period.

Note should be taken of the expressions 'in the style of' and 'after', since neither gives any definite clue as to the date when a thing was made. Normally the expression 'after' refers to a well known master whose work has been copied; it may be a contemporary copy but is more likely to have been made a considerable time afterwards. While on this subject, the question of bills or receipts for articles purchased might well be mentioned. When one spends a small sum of money, say £2 or £3, it is hardly worth bothering the dealer for a receipt: he is a busy man and is probably already thinking of the next customer. If, however, the purchase is in the region of, say, £20, I consider that the buyer is entitled to a properly made out receipt and that, when making this out, the dealer should give his view of the age of the article and also mention any repairs or additions. It should be said here, in fairness to the dealer, that no general dealer can possibly know everything. If you are purchasing metalwork from a specialist metal dealer, you are entitled to assume that he knows what he is selling and I think the law would be on your side in any argument. If you are buying a metal object in a general antique shop which deals in furniture, oil paintings, pottery, porcelain etc., I think it would be unlikely that, in the case of a dispute, you would win because the dealer could say that he was not a specialist in metalwork. This, however, would not entitle him to make out a receipt saying a thing was a 17th- or 18th-century object if it obviously was not. The very fact that he had so committed himself would show that he was assuming some knowledge of the object.

194 Many lamps of Victorian design were still being made 50 years later. Catalogue of the Army & Navy Stores, London, for 1928.

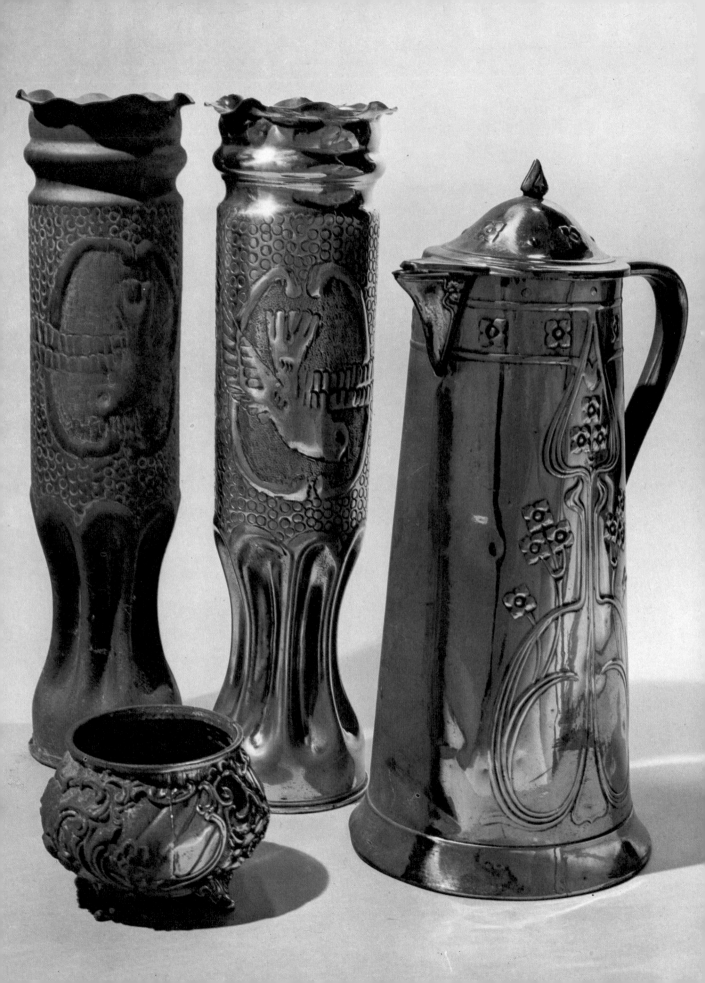

195 Items of metalware before, during and after cleaning. Private collection.

196 Painted metal, such as this beautiful Pennsylvania tinware, needs exceptional care in cleaning. American Museum in Britain, Claverton Manor, Bath.

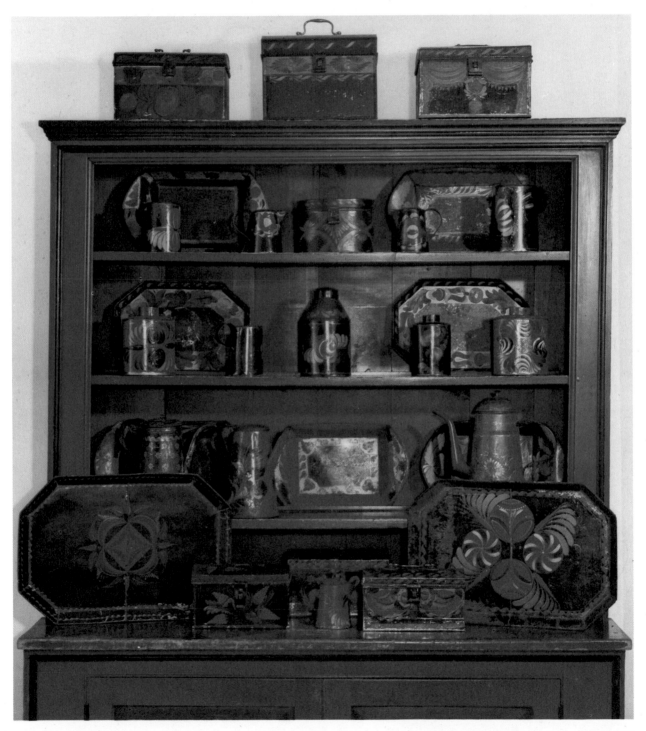

197 Door furniture of the 20th century, not the 18th. Hundreds of 'period reproductions' are made and sold by J. D. Beardmore & Co. Ltd, London.

As for the ethics of repairing, this is an old and knotty problem. According to its life and use any object in any material must suffer deterioration. How much repairing you personally will tolerate depends really on your own sense of discrimination and taste. If a thing has appealed to me and I wanted a specimen, I have always bought it regardless of the amount of restoration, in case I did not have the luck to find an unrestored example. Obviously, if I did find a much better specimen, I would dispose of the first one. A degree of restoration must be accepted; in the furniture trade, for example, restored brass mounts on a fine chest of drawers are normally allowed; in the case of an antique watch or pistol, repairs and restorations may have to be done to the mechanism. I see no reason why the same should not apply to a pewter pot, a candlestick, a Channel Islands milk jug, etc. Back we come to the old argument 'How much?', and again one must qualify by the rarity of the object. I think that with comparatively common articles like a brass candlestick the most that we can accept is a repair to the base or the sconce. The 'restoration' that results in four candlesticks where originally there were two is in my opinion unacceptable, and the result must be termed a fake.

The trade term 'marriage' should be mentioned here as this may well be halfway to being a fake. It occurs when parts of two or more antiques are joined together to make another article, as for example, in the addition of a handsome handle to a pot to make a tankard, or the marrying of candlesticks to a warmingpan cover or a pewter plate to make a wall sconce. Conversions, too, may produce a different article, as when a lip is put on to a tankard to make a jug or when pewter hot plate liners, divorced from bases, have had the foot ring filed down to turn them into pewter plates. Conversions were not always deliberate frauds. They were very frequently carried out for the benefit of the contemporary owner much as some people today convert old candlesticks into electric lamps disregarding the fact that they are lessening their value both aesthetically and commercially.

As a general rule the object considered worth faking is an old object – age with its suggestion of permanency being what is desired in a rapidly changing world – and it therefore follows that the fake which

survives to become old itself is appreciated and collected in its own right. Of these historic fakes, about the earliest group that we know is that called the 203 'Naples Forgeries'. Towards the end of the 18th century, the English milord, trotting round Europe on the Grand Tour, had a passionate desire to bring back home antique objects. These 'tourists' went in ever-increasing numbers: in the late 18th century some 40 000 English were recorded in one year alone, and it soon became obvious that there were not enough old things for them to purchase. Throughout Italy, accordingly, craftsmen in the various provinces took to specialising in the production of some specific form of antiquity or work of art in order to meet the ever-growing demand. The Neapolitan, however, appears to have been capable of producing a very varied range of 'antiques', and they were responsible for a vast quantity of small bronze dishes, lamps, figurines and so on, the sort of articles found in the excavations of Pompeii. These were brought back by the happy tourists to repose in a squire's library or a parson's study where they would rest in dignity for the next hundred years until people in the 1920s began to question their authenticity. It should, of course, be borne in mind that these were not bought in the sense that we buy antiques today: they were bought as old curios, and the buyer's sense of discrimination was perhaps not as strong as ours is. I personally find these pieces extremely interesting in their own right. They are beautiful casts and the work is good. In the light of our present knowledge they are easily distinguished from a piece of authentic antiquity by the false patination and the abundantly plain file marks used in the cleaning of a piece when it was being made. Following the success of these Naples forgeries, metal objects began to be made in the various other antique styles fashionable at the time. In England several firms, probably in the Birmingham area, produced a wide range of such objects and even went so far as to publish catalogues which enabled a customer to order a desk set, pair of candlesticks or other metal piece in the Greek, Roman, Egyptian or Gothic manner and also—amusingly—in the Chinese style to tie up with the feeling for chinoiserie at this period. Now, patinated and often corroded, they can be traps for the unwary.

Another very famous group of endearing fakes is 201 known as 'Billies and Charlies' after their makers. In the middle of the 19th century, two workmen of Rosemary Lane, Tower Hill, London, by name William Smith and Charles Eaton, found that city gentlemen would give them half a sovereign for peculiar metal objects dug up in excavations in the city. The idea occurred to them, and possibly to other workmen, that it might be a good idea to ensure a steady supply of these objects. They set to work in a workshop in the East End and produced thousands of strange metal objects, sometimes in the shape of dagger hilts, sometimes pilgrim badges, sometimes shield bosses, all made in cock metal (a poor quality metal composed chiefly of copper and lead scourings). Many are unconsciously amusing: the workmen had plenty of imagination but naturally no scholarship, and with cheerful confidence they mixed Roman and Arabic numerals in the same dating, they mixed hopeless Latin with dubious English in the same inscription; their knights and kings were straight from the world of childhood. In recent years an interest in them has grown, and as they now are over a hundred years old they are antiques in their own right. They are still occasionally found in antique shops either described as 'Billies and Charlies' or as 'antiquities' or just defying description. It is very probable that, due to a large contemporary need, the Birmingham metal trade took up the uttering of them; this might account for the vast numbers still in existence.

It is a moot point whether today's fake will exert the charm of these fakes of yesterday. But what is in no doubt at all is the fact that forgeries are turning up in ever-increasing numbers, so that it is difficult to keep pace with them and impossible to list all that one may come up against.

The final, main and inescapable reason for making a fake is money. Once an article begins to command a high price, and the increased value has become established, there have always been men who will try to get in on the deal. But there have been forgers who patently made an 'antique' as a *tour de force*, pitting their wits and knowledge against society and the 'experts'. Such a fake at its best may well be called a work of art. Like the perfect murder it can remain undetected for as long as its perpetrator chooses to keep quiet about it or until improved methods of detection are at last discovered. The detectable fake can still in many cases provoke a trial

198 Detail of a bronze chisel from Jericho showing corrosion products. The light green parts are 'bronze disease' caused by moisture reacting with cuprous chloride. British Museum, London.

199 Cross-section of the bronze chisel from Jericho (see 198) showing extent of corrosion. Only the bright central part is still metal. British Museum, London.

I have mentioned specific examples of fakes thoughout this book and in this chapter should like to confine myself to two very recent ones. Not long ago I saw completely new chargers, run in some metal similar to pewter, bearing in the centre of the base a late 18th-century touch which had been cut from some authentic piece in a state of damage beyond repair. This is completely wrong, and there is no justification whatsoever for producing such a terrible travesty of a pewter plate. Such action, I would think, is both unethical and illegal. The other example I would mention is that of the barber's shaving bowls and cupping dishes which have been produced quite recently in certain Mediterranean countries, made in what appears to be a type of aluminium. These have been patinated down to a powdery grey sheen reminiscent of pewter, and they are remarkably good facsimiles. When newly made they proudly display the country of origin in a modern mark on the back. Some that I have since seen have had this obliterated with something looking like an old touch. This is as deliberate a trap for the unwary as the addition of a coat of arms to a plain pot or the removal of an uninteresting inscription.

As far as the ability to detect fakes is concerned, it is difficult to transmit this from one person to another. It is made up, it seems to me, on the one hand of feeling for a period, its style, line and so on; and on the other hand, of knowledge of the techniques of the craftsmen and the stage of technical advance that they had reached; for example, one among many, early cast brass was smoothed up by turning in a foot lathe, and irregular grooves were sometimes left, whereas modern fakes, finished on a power lathe, have very regular turning. Another example is to be found in japanning: with early japanned ware the thin iron sheet was totally immersed in hot liquid tin which ran right into the sheet giving it a mild soft texture; the later technique did not appear to penetrate the metal to the same extent, and the result is a much harder metal. This two-fold knowledge often can be learned only by close study and frequent handling of specimens and, like patination, cannot be rushed.

There are, however, one or two pointers which may be of help. While writing this book it has come home to me once again, and very forcibly, that the style of a period is an all-embracing and very power-

of wits, and it is this underlying humiliating suggestion – that the person who buys a fake has bought a pup – that accounts partly for the unpopularity of fakes. But we always come back to the inescapable subject of money: fakes are worth only a fraction of the genuine antique and so are an extremely bad investment (at least for a number of years).

This is one type of fake – the work of an individual with some knowledge of the art world and probably of one aspect in particular, with some technical skill at his fingertips and with a sufficiency of selfconfidence. If he is a first class craftsman and copies meticulously the style and technique of his original, then one is very much at his mercy. Fortunately for the collector, in most cases he is anxious to produce a number of forgeries rather than an individual one and, in so doing, not only does he lose the skill of the earlier craftsmen but also he frequently establishes, without realising it, a recognisable pattern by which one may detect his copies.

ful feeling which is reflected throughout the craft objects of the time and that anything out of character is a sign of something suspect. An example of this is found among early forgers who were often uneducated and would remove the sconce or drip pan from a candlestick in order to make it appear of an earlier date, not realising that the overall line was then wrong for both periods. Another point to note is that fakes frequently turn out larger or, paradoxically, smaller but rarely the exact size of the original article. This may be due as much to lack of confidence as to lack of knowledge: it may also be due to the fact that the original article may be used as a template, mould or pattern, thus throwing the line slightly out. A very good example is where an early candlestick is used to make a mould, the resulting copy is cast from this mould and then has to be finished up by filing and polishing; this removes a not inconsiderable amount of the metal and makes the copy smaller.

Another point to be borne in mind is that patination and signs of wear should be in keeping with the supposed age of the object under scrutiny. The patination of a piece of metal—as opposed to a piece of old furniture—is the surface accumulated over many years where polishing and cleaning have not taken place (with furniture the word 'patination' is applied to the fine polish that results from years of care). With brass and copper articles, patination can range from green through to almost black; it takes many years to develop and, while it can be reproduced, this is not easily done, and the false patination can often be spotted by a serious collector. It gives an impression of being 'thin' and superficial and seems to have no depth to it. As for an article that has been constantly polished, although it will have assumed, over the years, a fine surface and a richness of colour, it will inevitably show signs of wear because every form of cleaning removes a minute fraction of the surface; for this reason the more rare and the more

202 Waterloo cannon and British Empire Exhibition
souvenir of 1925. Private collection.

203 Bogus antique lamps made in Naples. Private
collection.

valuable an object the less you should clean it. In any
old metal object experience will teach you the most
likely places to find signs of wear caused either by
cleaning (as on the highlights) or by normal house-
hold usage. It is essentially a question of common
sense. In the case of a ladle, for example, the hanging
slot will show wear on the top; as most people are
right-handed the inside of a ladle, as held in your
hand, will be worn as that is the side that comes into
contact with a hard surface when baling food out of
a container; very frequently on the shank of a ladle
near the bowl there will be signs of wear because a
careless cook serving, say, porridge would knock the
ladle to shake out remaining pieces of food, wearing
it down on that spot. Rims of the ladle should, of
course, be thin and worn. With tankards or pots etc.
look for wear in the places where you would expect
it on a handle and on a base.

Conversely, look too for signs of wear or thinning
where this would not be expected, as for example
on the bowl or body of a cup or tankard as a thin
patch here might mean that an inscription had been
removed in order either to make the article appear
older or to give it a more general appeal.

Very frequently the later workman will try to cut
his costs by using a cheaper material than the original
that he is copying, but an electroplated teapot in
Britannia metal, for instance, although it looks
imposing, will never possess the quality of a Sheffield
plate or silver one. Perhaps the most common and
most likely misuse (or faking) of material is the
brassed article. As soon as the technique of cast iron
was commercially established in the 19th century,
the ironmasters started to produce objects in cast
iron which were modelled on solid brass originals
and then brassed and sometimes even gilded. With
the technological skills of the 19th century it was
possible to produce objects as large as mirror frames
three feet in diameter, decorated with putti and
floral sprays which looked like gilt ormolu but were
in fact cast iron. In their own right they were well
worth collecting as superb examples of craftsmanship
in iron, but they should not be sold at the price of
ormolu. The simplest and most common form of
detecting this is to carry a magnet in your pocket,
and if you have occasion to question whether an
article is indeed brass or ormolu, just apply the
magnet to it. If it is iron or a derivative of iron

this will show quite plainly. It follows that if you
can apply a brass finish to an iron article you can
also get a bronze finish, again easily detectable by
magnet.

Slightly more difficult to detect are 'bronzes'
–lamp brackets, lamp standards, figurines, etc.
which are made of spelter and then plated to simulate
an antique bronze and sometimes (by a method
beyond the range of this book) to simulate silver.
Objects of this nature are definitely 'soft metal' as
opposed to real bronze which is a hard metal. As
good a test as any here is to train your ear to
recognise the difference between soft and hard metal
–a sharp tap with a penny will rapidly distinguish
what is soft and what is hard. A little practice
in your own home with an object of a known spelter
base and a genuine article in bronze or solid copper
will quickly teach you to distinguish between the two
sounds. There is all the difference between tapping
with a hammer on a square of brass and on a square
of lead.

Little research has been done on it, but there exists
a wide range of very dubious plated tableware carry-
ing the most extraordinary names. I have collected
some twenty-five different specimens all bearing a
remarkable series of stamps on the back which look
at first glance like silver marks; they also carry, for
good measure, such misleading names as 'Nevada
Silver', 'Afghan Silver', 'Hobsonian Silver', 'Silva'.
I am pretty sure that it is no longer permissible
to use the word 'silver' in this context so that, as
these items are now of the past, they are of some
interest. It should be remembered that, when these
sets of tableware were made, the people likely to buy
them were very much more innocent or ignorant
than we are now.

The early Sheffield plate marks were quite
definitely made to approximate to silver marks,
almost certainly with the intention of deceiving, a
matter which caused protracted trouble with the
Goldsmiths' Company. Although they do not give a
date letter, they are well worth studying in their
own right as one may learn from them.

Another point to bear in mind with Sheffield plate
is that early electroplate was frequently deposited on
copper and, therefore, that the sign of copper showing
through the worn silver is not an infallible indication
of Sheffield plate.

CARE AND CONSERVATION

This chapter is probably the most difficult one of all to write because this subject can be tricky and even dangerous. There are two main reasons for this. The first is that any form of cleaning or restoration of metal objects may – and frequently does – necessitate the use of various chemicals, many of which are poisonous. Even if by themselves they are not, sometimes combinations of them can produce fumes that are harmful and occasionally lethal. It cannot be emphasised too strongly, therefore, that no cleaning should take place in a confined atmosphere or in close proximity to food, and that any experimentation should be entered into very carefully, with every safeguard that can be made available.

The other reason for my hesitation concerns the metal article itself, because no overall diagnosis can be given, and each individual object must be subjected to individual attention. Obviously what is suitable for a pair of brass candlesticks of the 19th century, for example, is not applicable to a considerably earlier object such as a Roman bowl or lamp or other antiquity. Again, the use to which a thing will be put is an important consideration; for example, is your Georgian coffee urn or your pair of candlesticks going to be used or are they purely for display or to be kept as cabinet pieces. If used for food or drink, still more difficulties will arise.

All objects should be handled with extreme care until you have discovered your own abilities and the techniques that you can manage. In early stages of experimentation in cleaning and polishing you should practise on articles of no great value and, broadly speaking, the older a thing is the less you should clean it or even handle it. I must also stress the fact that the information I shall give in this chapter is of a general nature: if you have a piece of metalwork that you value a great deal or that is of such merit that it needs extra careful handling, the advice of a museum or of a specialist expert should be sought. There are so many different blends of base metals that the cleaning methods applicable to some will do more harm than good to others. There

204 A detail of a bronze altar from Maris (Yemen) during cleaning. British Museum, London.

are also certain individual pieces of metalwork which, because of their very nature, require specialist treatment.

At all times it should be borne in mind that in cleaning a thing your aim should be to clean and restore an object as near as possible to its original condition. There are, however, some exceptions to this rule: one is the case of an object of some age which has acquired a permanent and pleasing patina – a Roman bronze lamp, for example, or a medieval candlestick or bowl, which has become dark green, brown or black with age. If there is no deterioration of the metal, then this patination should under no circumstances be disturbed. A sparing application of a good quality transparent wax polish carefully removed with a silk cloth should not do any damage to a patinated object and will improve the surface.

Another example of an object which does not benefit from the attempt to restore it to its original state is a piece of old Sheffield plate which shows signs of wear. The colour of the metal showing through the silver – this is known technically as 'bleeding' – is to some collectors a point in its favour. In any case, replating by modern electroplating will never give back the original colour. The charm of Sheffield plate lies in the mellow colour of the old silver, nowhere near as white as modern electroplating. In its own lifetime, if there were a fault or if, through heavy usage, Sheffield plate had to be repaired, this was done by French plating, a method in which a sheet of very fine silver foil was laid over the worn part and made to adhere by a little gentle heat or by burnishing. This method is rarely used by craftsmen nowadays. Only when a piece of Sheffield plate has completely lost all its original plating and is reduced to an entirely copper appearance is it perhaps permissible to electroplate and then merely in order to restore it to something like its original state, especially if it were used for food.

Broadly speaking the first step in the care and conservation of a piece of metalwork is the removal as far as possible of whatever is causing deterioration, such as rust in the case of iron and steel, then thorough cleaning and polishing followed finally by the application of waxes or lacquers to help to delay decay.

205 Pontypool ware, such as this tray at the National
Museum of Wales, Cardiff, should be cleaned only
with substances which will preserve and not destroy
the existing paintwork.

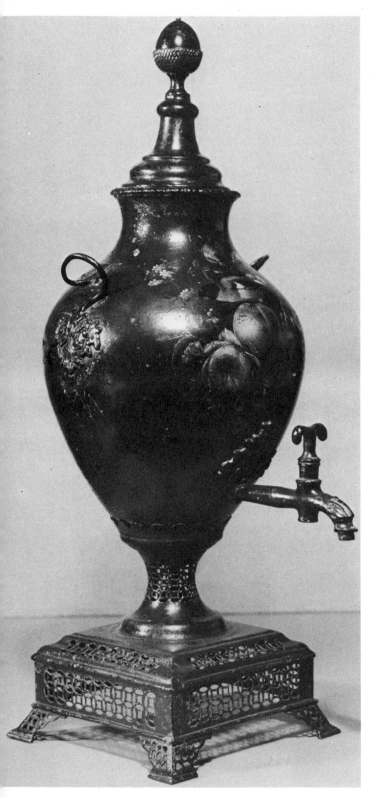

It is impossible to arrest decay completely: all one can do is to oppose it and delay it for as long as possible. Here the museum man is speaking, and I am aware that this may sound very pessimistic. As in any other form of antique a moderate, even temperature is required, and it is necessary to avoid extreme cold or damp (very much as for a human being). These are in effect the main essentials of what is known in a museum as 'conservation'. What techniques and practices you use and how you tackle the work is governed to a great degree on whether the metal is brass, steel or pewter and, indeed, the composition of the actual article.

Iron and steel

With iron or steel objects, which are frequently found in a rusty state, the first step must be to remove this rust. Any that is loose may be removed with a wire brush and then, if the object is fairly small, boiling in caustic soda will remove a great deal of what remains. Do not let this mixture come in contact with your hands or your eyes. If an accident should occur, the solvent for caustic soda solution is lots and lots of clean fresh water. For a larger object it is necessary to soften remaining rust by soaking the article for several hours in paraffin oil or in one of the commercial derusting oils such as Plug-gas A. In certain cases a commercial deruster such as genolite could be used. It should again be emphasised that what one uses will be governed by the requirements of each individual piece. I myself am not over-fond of chemical derusters because they tend to leave a dull matt-grey surface which the original piece rarely had. They are excellent, however, for treating pieces which are going to be painted a dull black such as wrought iron lamps or railings.

Another general method is to use a fine grade of emery cloth and oil. The emery cloth may be wrapped round a shaped stick for getting into the various contours of a pattern. The oil will help to prevent too many scratches; if you use emery paper dry you will get a very scratched surface indeed. Use the mildest emery that will do the job, and when you think you are near to finishing, cut it to a yet finer one. Coarse emery should not be used except in very bad circumstances indeed. Never clean too heavily upon a raised surface as you will tend to blunt the pattern.

Having cleaned the object to the degree you want, wash with methylated spirits, dry with clean cloth and place it, wrapped in a piece of newspaper, in some form of heated cupboard (an airing cupboard is ideal) and leave it there for two to three days to drive out any damp that may be in the metal. If the thing is as bright and clean as you want it and if you are not going to put it to practical use, at this stage seal with lacquer or wipe over with an oily rag. Some collectors wax polish their ironwork: if your house is very dry this is quite a good finish. The great enemy of iron and steel is of course damp, and this will cause rust very rapidly; as in almost every other form of metalwork a dry atmosphere is the most beneficial. If the atmosphere is damp or if, as is usual in England, there are chemical impurities or salt in the air, you cannot do better than periodically to wipe the piece over with a slightly oily rag. Periodically inspect iron or steel specimens for signs of rust.

Wrought ironwork

Some specimens of wrought ironwork may be rather large, as for example gates or window grills. Remove as much loose rust as possible with a wire brush, clean off with emery paper, seal with a derusting fluid and finally paint with a dull Brunswick black. For a really fine piece of wrought iron, the treatment should be left to an expert.

Cast iron

In the case of cast iron objects, normally of the 19th century and which are now being collected, there are two treatments. They can be cleaned of all loose rust, dried and painted black, a very good treatment for any form of iron grill of the 19th century, or they can be shot- or sand-blasted by a commercial firm – this gives a sort of silvery effect – and the object should then be lacquered.

Georgian or Victorian cut-steel

The cleaning of a piece in cut-steel must be approached with great care, and if possible each little facet should be cleaned separately. The stress must be on care and patience because it is important that you do not dull the edges of cut-steel. This applies to all examples of cut-steel from quite big objects such as Georgian fire-irons to small pieces such as a buckle, buttonhook or corkscrew. The great glory of cut-steel is its many facetted surfaces, and these should be kept as crisp as possible.

Brass and copper

The age-old method of half a lemon and salt is excellent especially for a flat surface such as a tray. Apply, rinse off, dry carefully and clean with an impregnated wadding, polishing finally with a soft cloth (a piece of old silk is ideal; I find that man-made fibres such as nylon tend to scratch the surface). Sometimes with deeply engraved or repoussé decorated objects, over-keen cleaning in the past may have clogged the pattern with the remains of old dry polishes. This should be removed with a little methylated spirits and a stiff brush and then cleaned with impregnated wadding as described above. This wadding is less likely to leave traces of cleaning material behind.

Another method for a brass article is to wash it in a mild ammonia solution and then to clean with either oxalic acid and salt or vinegar and salt. Following this treatment, it should be washed with water, polished and lastly lacquered.

To save cleaning, and consequently to preserve the metal, a modern technique much used by museums is to lacquer with a cellulose lacquer specially made for brass or copper. This should most certainly be carried out with any early or rare pieces and for pieces with fine crisp edges. The article should first be thoroughly cleaned, either as above and finished off with a succession of cloths until none is soiled, then cleaned with acetone. This should not be done in a confined space or near a flame as this liquid is very volatile. Cotton gloves should be worn to avoid fingerprints which would show under lacquer. (Note: rubber gloves should not be worn as some types are destroyed by acetone.) When cleaned, the piece should be lacquered with a good cellulose lacquer painted on slowly and liberally with slow easy strokes and avoiding bubbles. Do not worry too much about brushmarks as these usually disappear in the drying. If the piece has been previously varnished or lacquered this can be removed with paint stripper, following the manufacturer's directions, then treated as above. If the object is not handled too much, this type of lacquer will last for some years.

206 Fragment of a Roman sword, showing the condition when it was excavated. British Museum, London.

207 X-ray photograph of the Roman sword fragment revealing the lines of some inlay under the rust. British Museum, London.

Bronze

Bronze pieces, either in the form of a figurine or a really early goblet or lamp, have normally over the years acquired an all-over patination, ranging through many shades of brown to green. If this patination is breaking up, and there are spots of a brighter colour, as for example bright green, action should immediately be taken to stop this because this efflorescence is the change in the surface of the metal which is known as 'bronze disease'. It is extremely difficult for the amateur to treat, and a museum or a specialist restorer should be consulted at once.

As a temporary measure, if it is quite definitely active and the collector is unable to get speedy professional help, the light powder should be brushed off and the piece kept as dry as possible.

To clean a normal bronze, wash it with a very mild soapy solution, dry thoroughly and then apply a little fine wax polish.

198

208 Removing the rust from the Roman sword fragment, using the X-ray photograph as a guide. British Museum, London.

209 The inlay on the Roman sword fragment finally uncovered, showing military standards on one side. British Museum, London.

Ormolu

Ormolu was frequently used for candelabra, candlesticks, the handles of fire-irons, door and desk furniture and small ornamental pieces in general. The gilt was applied in various ways and with some forms of inferior ormolu was only a clear gold lacquer painted over finely finished and polished brass. This, I regret to say, was frequently used by English craftsmen copying the French. Cleaning should be tackled with great care; gold at best is a very soft metal, and harsh cleaning will remove it. As a first step in the cleaning of an ormolu piece, choose an inconspicuous area and observe the effect of cleaning on this. Use warm water to which has been added a mild solution of household ammonia and a good quality soap-based washing liquid. If no ill effects can be seen, continue with this cleaning for the complete piece. If a stronger cleaning mixture is needed, add more ammonia. Work in a current of air and wear protective gloves.

To clean ormolu mounts, carefully remove each from the piece of furniture, making a note of its original position. Save the pins, nails or screws which were used to fix it. It is a good idea to make sketches of mounts; the fixing pins can then be stuck through the equivalent hole. This is not merely a counsel of perfection: it can be very necessary as early mounts were individually made and will not always fit into another position. Once removed, they may be dealt with as described above.

If ormolu needs regilding, consult a firm of platers. Modern gilding by electroplating is rather bright and produces a shade different from that of the old ormolu. On the other hand the old technique of mercury-gilding (fire-gilding) is very expensive and gives off poisonous fumes. Very few craftsmen use this method, but for a superb piece it is worth trying to find a firm specialising in it. Never use a gold paint or lacquer as under no circumstances does this give the right appearance.

Pewter

If you collect this interesting metal, your first and immediate problem is whether to clean your pewter bright or to leave it patinated to a dull natural sheen. I am completely neutral in this argument: if the piece of pewter that I buy because it appeals to me has been maintained in a bright state, then I leave it like this; if on the other hand it has the quiet soft grey colour preferred by some collectors, I am equally satisfied. Of one point I am convinced – that pewter, if in reasonable condition, should be left as far as possible undisturbed: this piece of advice recommended by an early pewter collector in the 1900s is, in my opinion, equally applicable today. If the metal has deteriorated through neglect or by being exposed to extremes of heat and cold, and obviously needs attention, this should be undertaken with extreme care. Any dent or damage of that nature should be dealt with by an expert.

On the subject of cleaning this metal there has been an amazing variety of methods advocated over the centuries, everybody apparently having their own favourite treatment, and I shall give, a little later on in this chapter, a few of the standard cleaning techniques, some of which are based on methods used as early as the 17th century. I must stress however that in the light of modern knowledge not

one is infallible and that all should be used with extreme caution and only as a last resort.

During the period that pewter was in common use for food and drink, it was kept bright by a very mild abrasive, such as crushed eggshell, fine sand etc., was washed in soapy water, rinsed in clean water and dried, then, if not being used at once, wiped over with an oily rag. If pewter purchased today is bright and clean and the intention is to keep it that way, clean the piece with impregnated wadding, polish with a clean cloth and oil with olive or a similar oil.

If pewter is not kept polished, it gradually dulls down over the years, by a process of oxidation, to a soft grey sheen, much admired by many collectors. This patination is certainly attractive and, to preserve it, the piece should be kept very slightly oiled all over with olive oil. Oil of any description seems to revivify pewter by penetrating into the metal.

Unfortunately, due to the nature of pewter, its susceptibility to extremes of heat and cold and the consequent corrosion that can develop, this attractive metal is often purchased with bad oxidation or patches of what is known as pewter disease. This must be treated or the piece will be ruined. Great care must be exercised in this treatment both for the metal and also the person handling it, as the materials used are often poisonous or harmful to the skin.

If there is heavy corrosion (or pewter disease) one of the following methods may be of some use.

1. Add one pound of caustic soda slowly to four gallons of cold water, using an iron container. Heat the mixture slowly. Place some hessian or canvas in the bottom of the container and lay the pewter piece on it. Keep the mixture boiling for some hours, examining at intervals. If this shifts the corrosion, remove from the mixture, rinse thoroughly in warm water and clean with a fine abrasive such as crocus powder, rotten-stone or very fine emery powder and paraffin, finishing with powdered chalk or plate-powder. Lastly oil the piece.

2. Another method, for perhaps a less corroded piece, is to wash in a strong mixture of soap and soda, then cover the whole surface with a watered-down solution of hydrochloric acid applied with a rag on a stick. The strength should be 60% water and 40% hydrochloric acid. (Warning: always add the acid to the water, never the water to the acid.)

210 Fragment of a bronze altar from Maris, Yemen, showing the condition as excavated. British Museum, London.

211 Mechanical cleaning of the Maris altar fragment reveals details of the decoration. British Museum, London.

Leave on for a short while, then rinse off. Reclean with fine emery powder and oil. Wash, first in soapy then in clear water, and polish.

3. Another recipe for cleaning is: 2 oz caustic soda, 2 oz lime, 6 oz common salt. Dissolve this in three quarts of warm water. When dissolved, add the mixture to two gallons of cold water. Leave the piece of pewter in this to soak and finally clean with fine emery powder and oil.

4. Also useful as a cleaning agent is oxalic acid, either used neat or watered down. Rub in with fine emery powder, rinse off and polish, then oil.

After using any of these methods of cleaning, a prolonged soaking in paraffin oil for several days will do no harm and should revivify the metal.

For general cleaning, if this is necessary, the safest method is to use very fine abrasive powders such as rotten-stone or crocus powder, or a very fine emery powder. Put on with an oily rag and work in a circular motion to avoid obvious signs of scratching. Grades of 'fine' emery paper, liberally drenched in oil, may be used for cleaning but must be used with care. Always use the finest grades and again rub in a circular motion to try and avoid scratches that show. The piece can be finally cleaned with a little white spirit or methylated spirit, dried and then oiled.

All pewter will remain in good condition if kept behind glass. When properly cleaned it can remain in a good display cabinet for at least a year, and this of course is the best way of preserving it. A

185

good display of cleaned pewter may be seen in the American Museum in Great Britain. Pewter should never be stored in an oak display case or on oak display racks as this wood contains acid fluid which reacts against any metal of the pewter–spelter–lead group. An open oak dresser, against which it is often seen, is less dangerous to the metal as the collector would polish both dresser and metal fairly frequently and so prevent corrosion.

Lead

The above remarks apply in the main to lead. Objects in this metal that you may come across are tobacco-jars or small lead figurines.

Zinc also known as spelter

Zinc objects of the 19th century are frequently found and are often in a very dirty and distressed condition. It is possible that a stiff wire brush and a little oil will get these articles up to quite a high degree of polish. Wash the pieces in hot soapy water using a stiff brush; on no account use caustic or any soda. Clean with a wire brush and oil, and polish with an impregnated wadding. Finally clean with acetone or methylated spirits and, if you wish, lacquer. If you prefer not to lacquer them, these 19th-century pieces can be cleaned once a week with impregnated wadding without doing too much harm.

Tole, Pontypool, barge ware and japanned tin

196,205

Extreme care must be taken to preserve and not destroy the existing paintwork. You might find it useful to try a mixture of one-third white spirits, one-third methylated spirits and one-third linseed oil. This is a good and fairly harmless cleaning agent for paintwork. Apply with a cottonwool pad to a small corner of the object and see what results you get. If you are satisfied that you are not attacking the paintwork, clean the whole surface and apply a little good quality wax polish. If the piece is in definite need of paint restoration, try to find a competent restorer who will take the job on. The restoration must never alter the feeling of the original piece, and the object should not be entirely repainted; indeed, as much as possible of the original paintwork should be preserved. Do not attempt to paint it yourself unless you are experienced and competent, and then be careful not to overdo the restoration or the spirit of the original will be lost.

It is an idea worth considering for a collector to keep a commonplace book or register of pieces – where each piece was bought, how much it cost and also what methods were used to clean it. This information is often of great use at a later date, and if the piece is at all outstanding the collector is in effect starting a pedigree for it. Of course, if one knows anything of its earlier history, it is important that this also should be incorporated into one's notes. This is one of the reasons why certain prominent auction rooms always mention the earlier provenance of a piece, especially if it has previously been sold by them. In the field of metalwork, many famous pieces, recorded in the 17th and 18th centuries, are now untraceable or lost; it is always possible that they may turn up, and if they did it would be of great interest to know where they had been.

There is also another consideration that the collector or the student of social history should bear in mind. There are nowadays many items which, because either they have a built-in obsolescence or because they are superceded rapidly by a more practical or cheaper item, are of transitory interest or use. They are soon discarded, and for this reason any specimens of them that survive become rare. If saved by a collector, a short note recording the use for which the piece was intended and the period in which it was of use will be of importance to future collectors. A very common example of what I have in mind is the gadget for triangularly piercing beer cans. These are now superseded by the ring-pull fitted into the lid of the can, and as they are being discarded in tens of thousands all over the world they will be after a few years obsolete curios. It is surprising how soon the use of a small object becomes forgotten. I have had occasion to mention this particularly in the chapter on tools (page 147).

A final note: I must stress the need to use extreme care when cleaning your metalwork, both for your own sake and also for that of the metal collection. Among the factors that have to be borne in mind are the varying compositions of the individual metals and the state of decay in which an individual item may be found. Never rush into cleaning a piece. Never hesitate to consult a museum or a specialist on any problem that may arise.

BIBLIOGRAPHY

Anatomy of Wrought Iron, An (J. Seymour Lindsay) reprinted London 1964
An essential book on this subject

Antique Sheffield Plate (G. Bernard Hughes) London 1970

Copper through the Ages (published privately by the Copper Development Association) London 1962
This book is occasionally available in secondhand bookshops

Cut Steel and Berlin Iron Jewellery (Anne Clifford) Bath 1971

Decorative Antique Ironwork (Henry D'Allemagne) reprinted New York 1968

Decorative Cast Ironwork in Great Britain (Raymond Lister) London 1960

English Wrought Iron Work (Victoria and Albert Museum booklet) London 1962

Iron and Brass Implements of the English House (J. Seymour Lindsay) reprinted London 1964
Another essential book

Ironwork (Starkie Gardner) London 1914

Metals in the Service of Man (William Alexander and Arthur Street) 5th edition Harmondsworth 1972

Sheffield Plate (Victoria and Albert Museum booklet) London 1955

Technology in the Ancient World (Henry Hodges) London 1970

Victorian Electroplate (Shirley Bury) London 1971
A delightful and useful book, carefully written

Wine Label, The (N.M. Penzer) London 1947

ACKNOWLEDGMENTS

The publishers wish to express their gratitude to all those who have allowed items in their collections to be illustrated in this book and to those who have kindly supplied photographs.

Sources of Photographs
American Museum in Britain, Bath 33, 56, 60, 78, 88, 108, 116, 118, 119, 171, 178, 188, 196; B.P.C. Picture Library, London 112; E. Boudot-Lamotte, Paris 145; Brighton Corporation 1, 30, 44, 86, 91, 101, 104, 105, 160; British Museum, London 9, 10, 18, 25, 55, 206; British Museum Research Laboratory, London 198, 199, 204, 207, 208, 209, 210, 211; J. Allan Cash Limited, London 5, 11, 164; Robert Chapman, Plymouth 41, 42; Cooper-Bridgeman Library, London 16, 157; *Country Life*, London 21, 26, 90, 110, 154, 185; Germanisches Nationalmuseum, Nuremberg 187; Hamlyn Group–Hawkley Studio Associates 3, 4, 15, 20, 22, 23, 27, 28, 29, 34, 35, 36, 37, 38, 47, 51, 53, 61, 62, 64, 65, 66, 67, 68, 70, 71, 72, 73, 74, 75, 76, 84, 85, 95, 98, 100, 103, 113, 117, 120, 121, 122, 123, 124, 126, 127, 128, 130, 131, 133, 134, 135, 137, 138, 139, 140, 141, 142, 143, 144, 149, 152, 153, 156, 161, 165, 167, 172, 175, 184, 189, 192, 193, 194, 195, 200, 201, 202, 203; Hamlyn Group–Edward Leigh 43, 45, 46, 50, 54, 57, 58, 59, 125, 169; Hamlyn Group Picture Library 19, 49, 52, 69, 94, 97, 99, 115, 132, 168, 170, 186; Meccano Limited, Liverpool 190, 191; Metropolitan Museum of Art, New York 31, 109, 129; Museum of English Rural Life, University of Reading 87, 111, 114, 155, 173, 181; Nationalmuseet, Copenhagen 17; National Museum of Wales, Cardiff 14, 205; Hugh Newbury, London 136, 146, 151, 163; Picturepoint Limited, London 7; *The Rock Island Argus*, Rock Island, Illinois 179; Science Museum, London 89, 106, 107, 166, 174, 176, 177, 182; Sheffield City Libraries 12, 13, 81, 92, 93; Sport & General Press Agency Limited, London 150; Sun Alliance & London Insurance Group, London 147, 148; Victoria & Albert Museum, London 2, 8, 32, 39, 40, 48, 63, 77, 79, 80, 82, 83, 96, 102, 158, 159, 162, 183; Jim Witts, Solihull 6. Illustration 24 is reproduced from *Iron & Brass Implements of the English House* by Seymour Lindsay, Academy Editions, London.

INDEX

*The numbers in italic type refer
to illustrations*

Adam, Robert 30
Aladdin lamp *107*
Albert chains 114
Albo-carbon gas light *106*
alewarmers 34–36; ass's ear *42*;
 slipper 36, *41*
Allgood, Edward 19
alloys 7
aluminium 122
American Chair Company 139
American Museum in Britain
 (Claverton Manor) 23, 44, 75, 186, *33*
andirons *31, 32*
annealing 7
Anne of Cleves House Museum
 (Lewes) 23, 40, 120, 152
antimony 11
Argand burners *106*
Argand oil lamp 75, *90*
Argand, Aimé 75
Army & Navy Stores, Catalogue *194,
 200*
Arsenius, Ferdinand *166*
ashtrays 120, *139*
astrolabe, planispheric *166*
axe-heads, Bronze Age 15, *17*

balconies 125
Banches, Adam 77
Baradelle *177*
barbed wire *179, 180*
barbers' bowls 143
barge ware 19, 186, *22*
Beardmore, J.D., & Co. Ltd *197*
bellmetal 8
bellows 30–31, *27, 39*; Irish 31, *29*
bell panels 135
bellpulls 125
bells 149–150, 165, 172; cow *172*;
 horse 149, *172*; sheep *172*
Benares ware 162, *184*
Berain family 145–146
Berlin bronze 8
Berlin iron 8
berry spoons 73
Betty lamp *115*
billhooks 148, *173*
Billies and Charlies 171, *201*
Bilston enamel *16*
black bills 148
bleeding 179
bleeding bowls *see* barbers' bowls
'Bobbed' Wire Bible, The by J. Glover
 180

*Book of English Trades and Library of
 Useful Arts, The* 87
bottle-jacks 41, 44, *54*
Boulsover, Thomas 11–12
Boulton, Matthew 12
Boulton, Matthew, and Plate Co. 12,
 75, 116
bowls, copper 46
boxes 111–113
box irons 54–58, *65*
branders 43
brass 7, 155, 174, 181
Britannia metal 10–11
broiler *56*
bronze 7, 182, *17, 18, 198–199*
bronze disease 182, *198–199*
brown bills 148
bucket weights 152, *174*
buckle, Bronze Age *15*
buttonboxes 111
buttonhooks 111
buttons 107–111, *129, 132*;
 political 116, *136*

caddy spoons 71
candelabra 83, *76*
candleboxes 102
candle extinguishers 102, *103*
candle holders *100*
candle moulds 77, *108*
candle shears 102
candle-snuffers 102, *12, 103*
candlestands 83
candlesticks 80–83, 90, *8, 94, 99,
 102, 104, 108, 117*; chambersticks
 90; cobra 162–163; Gloucester
 candlestick *8*; pricket 80–81;
 sliding 83; student 99, *113*;
 traveller's 90
canteens 72
Canton enamel ware 163
casters 67, *79*
casting 7
cast iron *8*, 181
'cat' platewarmer 43
cauldrons 39, *63*
chairs 135–139, *162*
chalice sundial *see* cup sundial
chamber lamps *92*
chamber pots 63
chambersticks 90
champlevé enamel 15, 163
chandeliers 83–86, *110;* Knole
 chandeliers 86, *110*; wall sconces
 87–90, *96*
Channel Islands milk jug 46, *51*
chargers, pewter 63
chatelaines 107, *127*

chess sets 158
chest *19*
chestnut roasters 34, *4*
chimney cranes 39, *45*
chizel, bronze *198–199*
chocolate pots 69
Christiana burner *106*
cigar cutters 120, *123, 140*
cigarette cases 121, *124*
cleaning 179–186, *204, 206–209,
 211*; barge ware 186; brass 181;
 bronze 182; cast iron 181; copper
 181; cut steel 181; iron 180–181;
 japanned tin 186; lead 186;
 metalware *195*; ormolu 183–184;
 pewter 184–186; Pontypool ware
 186, *205*; steel 180–181; tinware
 196; tole ware 186; wrought
 ironwork 181; zinc 186
cloisonné enamel 18, 163
coaching horns 149
coal-hole covers *see* coal plates
coal plates 126, 127, *151*
coalscuttles 36
coasters 69, *93*
cobra candlesticks 162–163
coffee pots 69, *14*
coin cases *161*
coin scales 150, *161*
coin testers 150–152, *161*
Coleman lamp *107*
combination tools 145
compasses 143
condiment carrier *86*
conversions 170
copper 7, 181
coppers 54
copper trays 162
corkscrews 69, *4, 75*
cork-shapers 150, *167, 169*
Country Life 146–147
covered jugs *82*
cow bells *172*
cream jug *79*
crimping irons 58
crumb trays 73, *74*
cup sundial *176*
cup weights *see* bucket weights
curfew 23, *30*
curios 155–156, *171*
curtain ties 130, *154*
cut steel 181

damascening 15
Darley, Matthias *39*
Diderot, Denis 146
Dinanderie 155
diningroom equipment 63–73

dishes 63–67
dividers 143
dog grates 26
door furniture 125, 128–135, 7, 145, 152, 153, 155, 160, 163, 197
doorknockers 125, 130–135, 145, 153
door porters *see* door stoppers
door stoppers 130, 152, 160
douters 102
dressingtable sets 113
Drowne, Shem 126
Durham cathedral, knocker 145, 153
Dutch metal 8

Eaton, Charles 171
Edwards, George 39
egg cooker, Roman bronze 55
egg decapitator 85
electric lamp 109, 112
electroplate 12
Elkington & Co. 12
ember tongs 120
enamelling 15–18, 23, 163, 16
Encyclopaedia of Cottage, Farm and Villa Architecture and Furniture by J. Louden 135
EPNS *see* electroplate

fairground targets 160
fakes 167, 170–177, 201
fan 121
fenders 26, 38, 40
field furniture 139
fingerplates 130
firebacks 23, 36, 37, 38
firedogs 23, 24, 25, 26
fire gilt 12
fireguards 26
fire-irons 26–30, 34, 39
fire marks 126–127, 147
fireplaces 23–26, 21, 39, 59, 70
fire plates 127, 148, 149
fireside companions 30
fire stools 39
fire tongs 26, 39
fish kettles 44
flambeaux 75
flat irons 58
flower holders 107
foodwarmer 67
footman 43
forgeries 167, 171, 203; *see also* fakes
fork rests 73
forks 72, 83
Franklin stove 33
French plating 179
fruit basket 88
furniture 135–139, 109, 162

garden furniture 135
gas lamps 106
German silver 11
girandoles 87
Gloucester candlestick 8

Glover, Jack 180
goffering irons 58
Gore, Edward 96
go-to-bed matchboxes 80, 95, 120, 140
grates 26, 25, 35, 38, 39; dog 26
Great Exhibition of 1851, Catalogue 139
Great Western Railway station (Salisbury) 139
griddle plates 43, 50
gridirons 42
gunmetal 8

hambone holders 73, 84
hammers 143
Hampshire County Museum Service 143
Hancock, Joseph 12
hanging candlesticks *see* wall sconces
hard metal 10
hasteners 43, 54
hearth brush 39
heat-welding 8
herb cutter 60
Hilpert family 187
hinges 158
Hollandois 145
horse bells 172
horsebrasses 148–149, 170
horse hitching posts 164
hotwater plates 63
humidifiers 131
hunting horns 149

Irish bellows 31, 29
iron 7–8, 180–181, 5, 11; Berlin 8; cast 8, 181; wrought 8, 181
Ironmonger, The 111, 114, 155
irons 54–58; box 54–58, 65; crimping 58; flat 58; goffering 58; stands 58
iron stands 58

jack racks 41–42
japanned ware 18–19, 174, 186
jugs 46, 51, 74, 79, 82

kettles 44–46, 1, 67
kettle tilters 39
keyrings 156
keys 127–128, 156, 158
kitchen, 18th-century Nuremberg 183
kitchen equipment 39–58
knives 72
Knole chandelier 86, 110

lamps 75, 92, 101, 105, 114, 194; Aladdin 107; Albo-carbon 106; Argand burner 106; Argand oil 75, 90; Betty 115; chamber 92; Coleman 107; Christiana 106; electric 109, 112; gas 106; miner's 137; oil 114; oil table 92; oil wick

105; sparking 116, 119; student 103, 89; Tilly 107; whale oil 75, 101, 118
lanterns 90–99, 97
lanthorns 90
latten 8
lazyman toasters 34
lazy tongs 120, 103
lead 186
Lennard, Richard 23
Lennard fireback 23, 37
Léonard, Agathon 112
letter rack 72
lighting 75–103
link extinguishers 146
lion rim ornaments, Etruscan 15
locks 128, 158, 159
Longleat (Wiltshire), fireplace 21
Lords cricket ground (London), weather-vane 150
Louden, John 135

Manfredini, Luigi 156
mantel ornaments 36–37, 28
Maris altar 204, 210–211
matchboxes 80, 98; go-to-bed 80, 95, 120, 140; holders 98, 139; vesta boxes 121, 140
matchbox holders 98, 139
measures 152, 175; copper 46; gunmetal 46; pewter 63, 52; thistle 46; town 152; Winchester 152; *see also* weights
medallions 114–116, 160
metalware, 74, 195
Meuse enamels 18
Michelham Priory (Sussex) 75
miner's lamp 137
moneyboxes 160
Monteith 67
mortars and pestles 50, 150, 53; apothecaries' 150; kitchen 50
moulds 47, 66
mugs, pewter 46
Museum of English Rural Life (University of Reading) 148

nails 152–153, 181
napkin rings 73
Naples forgeries 171, 203
natural metals 7
New Book of Chinese Designs by Edwards and Darley 39
nickel 11
nutcrackers 51–54, 61
nutmeg boxes 50–51
nutmeg graters 50–51, 58

oil lamps 114
oil table lamp 92
oil vapour lamps 107
oil wick lamp 105
opera-glasses 122, 126
ormolu 12, 183–184

paktong 11
paper clips *122*
paper holders 122
pastry crimpers 57
pastry cutters 51, 57
pastry jiggers 51
pastry wheels 57
patchboxes 111, *16*
patination 175, 179
Patterson Brothers 156
penny banks *186*
Penshurst Place (Kent), firedog *24*, *26*
penwipers 122
pestles and mortars *see* mortars and pestles
pewter 7, 10, 46, 63, 184–186, *10*, *52*, *77*, *78*
pewter disease 184
pharmaceutical implements 150, 169
pigeon-breasted teapots *188*
pillrollers 150, *169*
pinchbeck 12–15
Pinchbeck, Christopher 15
pipe kilns 120, *143*
pipe racks *see* pipe kilns
pipe rests 120, *142*
Pitt & Dudley *77*
planes 145
plates, hotwater 63; pewter 63
platewarmers 43, *49*; 'cat' 43
poker 39
pole-heads *2*
Pontipool ware 19
Pontypool ware 18, 186, *14*, *205*
porringers 67
pot-hooks 39–40, *45*
powder compacts 113
pressing 10
pricket candlesticks 80–82
provenance 186
punch bowls 67
punch ladles 67
puppets 156, *193*
purdoniums *see* coalscuttles
purses, mesh 113

quaiches 67

railway station furniture 139
ranges, kitchen *200*
reading candlesticks *see* student candlesticks
repairing 170
repoussé *72*
reproductions 167
Revere, Paul, *31*
ring dials 152
Robey's over-type engine, model *182*
Royal Pavilion (Brighton) 40–41, 50, *62*

safety pins, prehistoric *9*
salamanders 43
Salisbury Museum (Wiltshire) 139

salts 67
samples, travellers' 158, *185*
saucepans 44, 67
Saugus Iron Foundry 23
sausage stuffer *60*
scales 150–152, *161*
Schott, Edward *121*
sextant 168
sheep bells *172*
Sheffield plate 11–12, 177, 179, *13*
shoe scrapers 135
skillets 44, *4*
skirt guards 107
slices 44
sliding candlesticks 83
slip top spoons 72
Smith, William 171
smoke jacks 40–41
smokers' aids *144*
smokers' companions 120, *138*
snuffboxes 120, *133*
Southwell minster, door *7*
souvenirs 155, 158–160, *189*, *202*
sparking lamps *116*, *119*
spelter *see* zinc
spice boxes 50
spillholders *28*
spits 40, *43*, *46*, *48*
spoons 71–73, *83*, 169; berry 73; caddy 71; slip top 72
standish 121–122, *125*
station furniture 139
steel 8, 180–181; cut *181*
steel yards 151
Stradivarius (Antonio Stradivari) 143
strapwork 125
student candlesticks 99, *113*
student lamp 103, *89*
sugar hammers 51
sugar nippers 51, *60*
sundials 152; American pewter *178*; cup *176*; portable 152, *177*; ring dials 152
Surrey enamels 15–18, 23
Sussex ironmasters 23
sweetmeat baskets 67
sword, Roman *206–209*

table *109*
tankards, pewter 63, *77*
taper extinguishers 93
taper holders 93
Taylor, Don 179
tea caddies 71, *68*
teapots 71; pigeon-breasted *188*
10 Downing Street (London), door furniture *163*
thimbles 114, *128*
thistle measures 46
Thonet, Michael 139
Tilly lamp *107*
tinder lighters 77–80, *91*, *108*
tin-openers 54, *64*
tinware 23, *196*
toasting forks 34, 135, *48*, *56*;

lazyman toasters 34
tobacco-boxes 116, 120, *130*, *134*, *135*, *137*
tobacco-jars 116, *131*
tobacco-stoppers 120, *141*
tole ware 18, 186
Tompion, Thomas 143
tools 143–148, *3*
toys 156–158, *157*, *187*, *190*, *191*, *192*
Tranter Company 143
traveller's candlesticks 90
travelling cutlery sets 72, *71*
travelling outfits 113, *108*
trays, copper 162; crumb 73, *74*; tinware *23*
trivets 42–43, *47*, *48*, *69*; footman 43
tutenag 11

umbrella stands 135
urns 69, *81*

vasculum 102
vesta boxes 121, *140*

waffle iron *4*
waggonjack *171*
waggon wheel *6*
wall sconces 87–90, *96*
warming pans 31
Watt, James 12
weather-cocks *see* weather-vanes
weather-vanes 125–126, *150*
weights 152, 175; bucket 152, *174*; *see also* measures
Wellcome Historical Medical Museum (London) 143, 150
Wellington, 1st Duke of, batterie de cuisine of 47–50, *62*
Westgate Museum (Winchester) 152
Whale oil lamps 75, *101*, *118*
Wilkes, John 158, *159*
wind clocks 125, *21*
wine cistern *80*
wine funnels 69
wine labels 69, *73*
wine strainers 69
wrought iron 8, *181*

zinc 186